3 1526 04354632 1

W9-BWH-391

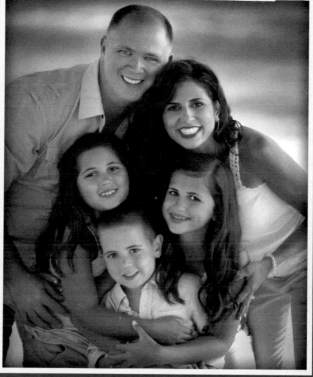

Photographing Families

Tips for Capturing Timeless Images

Michele Celentano

WITHDRAWN

WILEY

John Wiley & Sons, Inc.

Photographing Families: Tips for Capturing Timeless Images

Published by

John Wiley & Sons, Inc.

10475 Crosspoint Boulevard

Indianapolis, IN 46256

www.wiley.com

Copyright © 2013 by John Wiley & Sons, Inc., Indianapolis, Indiana

Published simultaneously in Canada

ISBN: 978-1-118-39170-9

Manufactured in the United States of America

10 9 8 7 6 5 4 3 2 1

No part of this publication may be reproduced, stored in a retrieval system or transmitted in any form or by any means, electronic, mechanical, photocopying, recording, scanning or otherwise, except as permitted under Sections 107 or 108 of the 1976 United States Copyright Act, without either the prior written permission of the Publisher, or authorization through payment of the appropriate per-copy fee to the Copyright Clearance Center, 222 Rosewood Drive, Danvers, MA 01923, (978) 750-8400, fax (978) 646-8600. Requests to the Publisher for permission should be addressed to the Permissions Department, John Wiley & Sons, Inc., 111 River Street, Hoboken, NJ 07030, 201-748-6011, fax 201-748-6008, or online at www.wiley.com/go/permissions.

Limit of Liability/Disclaimer of Warranty: The publisher and the author make no representations or warranties with respect to the accuracy or completeness of the contents of this work and specifically disclaim all warranties, including without limitation warranties of fitness for a particular purpose. No warranty may be created or extended by sales or promotional materials. The advice and strategies contained herein may not be suitable for every situation. This work is sold with the understanding that the publisher is not engaged in rendering legal, accounting, or other professional services. If professional assistance is required, the services of a competent professional person should be sought. Neither the publisher nor the author shall be liable for damages arising herefrom. The fact that an organization or Web site is referred to in this work as a citation and/or a potential source of further information does not mean that the author or the publisher endorses the information the organization or Web site may provide or recommendations it may make. Further, readers should be aware that Internet Web sites listed in this work may have changed or disappeared between when this work was written and when it is read.

For general information on our other products and services or to obtain technical support, please contact our Customer Care Department within the U.S. at (877) 762-2974, outside the U.S. at (317) 572-3993 or fax (317) 572-4002.

Wiley publishes in a variety of print and electronic formats and by print-on-demand. Some material included with standard print versions of this book may not be included in e-books or in print-on-demand. If this book refers to media such as a CD or DVD that is not included in the version you purchased, you may download this material at http://booksupport.wiley.com. For more information about Wiley products, visit www.wiley.com.

Trademarks: Wiley and the Wiley logo are trademarks or registered trademarks of John Wiley and Sons, Inc. and/or its affiliates. All other trademarks are the property of their respective owners. John Wiley & Sons, Inc. is not associated with any product or vendor mentioned in this book.

About the Author

Photo courtesy of David Guy Maynard.

Michele Celentano is an accomplished wedding and family portrait photographer with more than 25 years of experience. Michele is one of an elite group of fifty photographers contracted by Canon USA to be a spokesperson for the company's Explorers of Light program. She also was awarded a Photographic Craftsmen degree from the Professional Photographers of America and the Accolade of Photographic Mastery from Wedding and Portrait Photographers International. Her artwork has been published in photography magazines such as *Rangefinder*, *American Photo*, *Shutterbug*, and *Studio Photography*. In addition to running her portrait business full time, Michele conducts seminars, workshops, and lectures on professional photography in the United States and abroad. Visit her web site at www.michelecelentano. com to learn more about her seminars and workshops as well as to view her beautiful images.

Michele a native New Yorker and currently resides in Arizona with her husband Paul and between them three daughters.

Credits

Acquisitions Editor
Carol Kessel

Project Editor
Katharine Dvorak

Technical Editor
George Maginnis

Copy Editor
Lauren Kennedy

Editorial Director
Robyn Siesky

Business Manager
Amy Knies

Senior Marketing Manager
Sandy Smith

Vice President and Executive Group Publisher
Richard Swadley

Vice President and Executive Publisher
Barry Pruett

Book Designer
Traci Powers

Acknowledgments

"To attain you must aspire." Those are the words my grandfather wrote in my grade school yearbook. I remember asking him at the age of 12 what that meant. He smiled and told me to look the words up in the dictionary. "If you are going to be a gravedigger you be the best gravedigger there is." Those were my mother's words. I skipped the grave-digging job and picked up a camera with a will to aspire. Anything is possible! I know this because I have made a 25-year career from what some thought would turn out to be an expensive hobby.

Paul, you made me a believer when I did not believe. You are my true north, my heart, my soul, and the safest place to fall. You have brought a joy to my spirit that I could not have known without you. Thank you for your incredible and endless support during this process. I know it was not easy but you never let on. There were days I doubted this book was possible. You knew better and never let me get off course. I love you more than you could ever know.

Mom, thank you for believing in my talent and supporting my education and passion for starting my own business. I know there were days you worried that this would be an expensive hobby rather than a career but you always supported me. Your words, "Well, it's not neurosurgery, but at least she is trying something!" helped to get me where I am today. Your words only pushed me to prove I could achieve my dreams. I know you were horrified to find out that I smuggled expensive crystal and Tiffany china out of the house for photography school assignments; however, those first works of art from 1990 still hang in your house today. I hope I have made you proud.

Dan, you helped me spread my wings and fly. Heading out to sea and working as a cruise ship photographer are some of my greatest memories of my youth and I gained experience out at sea I could have never dreamed of. (That was your idea.) You are always there for me as a friend and as a father. Thank you.

Gary, thank you for being my first model and putting up with more than your share of crazy photo shoots. You were the first person to say, "You should be a professional photographer." You were there the first time I presented a program. You were my biggest fan, greatest supporter, best friend, and now the greatest dad to our amazing daughter. You will always be a part of my personal and professional history. Thank you for giving Anna the best "other mother" and one of the truest friends I could have ever hoped for. Louise, you are a true gift in my life.

Susan Cameron, there are no words for what you have added to my life. You are the kindest spirit with the coolest head and the warmest heart. You are the wisest woman I know and have the greatest understanding of what is truly important in life: to love and to be loved; to spend quality time with those you love; and to not worry about the little things because in the end it will all be okay. You are a fighter with a strong heart and I love you.

The list of photographers who have been influential in my life is too long for this paragraph; however, there are two who deserve special mention. Monte Zucker, you will always have a special place in my heart. The gifts you gave to me — I continuously work to pay them forward. I can still hear your laugh and smell the cologne that would linger long after your hugs. I know you watch over me from that perfect high key studio in heaven. Hanson Fong, I simply adore you and I am so proud to call you my friend. The greatest compliment you gave me was, "This is the fifth time you are taking my class. Why? You don't need me anymore." You are the King and you will always be the King!

To my "A" team: Alli, Ashley, and Anna. I am truly blessed to have each of you in my life. You have all taught me lessons about life that have become part of who I am. Learning to be a mother and a stepmother is a process that is far from perfect. Thank you for allowing me to grow into my role in your lives. I will always love you.

Being honored by Canon USA as an Explorer of Light has been a highlight of my career and I am beyond grateful to Canon, David Sparer, and Steve Inglima for believing in what I do and giving me an incredible platform from which to share it.

There are so many talented people who helped me through the process of writing this book. Ted Baird, thank you for your brilliant coaching. With your help, writing this book became a gift to myself, and one of my greatest personal growth periods. Dawn Irons, you have been a trusted friend and studio assistant for almost seven years. Without your groundwork with clients, sessions, model releases, being a sounding board and my organizer none of this would have been possible. Thank you so much.

To my team at Wiley, thank you, thank you, and thank you again for asking me to take on this project and supporting me all the way through it. Carol Kessel, Katharine Dvorak, Traci Powers, George Maginnis, Lauren Kennedy, Barry Pruett, Robin Siesky, Amy Knies, and Richard Swadley, thank you for all the work you put into this book. Without you this would not have been possible. I am incredibly grateful for this opportunity.

To every family who has given me the honor of creating their portraits, thank you so much for allowing me to be a small part of your family.

And last but certainly not least, to my "chosen" family of amazing supportive friends, thank you for every word of encouragement. I heard every word and your love and good wishes were felt.

Growth is only possible when positive people who help you reach your true potential surround you. Such people have more than blessed me throughout my life.

This book is dedicated to my daughter Anna.
You are the most beautiful gift I have ever received.
Thank you for being incredibly supportive during
this process. Every time you put your hand on
my shoulder and said, "Mom you can do this,"
you reminded me that anything is possible.
I will forever be grateful
for your love and support.

Contents

Chapter 4: Finding the Best Locations. **49**

Chapter 5: Understanding Your Client . **79**

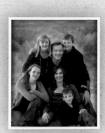

Foreword

When I first met Michele Celentano some 20 years ago, I was instantly impressed by her bubbly personality and her "I can do this" attitude. Over the years, I have had the wonderful opportunity to observe her evolvement as a professional photographer. When I saw her at the Professional Photographers of America National Convention as the keynote speaker, she wowed the audience with her exceptional photographic techniques. She did not speak at her audience, but most important, she spoke to the level of her audience on the principles of making her subjects look photographically timeless.

This book shows Michele's techniques on why and how her techniques work and it also shows and explains specific techniques that cannot justify acceptable photographic moments.

I personally enjoy her key phrases when posing her subjects. Why I like these phrases is because you are interacting with the subjects. You are creating a mutual working relationship by putting the subjects at ease, thereby capturing their natural expressions.

The key phrases also assist the subjects to pose naturally rather than appear looking "posed" in the photographs. The purpose to these key phrases is that the photographer is the director, i.e., a director directing the movie. The director, aka, photographer, leads the subject(s) into the proper pose, etc. Subjects always want to be led by a leader; Michele is the ideal photographic leader! A toast to you, Michele!

Hanson Fong
Master Photographer Photographic Craftsman

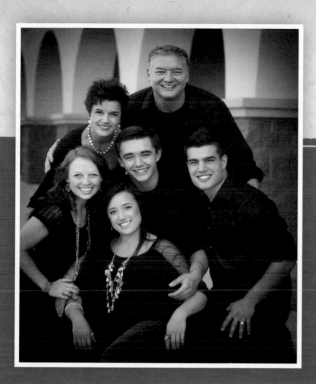

Introduction

family | **ˈfam(ə)lē** |

noun (plural **families**)

1. a group consisting of two parents and their children living together as a unit.

 • a group of people related to one another by blood or marriage: friends and family can provide support.

 • the children of a person or couple being discussed: she has the sole responsibility for a large family.

 • a person or people related to one and so to be treated with a special loyalty or intimacy: I could not turn him away, for he was family.

portrait | **ˈpôrtrət, - ˌtrāt** |

noun

1. a painting, drawing, photograph, or engraving of a person, especially one depicting only the face or head and shoulders.

 • a representation or impression of someone or something in language or on film or television.

* Definitions from Oxford University Press online (http://oxforddictionaries.com).

Blending these definitions, a family portrait is a representation or impression of people related to one another who are to be treated with a special loyalty or intimacy. They are a historical view of our families — a representation of a time in the history of our parents, grandparents, and even great-grandparents. They are the visual aid we use to help us tell our children stories about their family. Family portraits are important — maybe not as much for today than for the future, for the generations that will outlast us; the family portraits that help tell our story are really just the beginning of their story.

I was only 17 when my interest in photography began. To be honest, I failed photography in high school because I spent a fair amount of time cutting class to hang out with my boyfriend. You can imagine my mother's shock when I asked to attend photography school at the Center for Media Arts in New York City. My mother's exact words were, "How is she going to make a living taking pictures?"

My personal journey into family portraits started a long time ago, while I was aspiring to be a wedding photographer. It never dawned on me that being a wedding photographer meant that I was also a family photographer. I suppose this is where I began to learn about family dynamics and how to navigate family relationships.

I was born and raised in Brooklyn, New York, by my grandparents and my mother. I was an only child and spent most of my time with my grandparents because my mom worked full time. Nanny and Pop were old-school Italians and my grandmother was the oldest of nine children. In my house, family was everything. Sunday dinner was not negotiable, and blood was always thicker than water. There is no doubt in my mind that my upbringing has given me a strong appreciation for the meaning of family and family portraits. I truly believe with every fiber of my being that the portraits of those we love are the treasured, tangible items we hold closest to our hearts when they are gone.

The portrait of my grandfather and his family shown in Figure 1 is 99 years old. I love it because it represents my grandfather's generation, and it is a small window that allows me to see him as a child. A 99-year-old photograph is still important, relevant, and timeless. This is what I hope I am creating with my work. Someday when I am gone and the children in the portraits I created have grandchildren of their own, they too will hold a piece of history — their own personal histories.

I started my photography career in New York. High-end weddings were my specialty and I loved photographing them. Italian and ethic weddings were my favorite. The energy, the families yelling, the traffic, the huge churches, the ridiculously long limos, the over-the-top food, the women in the bathroom taking cash out of envelops if they thought the wedding did not live up to expectations, the brides and grooms counting cash at the end of the night so they could pay the band that played

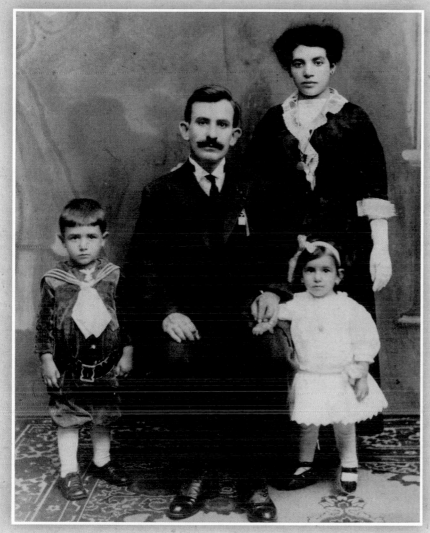

Figure 1

This is a portrait of my grandfather when he was three years old.

an hour of overtime because the party just wouldn't end. I loved it all! I loved it right up until my daughter was born and then suddenly the idea of being gone for 14 hours on the weekend wasn't appealing to me anymore.

When my daughter Anna was 16 months old we relocated to Arizona. Our new neighborhood was brand new and master planned for young family living. My plan was to rebuild my wedding business on a smaller scale and enjoy being a mom. Before long, neighbors and friends were suggesting that I photograph children and families. At first I was not all that thrilled with the idea. Patience with young children was a bit beyond my natural talents. I liked working with adults who could pay attention and stay where I put them. Sure enough, however, it happened — I began to photograph children and families and I enjoyed it. My years of wedding experience and speed was a great asset to photographing families with young children.

As my daughter grew older, I began to realize the importance of documenting family portraits. As a child we had lots of candid photos taken with a 110mm camera but we really didn't have professional family portraits. It was something I began to see great value in. It dawned on me that I had no real pictures with the grandparents

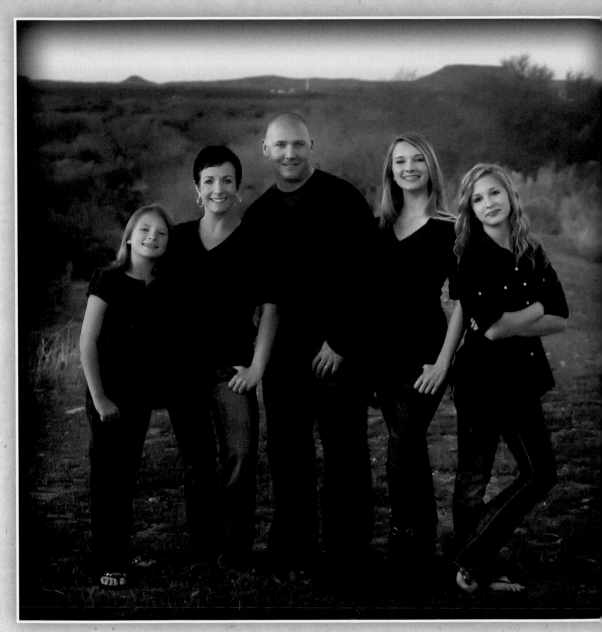

Figure 2
This is a portrait of my family. From left to right: Anna, Michele, Paul, Alli, and Ashley.
(Portrait by Angela Carson.)

who raised me, and that by being a portrait photographer, I am able to provide these important photographs for others. To this day when I photograph grandparents with their grandchildren I still get teary eyed. I always say to those children, "I know this isn't what you want to do today, but some day you will be so grateful you have these

portraits. They will mean more than you can imagine." The kids usually look at me like I am nuts but I say it anyway.

Today, I live in Anthem, Arizona, and am married to amazing man who "gets" me and all of my quirkiness. Figure 2 is a portrait of our family. I'm a wife, a mother, a stepmother, a runner, a yogi, and a bit of a gym rat. I continue to photograph families and children but mostly I love to teach photography to upcoming photographers. It really is an honor and a blessing to be able to give back to an industry that has given so much to me. Over the years I have been fortunate to earn my living by photographing people. (See, Mom — I told you it was possible!) Now more than ever photographers need education so that they can continue to produce quality work that will last for generations. I hope this book in some way will inspire and help educate photographers young and old on the beauty of creating timeless family portraits.

The 80/20 Rule

In my mind, to be a successful portrait photographer, it takes 80% personality and 20% technical knowledge. The technical stuff — cameras, settings, lenses, lighting — can all be learned. The personality part is where pros really shine. And you really have to like people — all kinds of people — from newborns to the elderly. If you are not a big fan of working with people, then you might be better suited for still life or product photography.

But being a great photographer is more than liking people; the people have to like you, too. You need to be able to instantly connect with people who you may have just met. You need to be able to direct people, take command of a crowd, and be assertive when needed. Confidence is a must. You need to be engaging and interested in your subjects. Asking a lot of questions is a great way for people to feel like you want to know more about them. The more you know your subjects and engage them in conversation, the more comfortable and relaxed they become.

If clients really like you and have a great experience, in most cases they will love the portraits you create for them. (That is, as long as they are not substandard quality, which is why you are reading this book.) On the flip side, I have seen wedding albums and family portraits that are done well but the client doesn't like them because in the client's words, "The photographer was a jerk." If clients do not have a great experience, it will be reflected in how they feel about their final portraits.

Knowing the names of all your subjects is a sure way to gain instant respect. I always make it a priority to know the name of each person I am photographing no matter how big a group is. In the initial conversations with parents who are interested in family portraits, I spend a lot of time asking about the children: what are their hobbies, which movies do they like, who are their favorite characters, what sports

do they play, what is their favorite subject. The more I can talk to children about what they are interested in, the greater the likelihood I will get natural expressions from them. That is my ultimate goal — natural expressions! The last thing I want to see in a portrait is a "cheesy" smile.

As photographers, we love cameras and all the cool gadgets that go along with them; however, most people do not like to be in front of a camera. The camera and being photographed can be intimidating. Our first job as photographers is to get our clients to relax and feel comfortable. We have to establish a relationship with our subjects. It may be a short-lived 1-to-2 hour relationship but it is the key to creating fun, believable portraits that your client will love.

As you can see, connecting with your clients has absolutely nothing to do with technical knowledge. This is the 80% of what we do. Having a pleasant, confident personality and being able to connect with everyone in the family, from the 2-year-old to the 80-year-old, is critical to becoming a great family portrait photographer. Engaging your subjects in a way that brings natural, beautiful expressions has nothing to do with how to work a camera, which lens you use, postproduction work, or fancy filters. Great expressions from your subjects are simply a reflection of you. A smile without an expression is just a smile. Expression is what brings portraits to life; it's what tells the story of the subject. Have fun, enjoy your subjects, and make them laugh. If you can do that, you are 80% there!

What to Expect From This Book

Cameras, lenses, postproduction work, locations, and white balance are really only a small part of what goes into the images passionate photographers create. You can read this book and many more to learn about f-stops and shutter speeds, but my goal is to teach you how to make everyone in your images feel and look beautiful and enjoy the experience so much that they love the images you create for them and remember how much fun it was doing them, too.

Having portraits created should be fun for the whole family as well as the photographer, but, of course, the portraits also need to be done well. Be a perfectionist in your work and always strive to grow and learn as a professional, but remember as much as you love the camera, most people do not. It's your responsibility to make every person you photograph look her best. It's not enough to find a great location with beautiful light and then stick a subject there and hope for a "pretty picture."

Throughout the chapters in this book, you will learn about posing subjects, camera settings, cropping images, postproduction workflow, how to find the best locations,

and techniques to make people look younger and thinner in the camera. My hope is that in these chapters you find inspiration and information mixed with some technical details, a touch of humor, and a lesson on the one thing that will make your photography incredibly special: you. You might just learn about yourself — what makes you special and why clients will come to you for their next family portrait.

People and the connections we have with those we love are what matter most in this world. I hope you find the joy and importance of capturing the essence of what family means throughout the chapters of this book. There is a great responsibility knowing the portraits you take will outlast you, outlast the people in them, and give generations down the line an idea of who their great-grandparents were.

1 | Getting Started with Family Portraits

For a large majority of portrait photographers, the idea of creating a photography business stems from a passion for taking pictures of people. But how do you get started photographing families? How do you turn a hobby into a business? Or if establishing a business doesn't appeal to you, how do you take the passion you have for taking pictures and create beautiful, timeless memories for future generations of your family?

In this chapter, I discuss how to get started taking family portraits. First you need to determine what style of portrait photography appeals to you most, and then you need to look at the type of equipment you will need to get started.

Determine Your Portrait Style

The first thing to think about before you start to photograph families is the style of portraits that appeals to you and to the clientele you want to work with the most. Are you more of a traditionalist or a candid photojournalistic photographer? Often both styles can be blended together. You can also market different styles of family portraits to a different demographic of clients. I have found that the style also can be dictated by the age of the family. Young parents with young children often request a more candid style of portraits than families with older children and grandchildren, who often prefer a more traditional style of portraits.

It's fairly easy to create candid images of young children running, playing, and interacting with their parents or older siblings. It is usually hard to get young children to pose for any amount of time, so a candid approach is sometimes to only way to go. On the other hand, candid style portraits don't always work with older children or even older parents. For example, can you imagine a couple of teenagers rolling down a hill holding hands or being thrown up in the air by Dad?

Further, sometimes the style of your portraits is dictated by the personalities of the family. I have worked with some families that are playful and affectionate with each other and that makes it really easy to get more casual, fun images. I have also photographed families that are rigid and quite awkward when I have asked them to lean into each other or get close. This is one of the reasons a pre-portrait consultation is so important (more on this in Chapter 8). Getting to know the personality and style of the family you will be working with before the session helps you plan for the type and style of portraits you will be creating.

Lifestyle/Candid Portraits

Do those wonderful carefree images that look photojournalistic "just happen?" In most cases the answer is no. True candid or photojournalistic images happen when the subject is totally unaware of the camera; they capture an unexpected moment without the subject knowing it. The lifestyle/candid portrait style I refer to is something more along the idea of staged or directed photography that looks as if it were candid.

Often staging or directing is involved when it comes to creating successful candid images. Let's face it: You plan a session, talk about the best time of day, choose clothing and a location, and then direct the subjects in some sort of way to create the images you have in mind. This style of portrait may not be completely posed, but it is orchestrated to a certain degree.

One of my all time favorite "journalistic" images was actually staged. The image "The Kiss by the Hotel de Ville" is one of the most famous photographs by photographer Robert Doisneau. "The Kiss by the Hotel de Ville" was actually planned and staged. For many years people thought it was an incredible candid moment between two

lovers on the streets of Paris, when in fact it was the manifestation of the photographer's imagination. It was quite the scandal when the truth was revealed. Apparently when the original negatives were found, they included many different frames of the famous image.

My mentor Monte Zucker used this Doisneau quote all the time, and it still rings true for me today:

> { I don't photograph life as it is,
> but life as I would like it to be.
> *–Robert Doisneau* }

I think this quote is true of family portraits, too. All families have their issues, ups and downs, and crazy moments, but when a group comes together for a portrait, each member puts his best foot forward. It's a time to celebrate the love within a family. It's my job as a portrait photographer to let the best of each family shine through.

The point of the story behind "The Kiss by the Hotel de Ville" is that as an artist and photographer, it is your job to create the images you envision. Have a vision in your mind of what you want to capture for each of your families and then make it happen. Your images can have a traditional feel or a more candid feel. Creating consistently good images isn't a game of luck; that is, by shooting 1,000 images, you hope to get a few good ones from each session. Consistent quality in your work takes thought and planning.

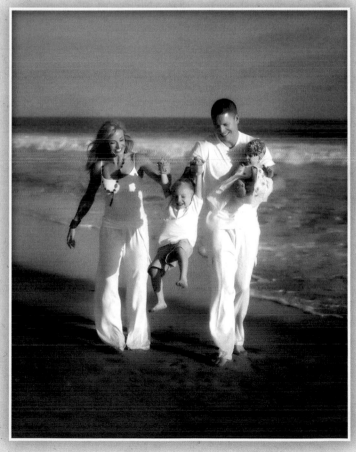

Figure 1.1
When you're photographing really young children, it's difficult to get posed or formal portraits. This looks like a fun candid image on the beach but it is staged.

Figure 1.2
Rossi, the little girl, was just starting to walk. For this shot I had her mom Laura bend down and hold her and look at something in the distance.

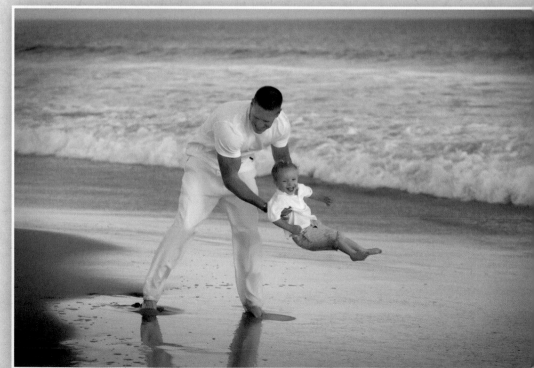

Figure 1.3
For this image I had Josh and his son Rhett play by the shore. At Rhett's age it's more fun and natural to create candid images.

You want to create portraits that will make your clients look their best, feel their best, and ultimately be a part of their lives for years to come.

In the series of images shown in Figures 1.1, 1.2, and 1.3, I photographed the family on a beach (an informal location) and let them sort of play in a directed way.

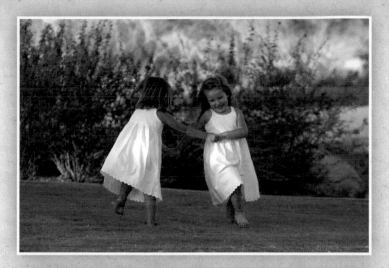

The next series of images, shown in Figure 1.4, were created to look "candid," but each image is set up. In the top image, I had the little girls play ring around the rosy. I placed them in an area with beautiful light and a great background. Their faces are priceless as they spin each other around. To create the image in the middle, I had Madi lay on her belly in the grass and then had Anna lay on Madi's back. They thought this was hysterical. Again, even though this shot may seem candid and natural, the girls were intentionally set up to get this shot. For the image on the bottom, I had the girls lie next to each other, put their arms around each other, and tickle each other. Again, this image appears to be candid, but it is posed.

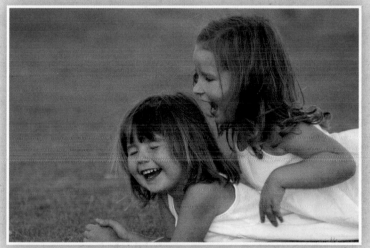

Figure 1.4

These little girls were three years old and not about to sit for a portrait. It was more fun to photograph them as the playful little girls they were.

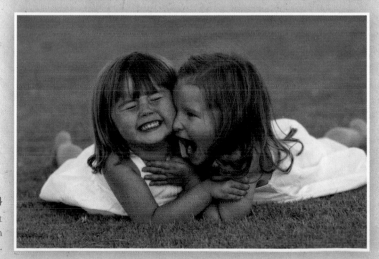

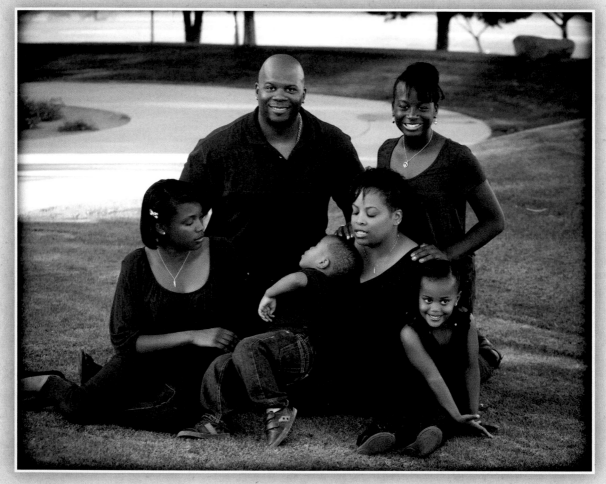

Figure 1.5
A two-year-old boy is unlikely to sit for a "formal" portrait. And, if he does, you have about 20 seconds to take the picture and hope that he is making a face Mom will like.

I love the images shown in Figures 1.5 and 1.6 because they are perfect examples of how creating a formal portrait with young children who are just not that into it is next to impossible.

Figure 1.6
These two images offer a great example of how to turn the session around to get really beautiful portraits while letting a two-year-old be a two-year-old.

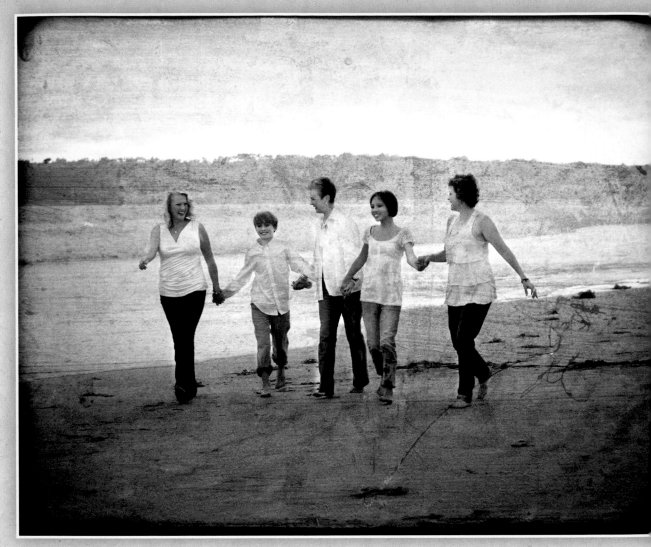

Figure 1.7
A casual stroll along the shoreline creates a fun and relaxed family portrait.

Even older family groups can have a casual feel to them if the location allows. The beach is a great location for the casual portrait shown in Figure 1.7. Walking along the shoreline holding hands is a great way to create a candid-like portrait.

Posed Portraits

Posed portraits tend to be more formal and structured than candid portraits. In most cases, the subjects are looking at the camera. Posing props such as furniture or posing stools are often used. With posed portraits, paying attention to hand placement, the direction of the body, the placement of feet, and head tilts and turns are all important aspects. Figures 1.8–1.13 illustrate examples of posed portraits.

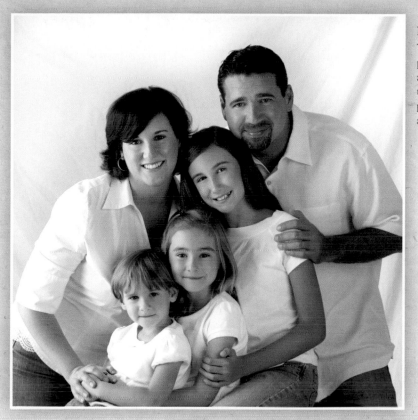

Figure 1.8
This is a classic studio portrait. Window light and reflectors were used to light this image. It is a posed portrait but still has a soft, casual feel to it.

Figure 1.9
Using the waterfalls as the background, I created this formal portrait using the rock as a posing prop and to create different heights between the subjects.

Figure 1.10
This is a great example of an extended family portrait in the park with members posed formally.

Figure 1.11
Even though this is a formal portrait, it still has a relaxed and natural look. Having the kids leaning in and everyone's arms around other family members help make this image look relaxed and natural.

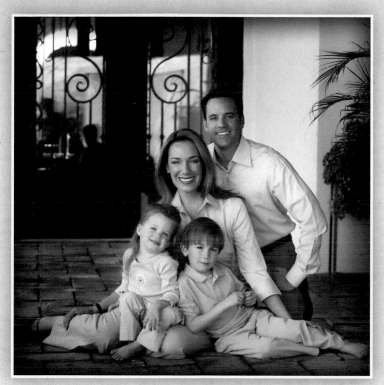

Figure 1.12
Using the client's home as the background for this family portrait makes it personal to the family.

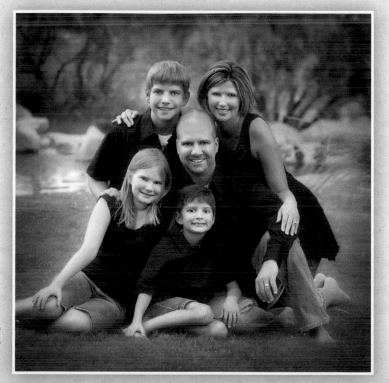

Figure 1.13
Having families go barefoot is a fun way to make formal portraits look more casual and relaxed.

Choose the Right Equipment

With all the choices out in the market today, it can be difficult to figure out what exactly you need to get started as a portrait photographer. I can tell you this — start with what you have and don't become a gear geek. I know it's easy to do because we photographers generally like our shiny new cameras and lenses. Don't be discouraged because you feel like you are working with less than the "very best." As a young and broke photographer, I started off with inexpensive camera gear and as I could afford better equipment, I upgraded a little at a time.

Cameras

A good digital single lens reflex (dSLR) camera is essential. I do not recommend point-and-shoot cameras for portrait work. A camera that can use different lenses, has good resolution, and has good low-light capabilities is a must. I suggest purchasing the best you can afford at the time.

Generally, camera choice comes down to personal preference and the type of photography you do. For example, I prefer a different camera when I photograph weddings than I do when I create portraits. (When shooting weddings, I am more concerned with frames per second than I am with megapixels; however, for portrait work, I am more concerned with image quality than frames per second.) I'm also hard on my equipment so I tend to like heavier camera bodies.

Canon cameras have always been my first choice. I started out using Canon cameras and have continued to use them over the last 25 years. Currently the Canon EOS 5D Mark II is my primary portrait camera (Figure 1.14). Almost every image you see in these pages was shot with the 5D Mark II. The new 5D Mark III will have hit the market by the time this book is published and I am looking forward to the upgrade.

Figure 1.14
One of the reasons I love this camera is because of its low-light capabilities. Most of my portraits are shot at ISO800 and I am able to make beautiful, large prints at that

If you are thinking about getting a new camera and you are not sure which one is right for you, check out rental companies. You can rent equipment and try out different cameras and lenses to see what you like. Check out which cameras feel comfortable in

your hands and how you like the images you get from them. Functionality is also important. How easy is it to change settings? Do you like the white balance results from one camera over another? Buy the best that you can afford. Professional-level equipment is important because the results will be better, especially when it comes to lenses.

Lenses

Many years ago, when I first began to purchase equipment, I didn't understand the differences in lenses and why "professional" lenses were so much more expensive than the amateur lenses were. That was until I tried one.

My first big lens purchase was the Canon 85mm f/1.2 lens. It cost a lot of money at the time, and I actually ended up buying a used one and it served me well for many years. I had previously owned an 85mm f/1.8 lens and could not understand for the life of me why the price difference was close to $1,800. How much better could a f/1.2 be over a f/1.8? It was night and day. I quickly renamed my 85mm f/1.2 my "magic" lens. With this lens I could create beautiful portraits in low light with no problems and the images were incredibly sharp.

I strongly suggest that you invest in good lenses. There is a reason for major price differences in lenses. In general, the higher the price of the lens, the better the quality. Faster, sharper lenses are going to be on the high end of the pricing spectrum. Lenses that are f/2.8, f/1.8, f/1.2, and even f/1.0 are considered fast lenses because the larger the aperture, the faster the shutter speed.

Telephoto lenses that maintain a large aperture all the way through are going to be more expensive as well. Some telephoto lenses might be f/3.5 at their widest, but might be f/5.6 at their longest. One of my most-often used and favorite lenses for portraiture is the Canon 70-200mm f/2.8 IS II because it is f/2.8 from 70 to 200mm.

Work your way up with lenses; they will outlast your cameras. I have probably upgraded my camera body four or five times and kept the same lenses. In every two years there will probably be a new, upgraded camera, but good lenses outlast camera upgrades. The lenses I recommend for portrait photography are the Canon 70-200mm f/2.8 IS II and the Canon 85mm f/1.2 II, and for fun the Canon 135mm f/2.0. The 135mm is not a necessary lens, but because it is a prime lens with a wide open aperture of 2.0 it is incredibly sharp and a stunning portrait lens. The 70-200mm will give you more range but there is something special about prime lenses.

What About Wide-Angle Lenses?

Wide-angle lenses are generally not recommended for portrait photography; it's a mistake to think that because you are photographing a large group, you need a wide-angle lens. If you have the room to use a longer lens rather than a wide-angle lens, use a longer lens. Wide-angle lenses are not kind to the body and can often distort people, especially those closest to the edge of the frame. Longer lenses create a compression that is much better for portraits. Stick to using your wide-angle lenses for landscapes.

Tripods

If you have not used a tripod for photographing portraits, you might want to give it a try. It will be awkward at first but once you get used to it, you may wonder why you lived without one as long as you did.

A good lightweight tripod with legs that are easy to lengthen and shorten is a good option. You will need to try out different tripods to see which one works well for you. It's probably best to shop at a local retailer so that you can play with different models in person rather than shop for one online and try to guess which tripod will work for you.

Posing Props

I have had a set of Hanson Fong's EZ-Steps posing blocks (http://hansonfong.smugmug.com) for more than 15 years and they are still going strong. They are a great posing tool as well as a shooting tool (Figure 1.15). I can seat and arrange subjects on them, remove individual blocks to change certain subjects' heights, or use them as cushions for the knees for those people kneeling on the ground. I also stand on them to gain height when photographing close-ups. They are high-density Styrofoam and light to carry around. (Much lighter than step ladders.)

Figure 1.15
In addition to rocks, chairs, and stairs, I consistently use Hanson Fong's EZ-Steps to help me pose subjects.

Chairs are also great posing props. Multiple armchairs are great for posing large groups. I often use an armless chair when posing groups. Using chairs, blocks, the ground, or partial walls are a great way to create different heights between your subjects.

Camera Bags

A camera bag can either weigh you down or make your life easier. When I travel, I use a large camera bag with wheels, which makes it much easier to get around airports. When I shoot locally, I like a bag that is light and easy to wear so I can get

to all of my lenses, compact flash cards, and ExpoDisc easily. UNDFIND (www.undfind.com) makes an amazing and easy-to-carry camera bag system. I use both the large-size bag as well as the waist shooter. The neoprene material keeps the bags light, and they are not bulky to carry. If you prefer a bag that is more like a purse and designed for women check out Kelly Moore camera bags (www.kellymoorebag.com). Her bags are both fashionable and function able. For traveling on airplanes I like a roller bag that will fit in the overhead compartment. Tamrac (www.tamrac.com) and Porter Case (portercase.com) make several great rolling cases.

Reflectors

Reflectors and translucent light panels are a great addition to your gear bag. My personal choice is a 5-in-1 reflector system. Stand-up reflectors are also great but they can be a bit more difficult to handle outdoors. If there is any type of breeze, your standing reflector will take off like a kite unless the stand is weighted down. If you want to use handheld reflectors and translucent light panels, I highly recommend having an assistant along for the session.

Photoflex (www.photoflex.com) makes several 5-in-1 reflectors. They fold into themselves and are easy to carry. I often use the translucent center panel if my subject is in direct harsh light and I want to soften the light. The white side is great for adding subtle light to a subject who may be shaded when you have a strong light source hitting the white. The silver side is really great at kicking highlights into the subject's eyes and can often add light to the subject when there is not a strong directional light. The gold side of the 5-in-1 adds warmth and is beautiful on dark-toned skin. Depending on the brand and which type you purchase, some 5-in-1 reflectors have a gold/silver combo side. This is nice for portraits because it adds a little bit of warmth without adding too much gold.

Summary

Are you a formal portrait or a lifestyle candid photographer? Maybe you like both styles and will incorporate each one into your business. Have fun experimenting with styles of photography. Keep in mind that not all candid-looking images are actually candid. There is still some staging and directing involved when creating candid images. Without thought and planning your candid images may look more like snapshots. In addition, formal portraits don't always need to look stiff or unnatural; even formal portraits can have a relaxing feeling when they are done correctly.

Your equipment should be an extension of your imagination. Equipment is the tool, not the artist. As the artist, you manipulate the tools to create what you visualize in your mind. Get to know your equipment so well that you don't have to think about how it works. Familiarize yourself with the camera's functions so using them becomes effortless, and know what your lenses will do at certain focal lengths and apertures. Read the manual, but practice using your gear every day. Now go have fun playing with different equipment and finding families to experiment with. Your own family maybe the most difficult to work with so finding friends might get you the experience you need.

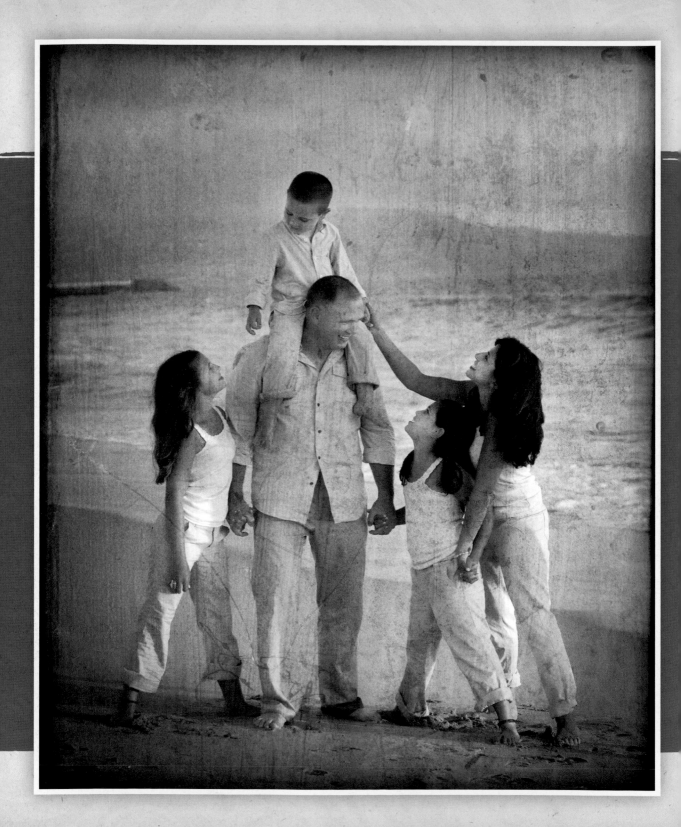

2 | The Elements of Photography

In all fields of art and photography, composition is the pulling together of certain visual elements to create an interesting or appealing painting, sculpture, design, or photograph. But it can be difficult to define what makes an appealing composition. Composition has many elements, such as the placement of subjects, leading lines, the rule of thirds, the use of space, and really anything that adds to the overall feeling of the work of art or photograph.

Interesting composition is well thought out. With photography, the photographer must decide where to place the subjects, how to crop the image, and which elements to include. Basically, to create an interesting and well-composed photograph, the photographer first designs the final image in her mind and then takes the final photograph. When you create compositions for your portraits, they will vary depending on the location, the number of subjects you are photographing, and your style of photography.

As with any form of art, there are basic, universal principles, or "rules." And, of course, rules are made to be broken. Breaking the rules of art and composition can be effective if you know the rules to start with and you break them with purpose. In this chapter I discuss the "rules," or elements, I believe are important to portrait photography.

The Rule of Thirds

The "rule of thirds" is probably one of the most well-known rules in art. Divide your viewfinder into sections: draw two horizontal lines and two vertical lines through every image to create a total of nine boxes, as shown in Figure 2.1. Think of your viewfinder as your canvas. How will you use the frame to create the composition of your portraits? In most cases when photographing traditional family portrait groups, your subjects will be centered in the frame. But, there may be times when you want to be a little more creative with your composition and place your subjects in different parts of the frame. Figures 2.2, 2.3, and 2.4 illustrate how to divide the frame of a horizontal image into even thirds. Figures 2.5 and 2.6 illustrate how to distinguish the four corners of the frame in a vertical image. Keeping these visuals in mind can help when you are trying to decide exactly where to place your subjects for either a vertical or horizontal portrait.

Figure 2.1
Think of your canvas divided into nine boxes. The same can be done for a vertical picture, too.

Figure 2.2
Which section would you like to place your subjects in? In the center, far left third, or far right third?

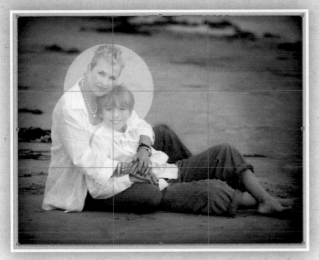

Figure 2.3

In this image the subjects are placed off center in the cross section of the upper left third and center left third of the image.

Figure 2.5

The four corners of the frame are highlighted vertically and horizontally.

Figure 2.4

The subject's right eye is in the upper third left of the frame, and her nose and mouth are in middle left third of the frame.

Figure 2.6

The subject is centered in the frame; however, the viewer is drawn to the top center third where the eyes of the subject have been placed.

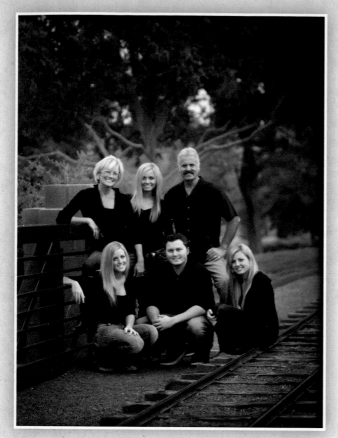

Figure 2.7
Using the leading lines of the railroad tracks as well as the railing brings the viewer's attention directly to the family.

Leading Lines

The use of leading lines can have a huge impact on images. Leading lines can draw your eye into the image, guiding you to the focal point and then drawing your eye through the image. Leading lines help the photographer direct the viewer to exactly what is important in the image. Many times the viewer doesn't realize that these lines affect how he travels through the image.

In Figure 2.7, I use the railroad tracks as a leading line to bring the viewer's attention directly to the family. In Figure 2.8 I used the concept of leading lines again. This time I used the wall to lead the viewer's eye up to the subject.

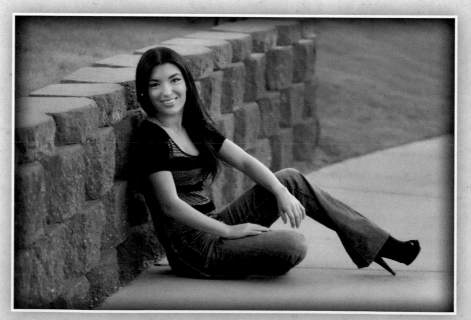

Figure 2.8
The wall creates a natural leading line, bringing the viewer's eye to the subject.

Creating diagonal lines when posing subjects is another effective way to create leading lines. In Figure 2.9, the tree branch becomes the leading line as well as a prop. The bottom of the branch forces the eye to travel to each girl's face.

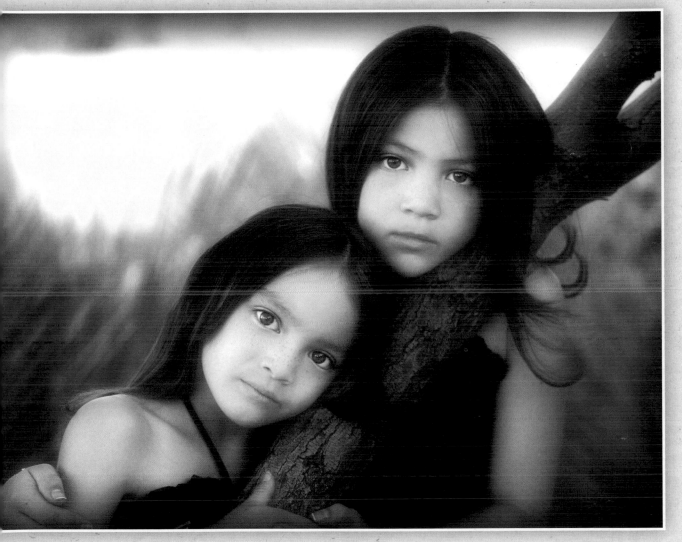

Figure 2.9

The tree branch is a prop as well leading line staring at the thumb of the sister in the left leading you to sister on the right in this portrait.

Space

You can also use space in an image to bring the viewer's attention to the focal point. Placing a subject to one side in the composition and leaving empty space can be dramatic. Notice the use of space and the rule of thirds in Figure 2.10. The subject's eyes are placed in the upper-right third of the frame to create space on the left side of the frame.

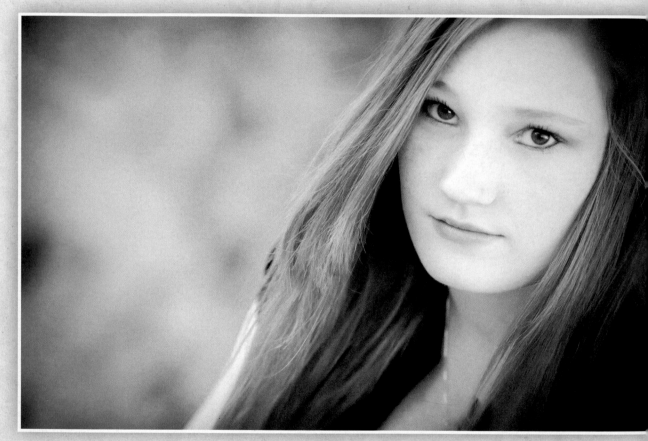

Figure 2.10
Not only have I created space in this image but also I placed the subject's eyes in the upper right third of the image.

Shapes

I can remember learning about geometry in school and wondering what in the world I would use it for in my "real" life. Geometrical shapes are a great element not only for composition but also for posing subjects. Shapes help create balance in compositions and structure in posings. Triangles are probably the most important shape when creating portraits.

Posing groups reminds me of a puzzle that young kids often play with: the one in which they have to fit the shaped pieces into the correct holes. Bodies and faces are shapes that need to be pieced together in order to create a well-posed portrait in which everyone looks good.

In Figure 2.11, I'm used a triangular shape to pose this family. I had the subjects separate their feet and point their toes to create the triangular base, and I put the little boy on Dad's shoulders to make him the high point of the triangle. Another example of using triangles in posing is shown in Figure 2.12. Beginning with the elbow of the bottom subject, you can see the triangular shape. (For more information about creating triangles, see Chapter 6.)

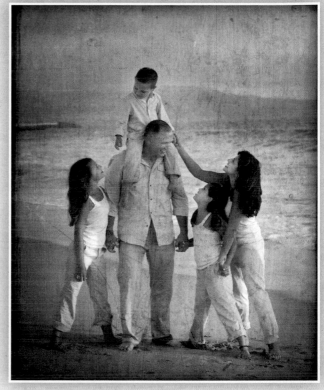

Figure 2.11
I posed the members of this family to create a triangle.

Figure 2.12
Notice how the three heads stacked together form a triangle.

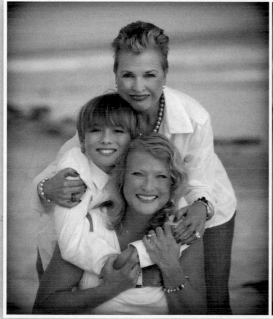

Texture and Depth

From textured walls on old buildings to light passing through the branches of a willow tree, if you start looking, you can find texture in most things. Texture is such a great element in photography because it helps you create visual interest, as shown in Figure 2.13. Depth is created by having a foreground, middle ground, and background in the image. For example, look at Figure 2.14. The bushes in front of the subjects are in the foreground, the subjects are in the middle ground, and the tree and vegetation in the back form the image's background. In this example the foreground and background almost frame the subjects.

Without texture or depth, images can look flat. Texture and depth are particularly important in black-and-white images. Because black and white lacks color, it is the texture, depth, and emotion that create an interesting image.

I love the image shown in Figure 2.15 because it was candid. I was photographing this family of seven and I asked Mom and Dad to sit. I then turned to talk to the children and direct them where I wanted them to go. When I turned back, I saw this image.

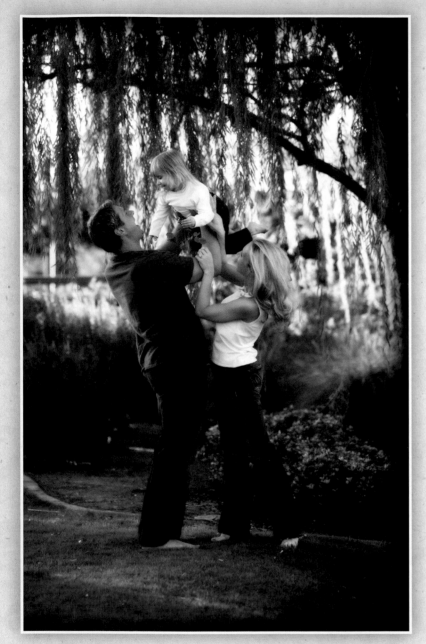

Figure 2.13
The backlight coming through the branches of the willow tree creates a beautiful texture.

Figure 2.14
The bushes (foreground) and willow tree (background) are both out of focus while the subjects (middle ground) are in focus.

Figure 2.15
What I love most about this image is the texture from the fountain grass in front of the couple and the texture in the bushes behind them. There is a sense of catching a secret moment.

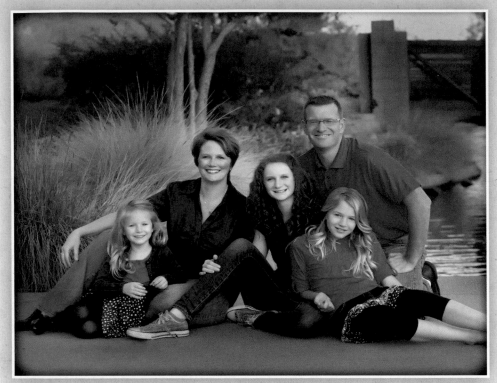

Figure 2.16
Even with bold hot pink, this color palette and portrait work. When meeting with a client, I usually discourage using such bold colors, but the mix of hot pink and navy blue is cohesive.

Figure 2.17
This family opted for tan with a little bit of silver sequins. Even though the two choices are very different, they work together.

Color

Color harmony is another element you should carefully think through, especially when photographing families. Clothing color has an impact on the portrait as well as home décor colors. A client with a Tuscan style home may not want to have a portrait with bright colors that will clash with the colors in their home. On the other hand, a client who loves bright, bold colors may find solid or muted colors boring.

Color harmony in the location will play a part in the portrait as well. It can be distracting to have each member of the family wearing different or opposing colors. Blending colors together or using bold colors in a cohesive way is a style choice of both the family and the photographer. Some clients prefer the look of everyone wearing the same color, and some like to mix it up and be a little bolder. You may want to chose location and clothing based on where the portrait will go in the family's home. For portraits going in a formal room, classic colors work best. If the portrait is going in the family room or a game room, brighter, more bold colors that are playful may be appropriate.

Figure 2.18
Picking up the natural colors found in the desert location, this portrait has great color balance.

The portraits shown in Figures 2.16 and 2.17 were shot in the same location but with completely different color palettes. The first family chose a bold color palette, while the second family decided on a more neutral look. Picking up on the colors of the desert location of their shoot, the family shown in Figure 2.18 used tans, browns, and even orange to incorporate natural earth tones into their portrait. Even though we have a bright pop of orange in this image, it works well with all of the other colors.

Impact or Emotion

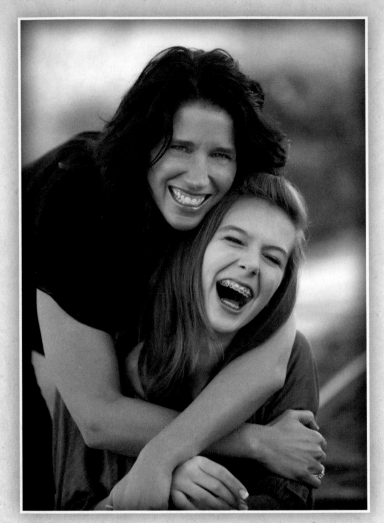

Figure 2.19
This portrait screams fun to me. Looking at this image I feel like I can hear the young girl laughing.

In the case of family portraits, the people who will be most affected by the portrait will be the family members. I have found that posing for and viewing family portraits can be emotional for the family and especially for the mothers of the families. The first time they see the portraits I created often brings tears. Mom may realize how fast her children are growing up and how they have changed. The family may be going through a tough time and the portraits remind them of how much they mean to each other. Teenagers can be problematic during those teen years and you may be able to capture an expression that Mom and Dad have not seen in some time — and that can cause an emotional reaction. Often I photograph a family right before the oldest child leaves for college, which again is an emotional time for parents, and because of that, the portrait takes on even more meaning than the family may have originally thought. There have been times I have photographed a family because someone is terminally ill and the family wants a portrait together. I can tell you that that situation is very emotional for me.

When you photograph families, you get to be a part of the family for a short time. I try to find a connection with people and that brings out the emotion and impact of the portrait. Figure 2.19, for example, captured a fun moment during a session and it shows. I love the image shown in Figure 2.20 because of the age difference and connection between the grandmother and granddaughter. The soft expressions in Figure 2.21, along with the beautiful hands of the elderly woman, create so much emotion. Making it sepia toned only adds to the aged look of this portrait.

Figure 2.20
The way the young girl is tilted into her grandmother and the soft expression on her face brings out the emotion of the relationship between this grandmother and granddaughter.

Summary

Having every element I discussed here in your portraits is not necessary. However, having at least two or three key elements is important. Elements are the ingredients that give your images interesting composition. Use the elements as tools. Keeping the important elements covered in this chapter in mind when looking for a location or figuring out how to pose a group can help you add so much variety and interest to your portraits.

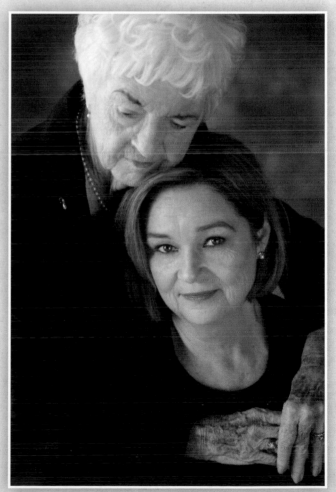

Figure 2.21
This mother and daughter portrait is one of my all time favorites. Carolyn's mother Valetta passed away a few years ago, and at her funeral Carolyn told me that this portrait was the last time she had her mother's arms wrapped around her. The impact of this portrait is immeasurable.

3 | Getting It Right in the Camera

This is the statement that may send me to an early grave: "Don't worry about it now; I'll fix it in Photoshop later." I hear new photographers say this all the time. Digital photography has created an environment where many photographers feel they just need to get the shot and will worry about color, balance, exposure, and cropping later.

When I was in photography school almost twenty-five years ago, we didn't have Adobe Photoshop. There was only "getting it right in the camera" or making the perfect negative. I had to choose the correct film, know how to use a light meter, know how to use the manual settings on my camera, and know how to process film (black and white, as well as color). I also had to know how to print in the dark room. I have to say I am so glad I grew up with film and learned proper techniques for getting it right in the camera.

Don't get me wrong, technology is amazing and we photographers now have the ability to correct mistakes; however, isn't it better to avoid mistakes and reduce your time spent in front of the computer? If I can encourage you to pretend you can't "fix" your images later, you will learn so much and save yourself quite a bit of postproduction time sitting at your computer.

Understanding Camera Metering and Exposure

For beginners it can be scary using anything other than the automatic settings on the camera. However, learning how to use different metering methods and choosing the one that you like best or using different metering modes for different shooting situations opens the door to creativity. Learning to override the camera's automatic metering modes allows you more control over your exposure and ultimately your images. Your confidence in your abilities will begin to grow as you learn how to master metering and exposure not to mention how much fun you will have trying new techniques.

P Mode Is Not for 'Professional'

Yes, I'm sure you already know that P mode does not stand for professional. P is one of the many automatic modes your camera may have. In Program mode you let your camera determine all of the exposure settings. There are so many buttons and different settings on your camera, and you may not know what to do with ones other than Program. However, I can take some of the mystery out of your camera and its many settings.

Each camera manufacturer uses slightly different names for similar settings and has different ways for finding them on your camera. Given I am not an expert on each specific manufacturer or the hundreds of different camera bodies and lenses available, I offer here only general settings. You will need to review your camera's manual and experiment with your specific equipment to fully understand how your camera operates.

Middle or 18% Gray

Digital single lens reflex (dSLR) camera meters are color blind — they meter for exposures in shades of gray and black and white, with white as the brightest part of an image and black as the darkest. DSLR cameras also use a reflective-light metering system. This means that the camera takes a meter reading from light reflecting off whatever you point your camera at. All cameras need to have a baseline exposure (a starting point) from which to capture the image. The standardized exposure based on the luminance of light reflected is universally known as middle gray, which is a tone that is about halfway between black and white on a lightness scale. Industry standards have used the term 18% gray for many years; however, middle gray is a bit more accurate because the range of gray can be anywhere from 12% to 18%.

In theory, your camera wants to balance the blacks and whites and create an exposure that is right in the middle of the two exposure extremes. Figure 3.1 illustrates a gray scale from bright white to the darkest black. Right in the middle of the two extremes is what is considered middle or 18% gray. That sounds great in theory; however, the world is not middle gray. One of the best examples of this is photographing snow. For example, you are on a skiing vacation with your family and want to photograph the beautiful, snow-covered mountains. There is nothing gray about snow (usually), but in an automatic exposure mode your camera's metering system will expose the scene to make it 18% gray. When you look at your ski vacation pictures later you will wonder why the snow looks kind of gray or "dirty."

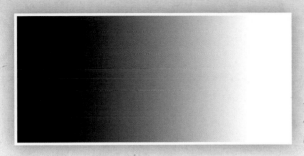

Figure 3.1
The area in the middle is considered middle or 18% gray.

Keep this in mind as you are shooting in an automatic metering mode: any other setting on your camera besides Manual (M) is considered automatic exposure metering. When the camera is metering something that is darker or lighter than middle gray, the meter will be inaccurate and either overexpose or underexpose the image. Under- and overexposure will vary based on the variance in tones.

Using the different metering systems in your camera can help you achieve more accurate exposures. A camera can meter for exposure several different ways:

- **Evaluative Metering.** Evaluative metering is the standard for most cameras. Evaluative metering takes into consideration the entire scene when determining exposure. It detects the subject, brightness, background, front and back lighting, and orientation of the camera, and then sets an exposure based on that information. It evaluates the entire scene evenly so no one area has priority over the other.

- **Partial Metering.** Partial metering takes into account about 12% to 15% percent of the viewfinder weighted at the center. This is often a good setting for backlit subjects.

- **Spot Metering.** Spot metering is for metering a specific part of your subject or scene. The metering is weighted at the center, covering about 3% to 4% of the viewfinder.

- **Center-Weighted Metering.** Center-weighted metering is just what is says — centered weighted, meaning it gives priority to the center area and then averages for the entire scene.

(Note: The percentages of metering areas will vary based on camera manufacturer as well as individual camera bodies. The numbers outlined here are based on the Canon 5D Mark II. Be sure to reference your camera manual for specific numbers for your camera body.)

Choosing a metering mode is a personal choice. It all depends on how you like to shoot. I prefer evaluative metering so that I can make exposure adjustments based on the knowledge that the camera wants to expose everything to middle gray.

Exposure Compensation

Exposure compensation is one of the functions of my camera I probably use most. When using the evaluative metering mode consider yourself a metering assistant. It is important to be aware that the camera is using the entire scene to create an exposure (a middle or 18% gray exposure). Knowing this, you are able to assess what in the scene is most important as far as exposure and adjust the exposure compensation accordingly. For example, I'm on the beach on a bright day, the water is reflective, and my subjects are wearing white. I know that the camera is going to want to expose this scene at 18% gray, and if I want the faces of my subjects to be correctly exposed I have to compensate so that I will get more white and less gray in the image. In other words, I have to "overexpose" according to the meter or dial my exposure to the + side of the compensation scale. I learned to master exposure compensation back in the day before digital existed and I could not look at an image or histogram on the LCD screen on the back of my camera to check my exposure. Learning to master exposure compensation will alleviate the need to look at the image histogram. I have never relied on a histogram because in some cases the histogram may not be accurate based on what you are trying to expose.

Figures 3.2 and 3.3 are designed to help you understand middle gray and how exposure compensation works. Here you can see that in an automatic exposure mode, middle grey is 0 on the exposure compensation scale.

The next series of images, shown in Figures 3.4–3.8, shows three sheets of paper (white, gray, and black). All three sheets of paper are shot under the same lighting conditions with Aperture Priority as the exposure mode.

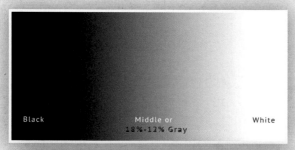

Figure 3.2
From left to right is a full gray scale from black to white with shades of gray.

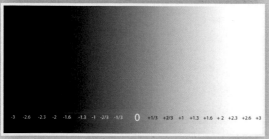

Figure 3.3
Looking at the exposure compensation scale you can see that 0 represents middle gray.

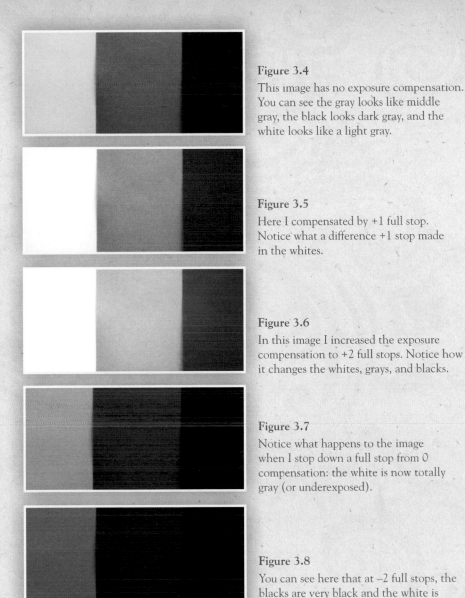

Figure 3.4
This image has no exposure compensation. You can see the gray looks like middle gray, the black looks dark gray, and the white looks like a light gray.

Figure 3.5
Here I compensated by +1 full stop. Notice what a difference +1 stop made in the whites.

Figure 3.6
In this image I increased the exposure compensation to +2 full stops. Notice how it changes the whites, grays, and blacks.

Figure 3.7
Notice what happens to the image when I stop down a full stop from 0 compensation: the white is now totally gray (or underexposed).

Figure 3.8
You can see here that at –2 full stops, the blacks are very black and the white is almost middle gray.

I encourage you to do this test with your camera. Each camera will have a slightly different sensitivity to compensations and you should be aware of how your particular camera works. For this experiment get a pure white, a middle gray, and the richest black paper you can find. Line them up next to each other and shoot them in different program modes, changing your compensations. Also shoot them in Manual mode to see what happens. The better you understand your camera and its capabilities, the better photographs you will be able to take.

Figure 3.9

Exposure compensation: −0.66. To exaggerate the point of compensation I compensated my exposure two-thirds of a stop under. Show this image is greatly underexposed.

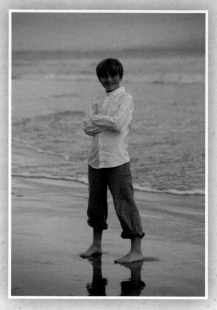

Figure 3.10

Exposure compensation: 0. With no compensation, my camera wants to make this image middle gray, and thus underexposes it.

Exposure Compensation in Practice

If you are using evaluative metering, you can count on your camera exposing for middle gray. This means that if you have a primarily white or very bright subject or background, your camera is going to make that white scene middle gray, thus underexposing your overall image. (A common way to describe this is "muddy.") Therefore, you want to use your compensation function and adjust to the plus side of the exposure compensation scale to get the correct exposure for the whites.

The series of images shown in Figures 3.9-3.12 provide examples of what happens if you undercompensate or overcompensate the exposure setting. The original image was taken on the beach close to sunset using a Canon 5D Mark II with a 70-200mm 2.8 IS (image stabilization) lens (f/4.0, ISO 160, 1/800 second). The bright sky, reflective water, and white shirt were underexposed without exposure compensation.

On the other hand, if you are photographing a family portrait and all of the subjects are wearing black, your camera will want to make the black middle gray and overexpose the entire image. In this case, you would need to dial down to the negative side of your scale to compensate for the darkness of the black.

Figure 3.12
Exposure compensation: +1.5. By compensating too much, this image is now slightly overexposed.

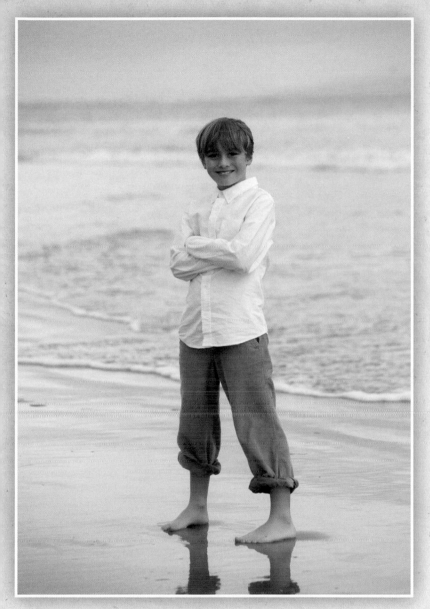

Figure 3.11
Exposure compensation: +1. Now that I compensated +1 stop, the exposure is correct. Keep in mind that according to the automatic metering system, this image by the standard of middle gray is overexposed. Because I know that the overall scene is brighter than the middle gray the meter wants to expose it to, I can make the choice to increase the exposure to get the shot I want.

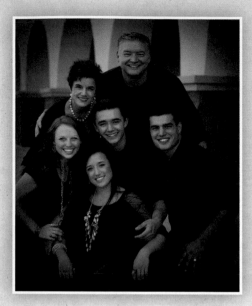

Figure 3.13
Exposure compensation: –2 stops

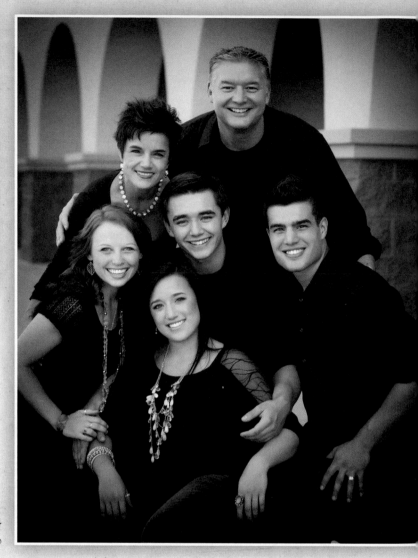

Figure 3.14
Exposure compensation: –1 stop

The next series of images, shown in Figures 3.13–3.16, are the same image shot in Aperture Priority mode on my Canon 5D Mark II with a 70-200mm 2.8 IS lens (focal length 75mm, f/4.0, ISO 320, 1/200 second). The only setting I changed for each image was the exposure compensation. In this case because I was in Aperture Priority mode, my camera made the adjustment to the exposure using the shutter speed. Notice that in Figure 3.15 I did not adjust my exposure compensation and the faces are overexposed. But in Figure 3.14, I adjusted by dialing down one stop and the exposure is perfect.

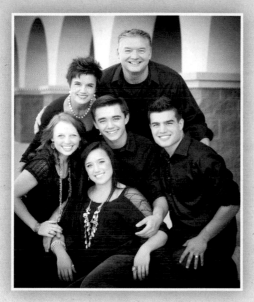

Figure 3.15
Exposure compensation: 0

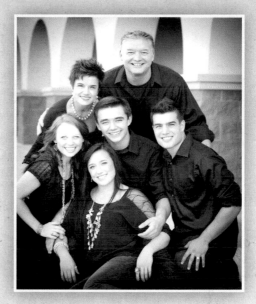

Figure 3.16
Exposure compensation: +1 stop

It may sound crazy to those of you who are used to adjusting your exposure in postproduction, but it is faster to compensate right in the camera than to fix exposure problems later. I personally would rather spend time behind the camera and not in front of the computer.

Automatic exposure is a great feature on cameras and can be pretty accurate. Your camera gets you in the ballpark and once you understand reflective automatic exposure and how to compensate when needed, you hit a homerun.

Understanding Program Modes

The four most common program modes are (1) Program, (2) Shutter Priority, (3) Aperture Priority, and (4) Manual. Here is a breakdown of these settings:

✳ **Program.** In Program Mode, the camera determines both the aperture and shutter speed.

✳ **Aperture Priority.** In Aperture Priority mode, you control the aperture and the camera sets the shutter speed. This setting is great for portraits.

✳ **Shutter Priority.** In Shutter Priority mode, you control the shutter and the camera sets the aperture. This setting is great for sports and action images or for long exposures.

✳ **Manual.** In Manual mode, you control both the aperture and shutter settings.

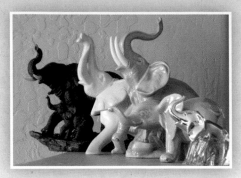

Figure 3.17
Shot at f/32. Everything in this image is in focus from the small elephant up front to the wall in the background.

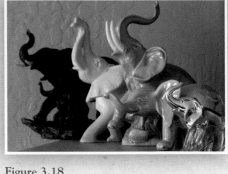

Figure 3.18
Shot at f/22. Notice how the elephant closest to the wall is not quite sharp.

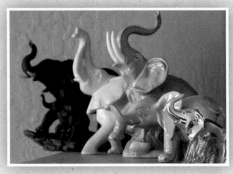

Figure 3.19
Shot at f/16. The wall is now becoming more out of focus, as is the white elephant two elephants away from the wall.

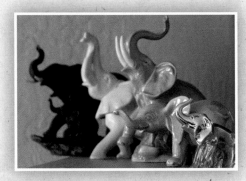

Figure 3.20
Shot at f/11. A greater portion of the image is out of focus.

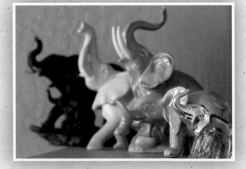

Figure 3.21
Shot at f/8. It's almost hard to see that there is a texture in the background.

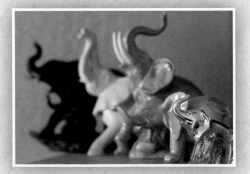

Figure 3.22
Shot at f/5.6. Almost everything except the first and second elephants is completely out of focus.

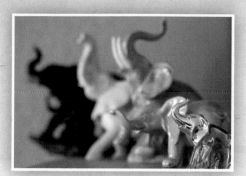

Figure 3.23
Shot at f/4.0. Only the little guy up front is in focus.

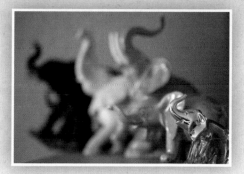

Figure 3.24
Shot at f/2.8. You can see how much the image has been affected from f/32 to f2.8. This image, shot at f/2.8, is far more interesting than the first image, shot at f/32, where everything is in focus.

Depth of Field

I want to be in control of the depth of field in each image I shoot, so I choose Aperture Priority mode for almost everything I photograph. Aperture Priority mode can also help you create portraits with blurred backgrounds. Figures 3.17–3.24 provide a short demonstration on controlling depth of field with Aperture Priority mode.

I collect elephant figurines. My grandmother collected them and now I do, too. (Just so you know, I only collect elephants that have their trunks up, and I always place them facing a window or door for good luck.) I decided to use part of my elephant collection for a demonstration on depth of field because the different sizes and colors of the figurines made them perfect for this project.

I photographed the following images using a 100mm macro lens with aperture settings that ranged from f/2.8 to f/32. I specifically placed the elephants near a textured wall so that as I changed aperture, you can see how the focus of the wall as well as the elephants changed. In these eight images, the only camera setting I changed was my aperture. I never changed the focal point. The camera was always focused on the first elephant.

Having control of your aperture is so important to the creativity of portrait photography. Each lens is different. Longer lenses provide less depth of field and wider lenses offer greater depth of field. This is one of the reasons I prefer longer lenses for portraits and why landscape photographers often prefer wider lenses.

What Is ISO?

ISO, which stands for International Organization for Standardization, is the measurement of how sensitive a digital camera's sensor is to light. The light sensitivity measurement is rated in ISO numbers 100, 200, 400, 800, and 1600. The higher the number, the more sensitive the sensor is to light. This means you can shoot in lower light at higher ISOs. The lower the ISO number, the less sensitive your camera's sensor is to light.

A film's ISO (formally known as ASA) rating measures the film's sensitivity to light — the higher the ISO/ASA the more sensitive the film is to light and therefore, the grainier the images appear. Grain in photos refers to the optical texture of processed film. In simple terms, the grain in film is actually the silver halide particles that are light sensitive. The higher the light sensitivity the grainier or "clumpy" those particles become. In black-and-white photography film grain could look very cool and artistic, but generally grain is undesirable. With digital technology the term "grain" has been changed to "noise" and instead of silver halide particles we have pixels. Therefore, image noise in digital is equivalent to grain in film, but from a different source. Digital noise appears as speckled pixels of color in your images. In general, higher ISO settings result in more digital noise.

Technology has improved over the last few years and ISO is one of the major improvements. In early digital cameras, the noise at higher ISO numbers made it unfavorable to shoot at higher settings. In the newest digital cameras, the lack of noise at higher ISO numbers is incredible. I shoot most of the portraits with my Canon Mark II at 800 ISO with beautiful results. The new Canon Mark III is even better.

Setting White Balance

You might be asking yourself, "What is exactly is white balance?" White balance is a photography term many have heard but few fully understand. In a nutshell, white balance helps ensure the colors in your photographs look the way they should.

The color of light varies greatly, and our eyes and brains automatically adjust for different lighting conditions. The color of light is measured in Kelvin (K) degrees. Kelvin is named after William Kelvin, the British physicist who discovered color temperature while heating a block of carbon. The block of carbon glowed in the heat and produced a range of different colors at different temperatures. At first the cube produced a dim, soft red light but as the temperature increased, the color changed to a bright yellow and then bluish-yellow light; and at its hottest point, the color was bright white and glowing.

When photographers used film, it had specific ratings for different types of lighting — daylight, tungsten, or fluorescent. You would choose the film you needed based on the type of light you were shooting in. Digital is a little different. You can actually set your camera to the exact Kelvin degree of the light in which you are shooting. That's if you have a

Kelvin light meter and have metered the color temperature of the light for every different lighting situation you come across. Most of us don't have nor need a Kelvin meter.

Digital SLRs have different automatic white balance settings based on the Kelvin scale. Here are some basic Kelvin temperatures for common lighting conditions:

Light Source	Kelvin Range
Candle light	1500K–1850K
Sunrise or sunset	18000K–2500K
Household tungsten	2500K–3000K
Noontime sun	5000K–5400K
Overcast daylight	6000K–7500K
Shade outside	7000K–8000K
Partly cloudy	8000K–1000K
Daylight	5500K–6500K
Bright blue sky	9000K–12000K

Color temperatures greater than 5000K are considered cool colors (blue, green, violet). Lower temperatures (2000K–3000K) are considered warm colors (red, orange, yellow).

Several white balance settings are standard for most cameras:

- **Automatic White Balance (AWB).** When set to AWB, the camera figures out the white balance for you.

- **Daylight.** The daylight setting is for use outside on a bright sunny day (5000K–6500K).

- **Shade.** The shade setting is for a shaded area outside or indoor window light (7000K–8000K).

- **Cloudy.** The cloudy setting is for overcast or cloudy skies (6000K–10000K).

- **Tungsten.** Tungsten is for indoor lighting without flash (2500K–2900K).

- **Fluorescent.** Fluorescent is for light you would see in the office or at a gym (3200K–7500K).

❋ **Flash.** The flash setting is for use with an electronic flash (5500K–6000K).

❋ **Manual.** Manual or Custom white balance requires you to shoot a white or gray card under lighting conditions and set your camera for that white point. Each camera varies so be sure to check your camera's manual on how to find the correct settings.

Custom White Balance

Like automatic exposure, the AWB setting gets you in the lighting ballpark; but I really like getting home runs, so I prefer the Manual or custom white balance mode so that I can custom white balance my shots for exactly the lighting condition I am in. When you custom white balance, you are basically informing the camera that an object should appear white under the lighting condition you are in. Many new photographers start out using the AWB setting but this may not always be a good idea when shooting outdoors. AWB tries to convert golden or warm light into white light.

Before I began custom white balancing for each lighting situation, I found I often used the cloudy or shade white balance mode. Each of these settings tend to be on the warmer side and I like warm skin tones. Your personal preferences will dictate how you like to set your white balance. Portrait photographers will most likely have different preferences for white balance than landscape photographers.

There are dozens of ways to custom white balance. I use a device called ExpoDisc from ExpoImaging (www. expoimaging.com/index. php) to custom white balance my portraits. It is a digital white balance filter made to fit over your lens and comes with a lanyard; this way you can hang it around your neck, and it is available to you anytime you need it. ExpoDisc comes in two different types of filters: a neutral filter and a portrait filter. The neutral filter is designed to give you a neutral white balance; the portrait filter is designed to warm up the white balance for warmer skin tones. You can use a white or gray card as well.

Figure 3.25
This image is a full frame shot for a 4x6 print. This is how I see the final image being printed: rectangular and with the eyes of the subject in the upper-right third of the image. This would translate to an 8x12, 16x24, or 24x30 print.

I personally like the ease and convenience of the ExpoDisc. I hold the disc up to my lens, shoot an image through the ExpoDisc in the lighting condition I'm working in, set the custom white balance to that image and am ready to photograph my families. As the temperature of the light changes outside, I can easily white balance again.

Cropping in the Camera

It's important to think about cropping in the camera for a few reasons. The first is artistic: you can be creative with your cropping right in the camera. For example, using the rule of thirds, you may want to place your subject in a certain third of the image, or maybe place the subject's eyes in the upper-right third of the image, possibly cropping part of his or her head from the frame. The second reason you may want to think about cropping in the camera is because you are thinking ahead to the final print size. The frame proportions of the camera are 4x6 inches. Keeping that in mind, if you are making an 8x12 or 16x24 print you can use the whole frame for your image. If you want to make 8x10, 16x20, or even 24x30 prints, you will need to take this into consideration when framing your image in the camera and leave room for 8x10 proportions. I like to start with a final image in mind so that I am aware of how I will want to crop an image. Figures 3.25–3.31 offer

Figure 3.26
The same image shown in Figure 3.25 cropped for an 8x10 format. I prefer the 4x6 crop. In this example, I think it's cropped too tight.

Figure 3.27
This represents a 5x7 crop.

examples of different cropping possibilities.

When you lift the camera to your eye, have a vision in mind. Cropping is part of the artistry of creating story-telling images. With the variety of paper sizes available, you can be creative with cropping. You don't need to stay within certain limits. How much space you leave, how you crop out the top of the head or part of the body tells a story. Sometimes by leaving something out of an image, you leave the storytelling to the viewer. Perhaps by leaving space in an image you allow the eye to wonder a little longer in that image. You don't always need to center your subjects. You can creatively crop for impact. Think about this when you are taking the image instead of thinking about it in postproduction.

Summary

Many years ago when I went to my first Professional Photographers Association meeting, an elderly photographer approached me and gave me some advice. He said, "The camera must become an extension of your hand. The functions and buttons should be second nature to you, and you should not have to think about the camera — only your subject." At 19 years old I thought he was a wacky old photographer and I dismissed his advice.

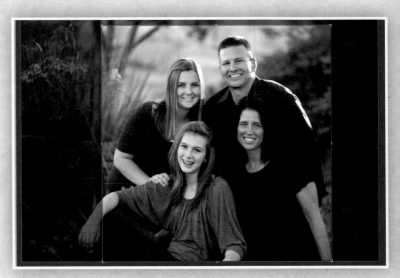

Figure 3.28
This is a square crop that would accommodate a 5x5, 8x8, 10x10, 12x12, or 40x40 print. Square images can be really interesting and offering them is a great way to sell something a little different.

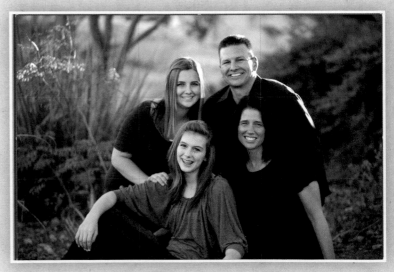

Figure 3.29
This is a full frame, 4x6 crop.

Twenty-five years later I realize that Al Friedman was indeed a wise man giving me amazing advice. Fully understanding your particular camera and all of its functions is the beginning of "becoming one" with your equipment.

Once a musician learns his instrument he doesn't have to think about it and music becomes effortless. When you hear beginners play the piano you know it because the flow isn't there. The beginning pianist is thinking about the next key, but the experienced pianist doesn't think about the piano and the keys; he only feels the music and it flows freely. The same will hold true with your camera, lenses, and other equipment. With practice you will know your equipment so well that portrait sessions will just flow and you won't have to think about getting it right in the camera. It will be second nature to you.

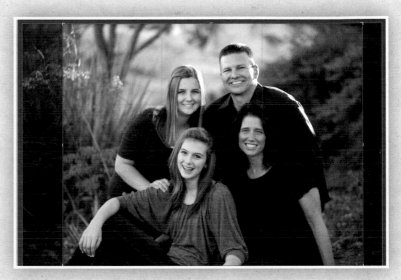

Figure 3.30
An example of an 8x10 crop.

Figure 3.31
This is an example of a 5x10 crop. I had this crop in my mind when shooting this image. I knew I wanted to see a movie theater-style image: long and rectangular. I thought it would give the image more impact.

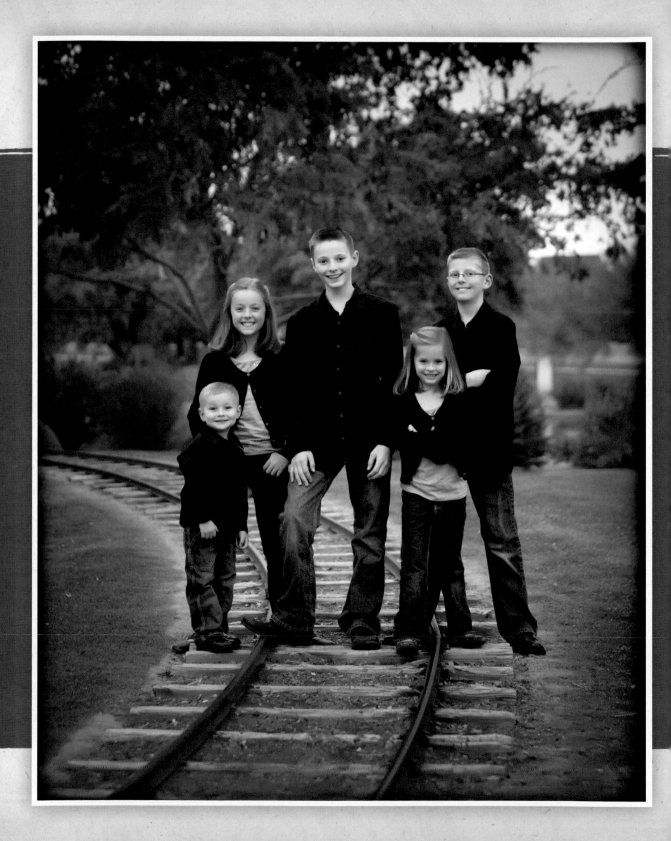

4 | Finding the Best Locations

Scouting a location, finding the right light, and creating images is part of the creative process of a photographer. During my daily life I often find myself stopping and looking at different locations that could work for portraits. I also pay attention to the lighting at certain times of the day. The time of day and light direction have a huge impact on a location. For example, at noon the same location may look completely different than it looks at sunset. Depending on the season, the same location will look different at the same time of day. You may drive by the same location every day and never notice it until the light is hitting it in just the right way.

It's easy to spot good backgrounds: waterfalls, weeping willow trees, the beach. But it may be more interesting to try to find locations that are not so obvious. Some of the most important aspects I look for when choosing locations are color, texture, depth, directional light, foreground, middle ground, and background. Because my style of portraiture tends to be classic and close up, the texture and depth of a location are more appealing to me than a "background." Most of the time I look for small spaces within a larger scene. Using a large aperture allows me to use backgrounds that may not be completely appealing at first sight but with the right light, texture, and depth of field can be perfect.

Finding the Perfect Light

Without light there are no photographs. Light is the one absolute essential thing you need to create a photographic image. Some photographers enjoy working with strobes and flashes while others prefer natural light. You might like both depending on the situation and the subjects you are photographing.

For the kind of work I do, I love natural light. Using natural light seems to be an easy idea or concept in theory, but finding the right direction and quality of light can be challenging. There is "good" light and "not so good" light. What exactly is "good light" and how do you find it? Is there a best time of day for good lighting? These questions are answered in this section but in order to truly start to understand light you must see it for yourself.

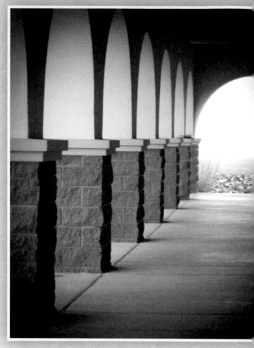

Figure 4.1

This is an example of open shade. The open archways are providing beautiful directional light into the open shade under the walkway.

As you travel around throughout the day start to notice the difference in how the light looks in the early morning, midafternoon, late afternoon, and early evening. Take time to notice how your surroundings look on cloudy days and on sunny days. Before you know it you will be driving around town asking the passengers in your car, "Do you see that beautiful light and how it is dancing on those flowers?" Happens in my car all the time.

Sweet Light/Twilight

I am a natural light photographer. I have always loved beautiful, natural light. I only use flash when absolutely necessary (think wedding receptions). Not all natural light is created equally, however. The light at different times of day can be different colors and can be soft or harsh. In order to have the perfect light, the light must be soft, warm, and directional. Noon is not an ideal time for outdoor portrait lighting, for example, because it tends to be cool, harsh, and directly overhead, which often creates raccoon eyes in subjects.

Sidelight or directional light is usually the most flattering. Even when using studio lights, you would not put a main light directly over a subject's head (unless you are doing glamour portraits with butterfly lighting). The main light usually comes from the side. The same holds true for natural light, whether it is indoor window light or outdoor light.

The two best times of day for natural light are sunrise and the hour before the sun sets. Since most families don't like getting up before the crack of dawn to get ready for a family portrait, I do most of my family portrait sessions around sunset. I usually start a portrait session 60 to 90 minutes before the sun sets. The sweetest light exists only minutes before the sun goes completely down, which is generally not enough time to photograph all of the portraits I do with each family.

Open Shade

What exactly is open shade? It exists when you have an area that is shaded from direct light but has a directional light source. Think in terms of a covered patio, as shown in Figure 4.1. Under the patio is a shaded area; however, there is a natural direction of light coming from the open area next to the patio. You may find open shade next to a building with light on three of its sides. Under trees can often be another great source for open shade. In some cases, your own body may create the shade you need for a subject.

Figure 4.2
Using only window light in my studio with reflectors shows how any window can create beautiful light.

Figure 4.3
This family was photographed in the studio using window light and one reflector. You can create the same type of look in your home by using a backdrop or fabric. Depending on your exposure, you may want to use a tripod to avoid camera shake.

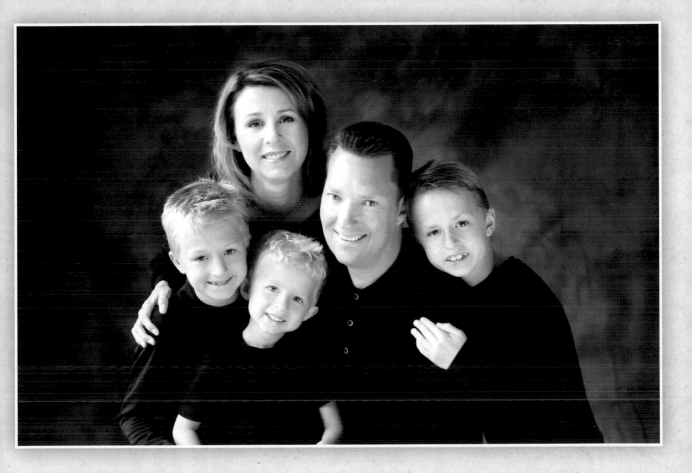

Window Light

Some of the most beautiful light comes right through the window (or even a door). You can use window light almost anywhere (anywhere there is a window, of course). When I used to photograph weddings, I took many of the in-home bridal portraits, and even group portraits, in the bride's home using window light. Depending on how much light you have, you may need to use a tripod to avoid camera shake due to a long exposure.

My studio was built with windows. In the five years I have been in my studio I have used strobe lights twice. My point in saying this is that you don't really need a studio or a flash to create beautiful indoor portraits. The series of portraits shown in Figures 4.2–4.5 illustrate the types of images that can be created using window light.

Figure 4.4
For this image, the window is not only the main source of light but also acts as a prop. I did not use a reflector because I wanted the lighting to be dramatic. Using only a main light without a reflector creates a stronger contrast between light and shadow on the subjects face. In general the more contrast between light and shadow the more dramatic the lighting.

Figure 4.5

For this simple portrait I used the same window light with one reflector to the left of the subject (camera right) in order to add a little fill light.

Window Light with Reflectors

Virtually thousands of reflectors are on the market today, ranging from small handheld reflectors to large reflectors that require stands. You will find white, silver, and gold reflectors, and every combination of these. White is the least reflective of all three, and you can use it in stronger light, or if you only want a small amount of reflection. Silver is the strongest reflector and you can use it as a fill light, or use a small silver reflector under the chin to pop a bit of catch light into the eyes. Gold reflectors give you just that: a warm gold light. I find the darker a subject's skin tone, the prettier the light from the gold reflectors.

Different sizes and colors will give you unique results. If you have an assistant, handheld reflectors are great because you can direct light exactly where you want it. If you don't have an assistant, standing reflectors work well, too.

I like a 5-in-1 reflector system. I like to have a white, sliver, silver/gold mix, and black reflector in addition to the scrim (transparent panel) at my disposal. The scrim is great when you want to block or soften light. Depending on the type of 5-in-1 reflector there may be a black side as well. The black side is wonderful when you want to subtract light from your subject.

Choosing Locations

Choosing a location for environmental portraits is more than just looking for a pretty place. There are many elements that help create the perfect location. There have been times I brought a family to a location that they were a little concerned about because the scene did not look pretty or attractive. I sometimes use an odd wall or an area with dead bushes and trees. Clients see things differently than I do. Most clients look at the background exactly as it is. I look at the light that exists in the area, the direction of the light, and how I will place subjects in the scene. Important things to consider when looking at locations/backgrounds include:

※ Where is the main source of light coming from?
(You are looking for directional light.)

※ Is the scene backlit?

※ Is there open shade?

※ Will you use the background by shooting straight on or from an angle?

※ Do you want to place your subjects close to or far from the background?

※ Does the background offer texture, depth, and color?

※ How will you pose a family in the location?

Skating Rink

The location shown in Figure 4.6 is the lower portion of a fence around a skating rink. The direction of light is on the other side of the rink. Adding a reflector gives this location great directional light. To create the portrait shown in Figure 4.7, I had Anna sit on the ground against the bottom part of the rink. Instead of shooting this image straight on, I was at almost a 90-degree angle to the wall. Turning Anna's face to the wall and cropping out some of the hat helps give this image impact.

The area next to the rink offered an instant change of background, as shown in Figure 4.8. The grass area was in open shade with directional light coming from the right side. There was also a golden light coming through the trees.

I created the portraits shown in Figures 4.9, 4.10, and 4.11 in this area with a wide-open aperture to blow the background out of focus. You can see the direction of light on Ashley's face (Figure 4.9). When I added Anna, I placed Anna in front of Ashley and had Ashley lean over Anna's shoulder as Anna tilted her head back to Ashley (Figure 4.10). The background is still out of focus, and has color, texture, and depth. In Figure 4.11 the girls are in the exact same place as in Figure 4.10. I simply changed

Figure 4.6
At first glance this skate park does not look like the ideal place for a portrait? Or is it?

Figure 4.7
Using only the blue part of the bottom of the fence I was able to create an interesting portrait of Anna.

Figure 4.8
The same area of the park but shooting in a different direction.

Figure 4.9
A wide aperture and high camera angle and direction of light helps make this location perfect.

the camera angle. I am now below eye level, closer to the ground. Changing camera angles completely changed the background to a high-key blown-out sky. In this pose, when the camera is so far below the subjects, I have them leaning toward me. They are leaning far enough over so that their faces are on the same focal plane as the camera. Having subjects lean into the camera also eliminates shooting up their noses when I am so far below them.

Rocks, Trees, and Fountain Grass

For most clients, the location shown in Figure 4.12 does not look like an ideal location for family portraits. The elements that drew me to this spot were the open space and shade in the foreground; the light, texture, and depth in the background; and the directional light coming from the right. Figure 4.13 shows how posing Mom and Dad in open shade with directional light created a hair light on Mom and an accent light on Dad's face. Using the same location as in Figure 4.13, I posed Dad and his daughter together in Figure 4.14. The highlight on her hair is coming from the directional light on the right side of the camera.

Figure 4.10

The light coming through the trees gives this portrait beautiful texture and back light.

Figure 4.11

The same portrait with a change in camera angle. Shooting from a low camera angle changes the background from the trees to the sky.

Figure 4.12

Initially this location did not seem ideal for a family portrait session. However, it provided many of the attributes I look for in a location: open space, texture, depth, and directional light.

Figure 4.13

The directional light coming from the right created a beautiful hair and accent light on the subjects while the background has light and texture. (The accent light is that little highlight you see on the side of Dad's face and on Mom's hair.)

Figure 4.14

The most important reason I like this location is the direction of light — it's in open shade and the background has great texture.

Crossing the Bridge

The bridge shown in Figure 4.15 crosses over part of a lake near a waterfall. The first thing I notice is the leading lines in the bridge. However, standing up and looking at the bridge straight on is boring and the background is not pleasing to the eye. When I changed my viewing angle, I was able to find more a more pleasing background (Figure 4.16). Raising the camera angle above the railing gives me a different perspective and background as well (Figure 4.17).

Figure 4.15
Looking at this bridge straight on is not pleasing to the eye. When I bent down and looked down the railing, the bridge became more interesting to me.

Figure 4.16
This little boy is leaning on the other side of the bridge railing. He has beautiful direction light on the left side of his face (camera right).totally different image in the same location.

Figure 4.17
Using the leading line of the top of the railing and a higher camera angle I created a totally different image in the same location.

See What Your Camera Sees

As you look for backgrounds look for small, narrow spaces. Look for what the camera might see. Your vision gives you an expansive view of the world, but the camera gives us only what we choose to see and photograph.

It is easy to see your surroundings like a camera: create a frame with your hands. Place your hands in front of you with your fingers pointing up. Place one thumb over the other, close one eye, and look through the frame. You can now scope out locations with what the camera sees instead of what your eyes see.

Figure 4.18
To an inexperienced photographer this spot looks like just a walkway, not a good place for a portrait.

The Walkway

Looking at the location shown in Figure 4.18 does not inspire the thought, "What a perfect place for portraits!" Except that it does to me. Looking past the ugly poles I see a beautiful leading line, directional light, and open shade. You can see the strong directional light in the foreground of this location but the area behind it is in open shade — perfect for a portrait.

Using the ledge as a posing prop and a leading line, I had Courtney sit on the edge of the ledge and separate her feet slightly (Figure 4.19). Placing her to the far right of the image allows me to use the line of the ledge and using a fairly wide-open aperture allows me to blur out the background. Without moving Courtney I then created the close-up portrait shown in Figure 4.20. I raised the camera height and came in for a close-up. I placed her in the upper right third of the frame and then tilted my camera to exaggerate Courtney's lean.

Figure 4.19
Using the ledge as a leading line and a wide aperture makes this location perfect for this full-length portrait.

Figure 4.20
A higher camera angle and zooming in with my 70-200mm lens allowed me to create this close-up in the same location.

Figure 4.21
The harsh light in the background of this location helps to give the image depth.

Figure 4.22
The subjects are in the shade and the foliage in the background is lit by the setting sun.

A Wide Walkway

The location shown in Figure 4.21 is one of the locations I sometimes take families to and when I do, they usually look at me funny. It is the same area as the previous example only a bit farther down the walkway. Some of the first things I notice about this location are the beautiful directional light and the area of open shade in the foreground that has light, texture, and depth. The light is coming from camera left. You can see the harsh light in the background and the directional open shade in the middle and foreground.

To create the portrait shown in Figure 4.22 I used a small armless chair as a posing stool. My camera height is slightly above eye level in order to crop out the sky and use only the trees and foliage as the background. Because

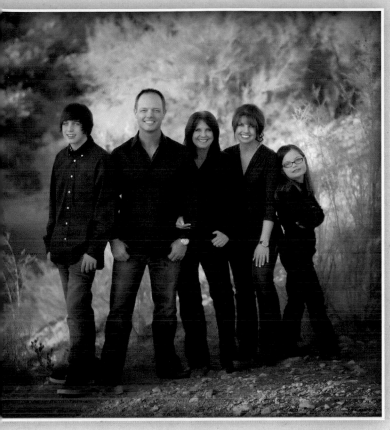

Figure 4.23
All of the colors of the background and clothing add to the warm feeling of this family portrait.

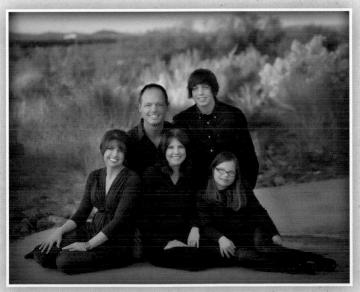

the family is in shade and the background is in direct sunlight, the foliage is lit up, which gives this image the light and texture needed for the background.

In Figure 4.23 the family is seated on the ground right at the edge of where the light and shade meet. It's the same location shown in Figure 4.22 photographed from a slightly different angle. There is a building to the left of the camera that is creating the area of open shade for the family. As the sun continued to go down I was able to move the family deeper into the foliage to create the full-length image shown in Figure 4.24. In this image the family has soft directional light on their faces coming from camera left and they are standing on a slope. To keep a good balance between the different heights of the subjects, I posed the tallest sibling on the low side of the slope and the youngest child on the high end of the slope.

Figure 4.24
As the sun continued to set I was able to move the family deeper into the foliage to take advantage of the colors of the foliage and the light late in the day.

Figure 4.25
Looking at this wall straight on isn't very interesting, but looking at it from an angle or down the line of the wall makes it a much more interesting background.

Figure 4.26
By shooting at an angle I am able to take advantage of the repeating pattern of the pillars and the texture and depth of the wall.

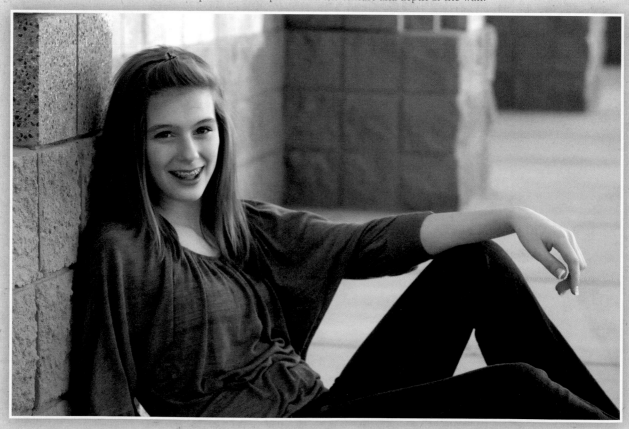

The Wall

This wall is awesome (Figure 4.25)! It's one of my favorite locations. The wall forms the back side of hockey rink bleachers. It's an unexpected location because as you can see in Figure 4.25 it doesn't look like much at first, but the late afternoon directional light that is falling on the wall is perfect portrait lighting. The wall also has great repeating lines that I think are visually interesting.

I photographed Jensen as shown in Figure 4.26 using the wall at an angle to make use of the repeating pattern from the pillars, the texture, and the depth. She seated on the floor and leaning up against one of the pillars. I'm at an angle so that I can incorporate the wall as the background. Her face is in the left upper third of the image and the directional light on her face is coming from camera right. I had her bend her knee to create a triangle shape and leading line. Building on Jensen's pose I added her sister and her mom (Figure 4.27). Using the vertical line of the wall I stacked their heads close to each other and had them lean into Jensen.

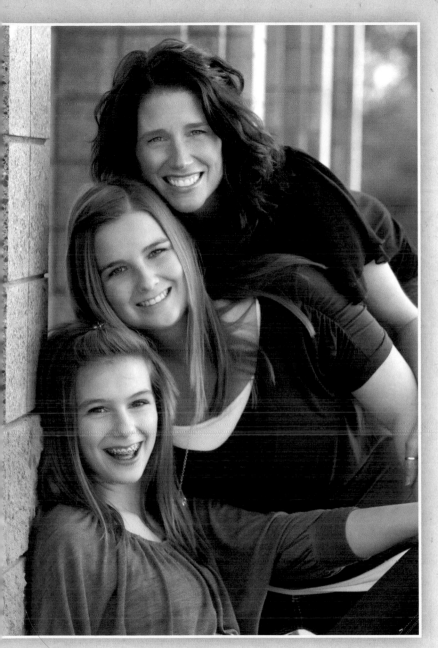

Figure 4.27
Building on Jensen's pose I added her sister and Mom to the portrait stacking their heads in a diagonal line.

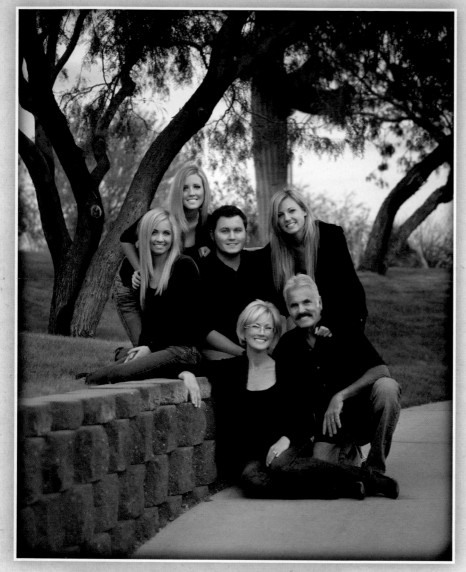

The Retaining Wall

Retaining walls are great for portraits because they are generally shorter walls and perfect for posing people. The retaining wall shown in Figure 4.28 is fantastic. It gives me an amazing posing prop, it provides a great leading line, and has texture and depth. Shooting the wall at an angle, placing the family at the end of the wall, and using the front part as the foreground for the image makes it more interesting than shooting the wall straight on (Figure 4.29).

Figure 4.29
Posing the subjects at the end of the retaining wall gives this portrait texture and depth.

Figure 4.28
This retaining wall offers depth, texture, a leading line and a posing prop – It's a perfect location for portraits.

The Not-So-Perfect Park

When I arrived at this park I realized quickly that it was not an ideal location for a portrait session. There were almost no areas of open shade. Almost the entire park was in direct sunlight. The only area that provided the open shade I was looking for was next to an office building and a large solar panel (Figure 4.30). However, I liked the color in the landscaping flowers and the depth that the light through the trees provided so I gave this location a try.

My subject was a busy three-year-old who did not want to sit for a portrait, but I knew that if I placed her where I wanted her to be I could create the images I had in mind. I placed the subject in the middle of the flowers in order to create a foreground. I then asked her to pick some flowers for me. Having her two sisters kneel down next to her and lean in I was able to take full advantage of this area (Figure 4.31). The solar panel is to the left of the image.

Figure 4.30
This was the only area of the park that had open shade provided by an office building. The rest of the park was in direct sunlight.

Figure 4.31
Making use of the light in the background and using the flowers as foreground I created a portrait with depth and texture. Asking my subject to pick some flowers adds a feeling that this was a candid moment.

The Church Archways

When I saw the archways of this church I immediately thought that it would be an awesome location for portraits (Figure 4.32). The building wall itself was not ideal but when I went by to scout it out, the church had everything I look for in a location. The archways provide a repeating pattern, there is stunning open shade, the length of the side of the building provides depth, and there is texture on the bottom of the archways.

To create the portrait shown in Figure 4.33 I placed the subjects in a shaded area of the scene. Because the direction of light is slightly behind and to the side of the family, I used a sliver reflector to reflect light back into their faces. The reflector is placed camera left.

Figure 4.32

The archways on the side of this church provide a stunning background by creating an area of open shade with depth and repeating patterns.

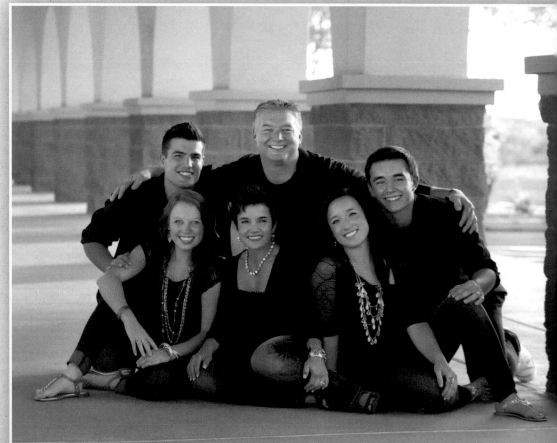

Figure 4.33
Using a silver reflector I was able to add the needed light for the faces of this family. The archways provided the perfect background.

Figure 4.34

At first this location may seem to be too busy for portraits. However, the foreground provides open shade while the light falling on the background creates depth and texture.

Fountain Grass

The location shown in Figure 4.34 is interesting because if you look at the entire scene it looks too busy for portraits. There is a sign in front of the fountain grass. The building to the left might be distracting, and the fountain grass may seem to be in the way. However, by changing my camera angle slightly I was able to crop out the building, and I used my subjects to hide the sign to create the portrait shown in Figure 4.35. The subjects are in open shade with light falling on the areas behind them providing texture and depth in the background.

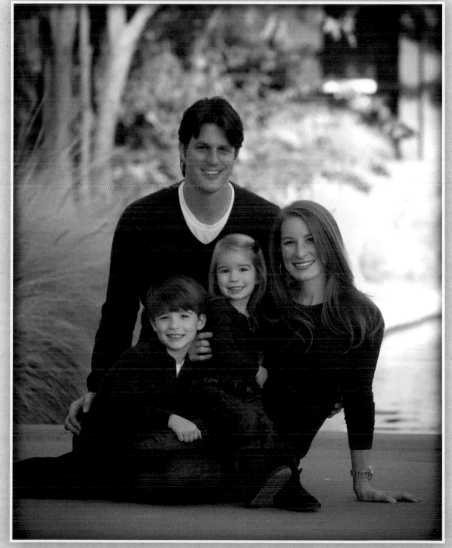

Figure 4.35

Using the family to hide the sign in front of the fountain grass and angling my camera away from the building, I created this portrait.

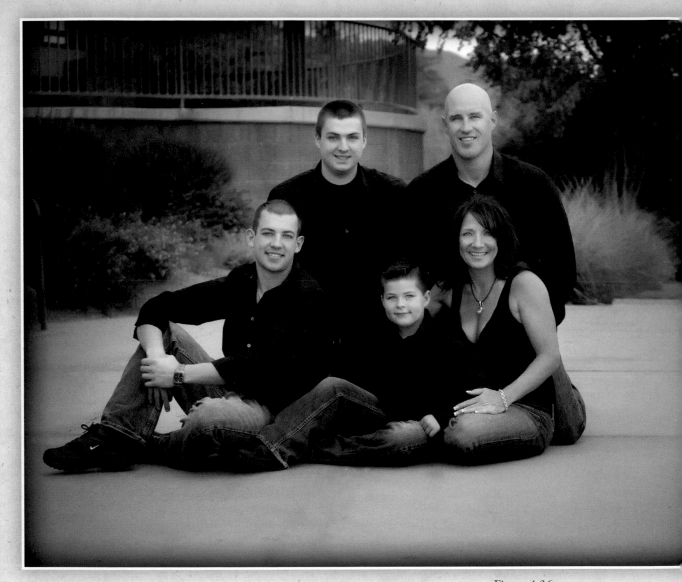

Figure 4.36

Here I incorporated more of the background including the wall of the building.

In Figure 4.36 I moved the subjects farther away from the background so that I could use more of the background.

Changing the height of the camera, cropping out the sign and the building, throwing the background out of focus, and using the fountain grass as the foreground now creates another background using essentially the same area (Figure 4.37). The fountain grass now becomes part of the foreground, adding texture to the front of the image while the bridge and tree become the background.

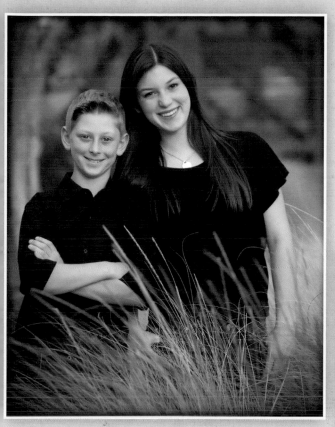

Figure 4.37
These portraits were shot in the same area but here I used the fountain grass as part of the foreground instead of the background.

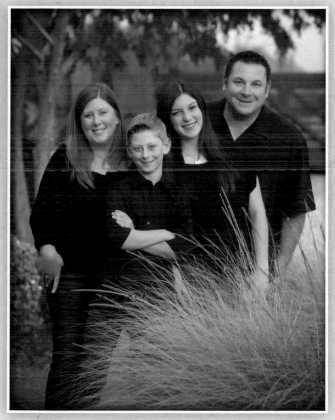

Figure 4.38
This secret spot is near a waterfall and is hard to see from other areas of the park.

A Secret Sweet Spot

This area, shown in Figure 4.38, is completely hidden in the park. It is near a waterfall and is tucked between fountain grass and palm trees. The great thing about this spot is that it is in open shade and the rocks make a posing prop. Using the rocks to pose the family shown in Figure 4.39, I sat Mom first and then had Dad kneel with one knee behind Mom. I had their son sit on the rock on both knees behind them, and lean onto Mom's shoulder. I then placed their daughter in front, leaning on Mom. Figure 4.40 shows a different family in the same location posed with Dad in the center and everyone around him.

Figure 4.39
The large rock in this hidden location makes a great posing prop.

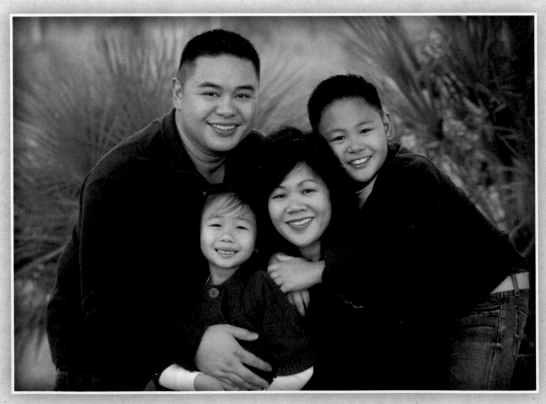

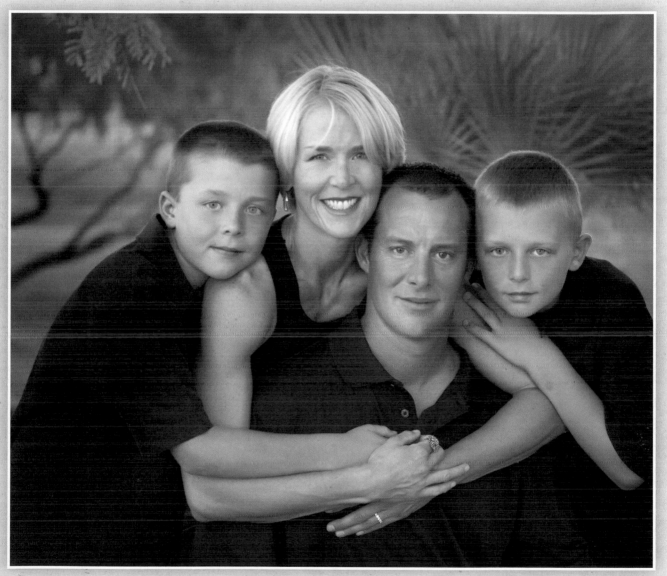

Figure 4.40
The same secret spot with a different family and pose. In this portrait Dad is the center of attention.

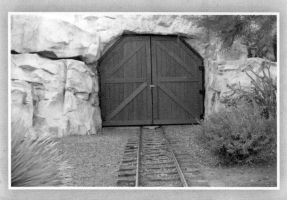

Figure 4.41
This doorway was bathed in beautiful open shade with the sun started to set.

Figure 4.42
To take advantage of the texture in the rock wall, I placed my subject at an angle to the door instead of straight on.

Figure 4.43
A shy little girl. I love her expression.

Doorways

Doors can make a great background. If the door looks interesting and has texture and great light, go ahead and try it out. In Figure 4.41 the sun is setting on the other side of this tunnel putting these doors in beautiful open shade. The brown shirts on the kids up against the warm color of the wood door made this a great location for the portraits shown in Figures 4.42 and 4.43.

Summary

Scouting locations is fun and part of the creativity of photography. Walk around your neighborhood at different times of the day to find interesting lighting patterns and open shade. Look for scenes and backgrounds that are not obliviously a beautiful background. Instead of looking at a potential background straight on, check it out from an angle. Look for interesting doorways that could offer texture and color to your backgrounds. Don't just think in terms of backgrounds for your locations but see if there is something that can be used as foreground. When you are indoors, try using window light and turning off your flash. Natural light is always the most flattering (in my opinion).

I know I have said it a million times but I just can't say it enough: As long as you can find the direction of light you want to use as your main light you can create beautiful portraits anywhere. So, when scouting out available light locations for portraits first think about the direction of light; look for open areas of shade; seek out backgrounds with light, texture, depth, and color; and then think about how you will place people in that scene. Photograph locations from different angles to get a different perspective, and have fun creating amazing images for your clients using locations that at first don't look good, but with your expertise turn out to be the perfect spot.

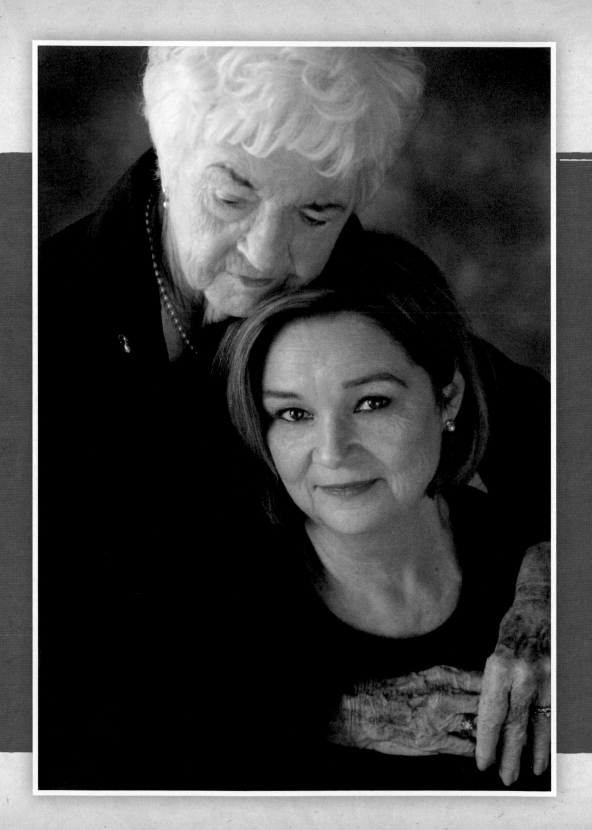

5 | Understanding Your Client

A big part of being a professional photographer has nothing to do with cameras, lighting, computers, or anything technical at all. It is about understanding and relating to people. Understanding what drives mothers when they're purchasing portraits, understanding children, understanding the nuances of how to work with large and blended families, and even understanding how to incorporate the family pet. This is all about the 80%. I can tell a lot about a family by spending just one hour photographing them. Every family is different and you will need to tailor your approach.

Some families are goofy and playful and others are formal and restrained. In some families Mom is in charge, in others Dad is in charge, and I have even seen families where the children are in charge. You will find mothers who want the "perfect" family portrait because that is how they want to see their families. Other moms just want a portrait that reflects the way their families actually are. Usually the dads are just along for the ride (and usually not thrilled about the whole thing).

Photography is about relationships and understanding people, and relationships are critically important to your success. Having empathy for the elderly, having patience with children and animals, being sensitive to different family dynamics, and learning how to make people feel comfortable and relaxed is vitally important for a family portrait photographer. These skills are not natural for everyone; therefore, it is important you work on your people skills as much as you work on your photography skills. This chapter takes a look at some of the important people skills you will need to be a successful family portrait photographer. It offers tips on how to engage a two-year-old, how to get a natural smile out of a preteen, how to manage a portrait session with blended families, how to work with elderly subjects, and even how to add the family dog to the mix.

Working with Children

If you are going to work with children, you need to learn to act and think like them. You will need to have a favorite princess, know how to sing popular kids songs, be ready to get down on the floor, have more patience than you dreamed you could have, be comfortable making animal sounds, and even be willing to toot. (Five-year-olds think that anything to do with poop or tooting is the funniest thing in the world, so you better know how to talk about it.) You also need to know when to take a break to give kids a few minutes to reset because they have been sitting in front of the camera too long for their attention span.

When I'm working with children between the ages of eighteen months and six years old, I start by squatting down to their eye level to talk to them. Coming down to a child's eye level is a great way to become less intimidating. Then I start asking silly questions such as, "Are you married yet?" You should see the face of a 5-year-old boy when you ask him if he is married. I ask about crazy foods: "Do you like to eat pig toes, lizard legs, butterfly ears, or alligator tails?" The sillier the question, the better. Ask a little girl who her favorite princess is. When I tell a little girl that I also have a favorite princess, her face always lights up. We are now having a conversation she is engaged in and is excited about. (By the way, my favorite princess is Mulan. I know she is not a popular princess, but let's face it, she single handedly saved China after joining the army disguised as a man. Now that is a real princess.)

Kids have favorite movies and they will watch the same one hundreds of times. If you can quote lines and imitate character voices, you will get kids to laugh naturally. I highly recommend investing in all of the great children's movies. It will give you so much to talk to kids about and it makes you look super cool, too! During the initial consultation with Mom, ask about her children's favorite shows and movies and brush up on them before the session.

Another great technique for getting children to relax and feel comfortable in front of the camera is to have them make silly faces. Having children make all kinds of goofy

Children's Movies You Should Know

Here's a list of some of the popular kids' movies you should be familiar with:

- A Bug's Life
- Antz
- Babe
- Bambi
- Beauty and the Beast
- Cars
- Chicken Run
- Cinderella
- E.T.
- Enchanted
- Finding Nemo
- How to Train Your Dragon
- Hugo
- Ice Age
- Kung Fu Panda
- Monsters, Inc.
- Pinocchio
- Ratatouille
- Shrek
- Spy Kids
- Tangled
- Tarzan
- The Harry Potter series
- The Incredibles
- The Iron Giant
- The Lion King
- The Little Mermaid
- The Muppet Movie
- The Princess Bride
- The Wizard of Oz
- Toy Story
- Up
- Willy Wonka and the Chocolate Factory
- Winnie the Pooh

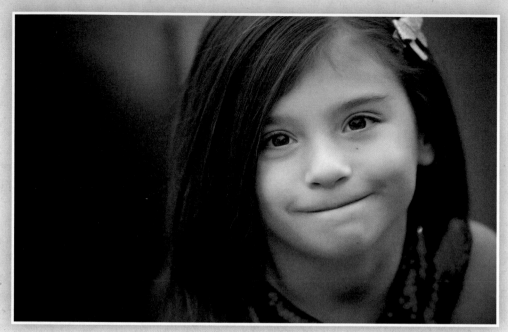

Figure 5.1
"Let me see your serious face."

Figure 5.2
"Let me see your mad face."

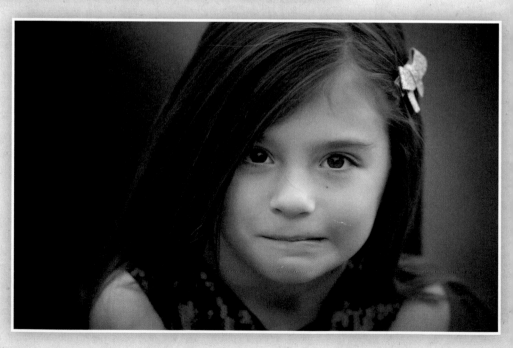

faces relaxes their facial muscles and somewhere in-between the funny faces, natural laughs and expressions emerge. I'll ask children, "Let me see your mad face, your sad face, your surprised face, your tired face, your mommy-please-can-I-have-ice-cream face." It works because kids like to make funny faces. I have to say, it usually freaks

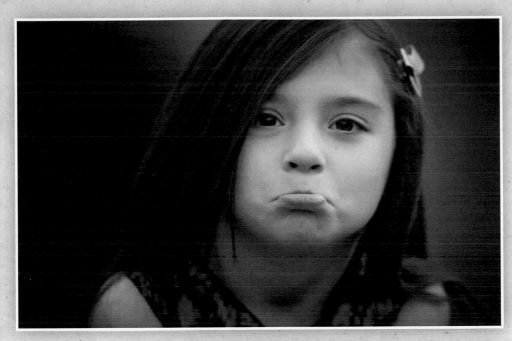

Figure 5.3
"Let me see your sad face."

Figure 5.4
After all the silly faces, a natural smile appeared.

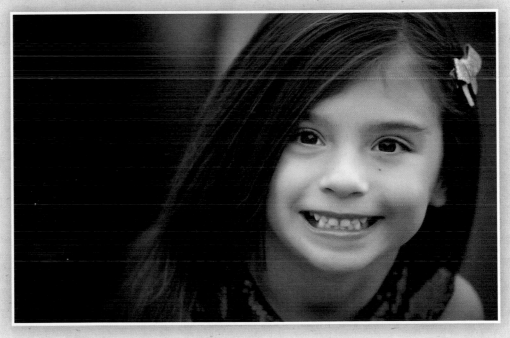

Mom out and she quickly lets me know that's not the expression she's looking for. I tell her not to worry: this exercise leads to the expressions she'll love. Figures 5.1–5.4 illustrate the series of images I got when I asked Noel to make silly faces. In the end, she naturally smiled.

Keep in mind that boys will react differently than girls. Boys tend to make a lot more silly faces or hold their lips in a weird way. Girls tend to be more compliant and have fewer silly faces. Also, asking young children to smile or say "cheese" or "pizza" is not the best way to elicit natural expressions. Those catchy phrases usually get you "cheesy," squinty smiles that moms usually don't like because they are not representative of her "baby."

Another important step toward successfully photographing children occurs during the pre-portrait consultation when I explain to the parents that they should not prep the children for the session. By prep I mean this:

"Practice your pretty smile!"

"If you behave, I'll buy you a special toy!"

"Do everything the photographer tells you to do!"

The prepping list goes on and on. All that prepping puts pressure on the children, and then they either melt down or give a totally fake smile. I can always identify the "over-prepped" children. I can see them a mile away by the way they look to their mom for approval after every direction I give them. Occasionally, I will ask the parents to step away so that the child no longer worries about their approval and then relaxes with me.

Children Ages 18 Months to 4 Years

Working with children between the ages of 18 months to about 4 years is probably the most challenging. This age range is all about me, me, me, and now, now, now! If you understand this, you will be a lot less frustrated when shooting (I mean photographing) this age range. At this age, there really is no reasoning or bargaining to be done. These kids have a clear agenda in their minds and you work with what you are given.

Parents often try to bribe children with candy and all sorts of other things but it usually doesn't work at this age simply because developmentally, cause and effect is not understood yet. With older children you can use cause and effect: "If you do this now, we can do this later." Not with younger children. If you offer candy as a reward later, the only thing a two-year-old will think about is, "I want that candy and I want it now." In most cases, this can put an end to the session.

Engaging children of this age is the best way to get them to respond to you. If I am working on location at a park, I will often ask children to look for silly things that they will never find. For example, I will ask, "Can you find a purple rock with green and pink dots on it?" The child will start looking and eventually look at me and say he can't find it or pick up a gray rock and say, "Here it is." Either way this tactic usually offers a great expression or an adorable image of the child looking down.

Figure 5.5 is a sweet portrait of two bothers I could not get to sit still together. They are

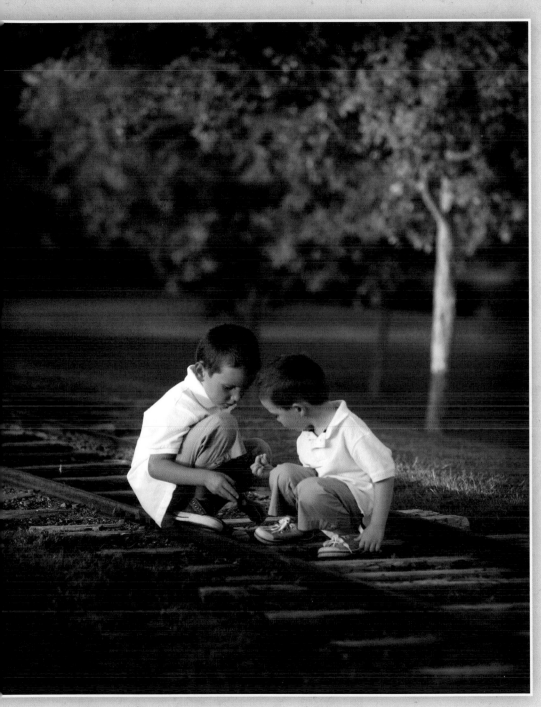

Figure 5.5
To get these brothers to be still for a moment, I asked them to look for purple and green rocks along the train tracks. One element that makes this a sweet portrait is that the boys are interacting with each other.

about three and five years old. In order to get them to squat down and stay in one place for more than two seconds, I asked them to look for purple and green rocks along the train tracks. You can see the little boy in front is holding a rock.

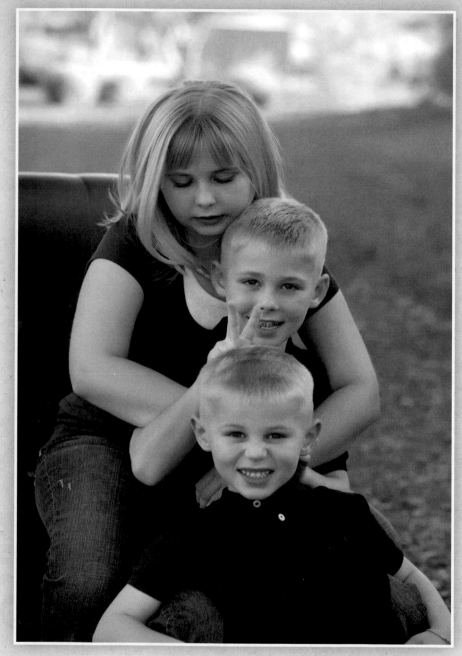

Figure 5.6

Kids in the 5 to 10 age range often try to see if you will notice what they are doing. Pay attention to hands and expressions.

Children Ages 5 to 10 Years

Children from about 5 to 10 ten years old are pretty awesome. They are usually willing to have their picture taken and they tend to follow direction well. At this age you can talk about school, sports, friends, and any other interests. You may find that 6- and 7-year-olds are still a bit immature and even though they follow directions, they may sabotage pictures by making rabbit ears, peace-sign fingers, or silly faces (Figure 5.6).

Children Ages 11 to 14 Years

Kids 11 to 14 years old can be a bit challenging. These are the awkward years. Kids may have braces and acne, and they are self-conscious. They don't want to be seen with their parents in public because they could run into a friend from school who will give them a hard time the next day. Sometimes putting this age group at ease is tough. I give them permission to not smile.

Knowing that they don't have to smile is often enough to get this age group to relax a little. I also love images of this age that are a bit more on the moody side. And sometimes asking a preteen to be "serious" makes him laugh naturally. For example, in Figure 5.7

Figure 5.7
I first asked Jared to be serious and to not smile. I knew he'd start to crack, and then, I got the smile I was after.

I asked Jared to be "serious," knowing that within a minute he would probably start laughing, and I was right. Again, moms will have certain expectations of their children, and giving preteens and teens permission to be themselves is a great way to connect with them.

Understanding the developmental stages of children will help you communicate with them at their level and help keep you from being frustrated when working with a family with young children. It also helps to let Mom know that her child is completely normal and you don't expect a two-year-old to sit in one place for more than two minutes. Younger children need more breaks during a portrait session than older children do; therefore, the sessions can take longer.

Child Developmental Stages

While I am no expert in the psychological developmental stages of children, the following are my own observations and experiences on what to expect from different ages.

❉ Ages 3 to 6 Months

Begin to play peek-a-boo

Respond to their names

Respond to a parent's voice differently than others

Attempt to imitate sounds

Laugh out loud

Smile spontaneously

❉ Ages 6 to 9 Months

Can express stranger anxiety (may be clingy to Mom or Dad)

Respond to language and gestures

Can distinguish between friends and strangers

❉ Ages 9 to 12 Months

May begin walking

May be getting ready to talk

Respond to a firm "no"

Experience stranger anxiety

Can hold small objects in their hands

Understand that an object still exists even when it is not in view

Respond to silly noises

❉ Ages 1 to 2 Years

Have an attention span of approximately 2 to 3 minutes

Like to run, run, run

Show pride in new accomplishments

Play independently

Express negative feelings

Show affection for parents

Begin to match similar objects

❉ Ages 2 to 3 Years

Have an attention span of approximately 3 to 4 minutes

Are more assertive (they love to say no)

Experience rapid mood changes

Can display aggressive behaviors

Do not understand cause and effect

Require instant gratification

Have trouble self-regulating

Defend possessions (mine, mine, mine)

Participate in simple group activities

Have a short memory

Believe everything you say

Are very curious

Are completely self-centered

Meet frustration with crying, kicking, biting (you know, the temper tantrum)

❊ Ages 3 to 4 Years

Have an attention span of approximately 4 to 7 minutes

Have no understanding of cause and effect

Cannot consider motivation behind action

Want to please others

Can follow a series of directions

Love to play pretend

Are interested in others

Ask why and how

❊ Ages 4 to 5 Years

Have an attention span of approximately 5 to 10 minutes

Are beginning to understand moral reasoning

Are beginning to understand cause and effect (if you do this now, you can have a lollipop later)

Compare themselves with others

Express awareness of other people's feelings

Still like to pretend

Like to be helpful

Enjoy obedience and thrive on praise

❊ Ages 5 to 8 Years

Have an attention span of approximately 15 to 20 minutes

Are very direct

Thrive on praise and acceptance

Are beginning to have self-confidence

Want to be first, the best, and the winner

❊ Ages 8 to 12 Years

Have an attention span of a pproximately 30 to 45 minutes

Like a challenge

Understand rules

Want to join in with the adults in their lives

Are sensitive to failure

❊ Ages 12 to 14 Years

Have an attention span of 45 to 60 minutes

Self-conscious

Friends are more important than parents

Moody

Like to test rules and authority

Style influenced by peers (not always happy with their parents' choices in portrait clothing)

Calming Nervous Moms

Most mothers are seriously stressed about having portraits taken even if they don't say it. There is a lot emotionally wrapped up in this for her. Some of it has to do with how she wants to see her family and how she sees herself. During the pre-portrait consultation I spend quite a bit of time letting Mom know that she does not need to be worried. Mothers will worry about every little detail about the session: the clothing, her kids' messy hair, stubborn teens, impatient dads, her makeup, if she looks fat, if you can see the one blemish on her chin, if her children will behave. Everything has to be perfect. The source of stress for mothers is endless.

Figure 5.8
Father-daughter relationships are special. This is a portrait of my daughter and her father.

It's important to remind Mom that taking family portraits is fun and that she should relax and enjoy the process. If she can relax and have fun, she will be more likely to like the way she looks in the portraits. (As a side note, because most people don't like the way they look in pictures, it's important to show before and after retouching samples. This allows Mom to know that if there are flaws she doesn't like, you can correct some of them later.)

First-time moms usually have high expectations for their young children. Some new moms become frustrated with children in the 18 to 36 month age range. Explaining the developmental stages of this age group to the mom helps her realize that you know how to work with her child.

Figure 5.9
Wrapping Dad's arms around his daughter and bringing her hands up to hold onto him is a wonderful way to show the connection between them.

Finally, when you meet up with your family the day of the session, take note of the mood. Does Mom look especially nervous or does she look relaxed? For the most part, the mood of the family depends on Mom's mood.

Warming Up Reluctant Dads

Dads can be really tough when it comes to family portraits. Again, everyone is different, but I find most dads to be fairly uncomfortable when it comes to having their pictures taken. Usually if I meet Dad at the consultation, the session flows a little more smoothly. In most cases, Mom will usually come in to meet me for a consultation without Dad. If the first time I meet Dad is at the session, I need to break the ice and put him at ease. It helps to instantly identify that this portrait session was probably not on his Top 10 list of things to do this week. Acknowledging that he may not be comfortable is a great way to break the ice.

Once the session gets rolling I usually let him know that it won't be too painful and I promise not to bite. The best compliment I get at the end of a session is usually from Dad, when he says, "I wasn't really looking forward to this but it actually turned out to be a lot of fun. Thanks!" So, make it fun. Engage Dad; find something to joke with him about. Have the kids hug him or have them do a family pile up with Dad on the bottom. Another way to get Dad to relax is to photograph him with his "little" girl (Figures 5.8 and 5.9). Dads usually light up when they are photographed with their daughters. Girls somehow bring out the softer side of dads.

Figure 5.10
My daughter, Anna, has two families, but really it's more like she has one big crazy family.

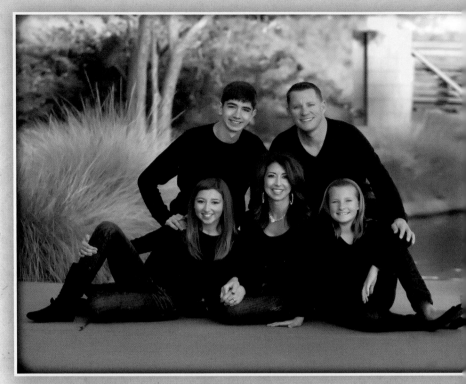

Working with Blended Families

I am the queen of photographing blended families! Figure 5.10 is a portrait of my daughter Anna (lower right) and her "other" family. Louise is her stepmom, Olivia is her stepsister, Nick is her stepbrother, and Gary is her dad. I have been photographing them for five years, and every year Louise gets plenty of phone calls from her family telling her how much they like her family portrait on her Christmas card.

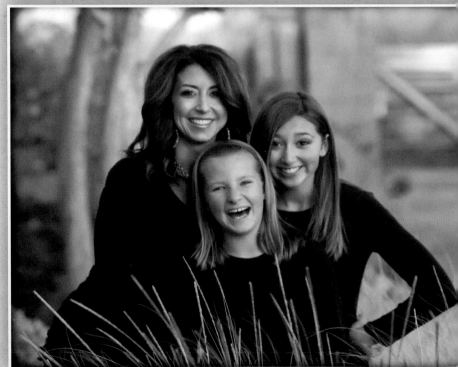

Figure 5.11
A fun image of the girls.

Here is the thing about blended families: they can be even more stressful than traditional family portraits. Your people skills and ability to understand the dynamics of the group is important and will help both you and your client. Figures 5.11, 5.12, and 5.13 illustrate how I try to lighten the mood and have fun during my portrait sessions.

Figure 5.12
You can see how much fun we have during these sessions.

Figure 5.13
I couldn't resist having a picture with Anna while we were there, so I set up the shot, jumped in the frame, and had Olivia take the picture.

Figure 5.14
The entire family.

The blended family shown in Figure 5.14 includes six-year-old Joshua, nine-year-old Austin, their dad, Greg, and their stepmom, Leslie. Joshua and Austin are both great kids and the session was a blast. Joshua, shown in Figure 5.15, is a very active six-year-old and interested in everything. Sometimes kids are curious about my camera and I use this curiosity as a bargaining chip. I could tell that Joshua had a lot of energy and wanted to check out my camera, so I made a deal with him. The deal was if he did everything I needed him to do for the next 30 to 40 minutes, I would let him take the last picture.

Next, I photographed his brother Austin (Figure 5.16). I asked Austin about school and his favorite subject. I then added Joshua to the portrait, while continuing to ask him about his favorite foods (Figure 5.17).

Figure 5.15
Six-year-old Joshua stood still for me while I tried to guess his favorite food.

Figure 5.16
I kept Austin engaged by asking him about his favorite subjects in school.

Figure 5.17
The more quickly you can work with children, the better since they have short attention spans and can get bored easily.

I then wanted to photograph Greg and Leslie together. With blended families, it can be difficult for children to see their biological parents with someone else. When I started photographing Greg and Leslie together, the boys started jumping up and down in front of the camera (Figure 5.18). As long as you understand why this behavior may be happening, you can work around it without having the parent get upset with the kids. A six-year-old does not know how to verbally express that he feels uncomfortable seeing his dad with someone other than his mother. At his maturity level jumping up and down in front of the camera is his way of expressing that. This is normal behavior for a six-year-old boy. I reminded him of our "deal" and asked him to help me and hold my ExpoDisc. I gave him a job that distracted him from the portrait.

Children in blended families often need extra attention from their parent because they can feel the stepparent may be getting more attention or "love" than they are, so I always make sure the children have a portrait with their parent (Figure 5.19). In years to come, this portrait will mean a lot to them.

Figure 5.18
It can be difficult for children to see a parent photographed with a partner other than their mom or dad.

Figure 5.19
I often spend the most time on the parent-child portrait so the children feel that they had special time with their parent.

Once the kids feel comfortable and that they have had their time with the parent, I like to photograph the whole family. At this point everyone has generally warmed up and is feeling more relaxed. When it came to the end of this family's session, Joshua had held up his end of the bargain, and I let him take the final shot with my camera. As you can see in Figure 5.20, this kid might have a career.

Figure 5.20
Dad doesn't really need the top of his head, does he?

Working with Large Family Groups

Extended family groups can be challenging. You now have a variety of family dynamics going on — from siblings to parents and children, from grandparents and grandchildren to aunts and uncles and cousins, and maybe even a dog or two (Figure 5.21). In most cases, an extended family portrait happens because the family is in town for the holidays and some members think it would be great to get everyone together for a family photo. Usually one person is left organizing the whole thing and not everyone is thrilled about having a family portrait done.

Extended family groups take extra time and organizing. I will photograph the entire extended family as well as the individual groups: the children alone, the grandparents and grandchildren (Figure 5.22), all of the cousins, the siblings, and so on. The different groupings can be endless. The best way to organize the portrait session is to start with the entire group first, then each of the families, starting with the family that has the youngest children. (You know, the children with the shortest attention span.) Make sure you go over the plan with the person who hired you and ask for any special requests up front so you are prepared the day of the session.

Family Groupings

Following are the typical family groupings clients like to have photographed:

- Each individual family

- The matriarch and patriarch of the family with their children

- All of the siblings together

- All of the cousins and grandchildren together

- The grandparents with all of their grandchildren

- Grandmother, her daughter, and her granddaughters together

- Grandfather, his son, and his grandsons together

- The entire extended family

In general, the older the overall age group, the faster these groups will be. Small children in large groups will take more time.

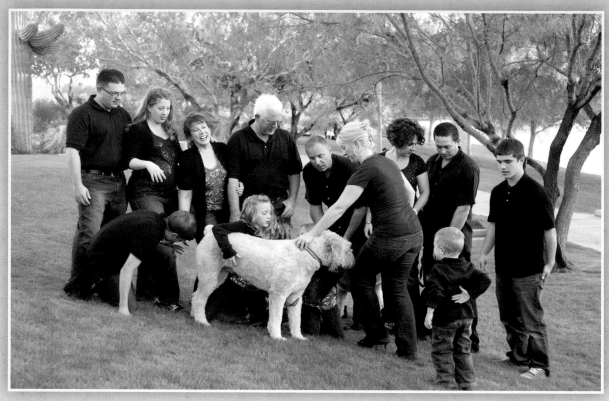

Figure 5.21
When working with an extended family group that has young children and dogs, you can expect a little chaos.

Following are some tips for staying organized during large family portraits sessions:

✣ Know the names of each family member.

✣ Know who is married to whom and who their children are.

✣ Keep a checklist of what groupings you have done so you don't forget anyone.

Figure 5.23 is the final result of this extended family group. It was late in the session and while I usually like to do the entire group first, the light was perfect and the location was amazing, so I set up another full group here and this one turned out to be the family favorite.

Figure 5.22
I love this image because I have all the grandchildren ready to be photographed with grandpa and this little guy wants nothing to do with it. The family loves this image, too, because it's funny and that's how the youngest grandson was that day.

Figure 5.23
Three generations are represented here: grandparents, their three daughters with their spouses, and six grandchildren.

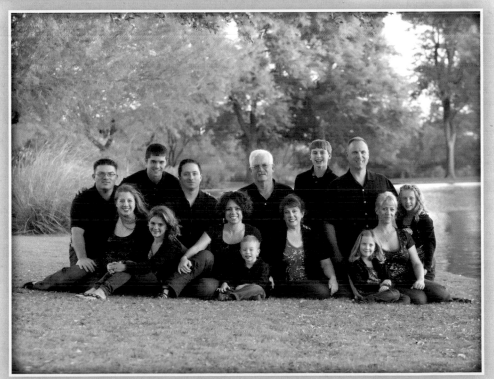

Adding the Family Dog

When I first started to photograph families, I was not a dog person and I would discourage clients from having animals in their portraits. That was until I started to photograph my assistant Dawn's family. For years I photographed her family for the holidays and one year she got a puppy and begged me to photograph the dog, too (Figures 5.24, 5.25, 5.26). Oh, I won't lie — it was hard.

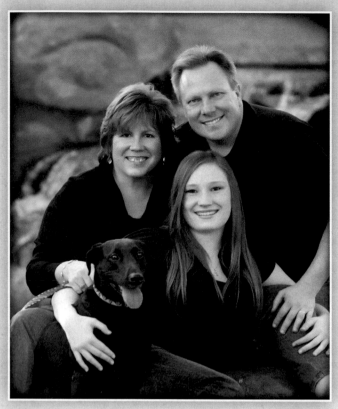

Figure 5.24
Libby is a few years old here and every year she is a part of the family portrait.

Figure 5.26
For the last image of this session with Dawn and her family, I had them walk along the water. I already had a vision in my mind of creating more of an art piece than a traditional portrait.

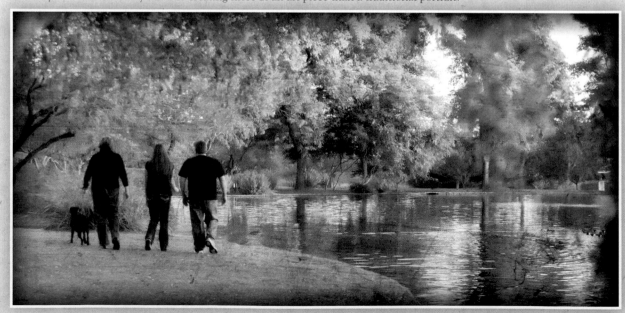

Figure 5.25

Libby is really sweet but very nervous and skittish, so getting her attention is often difficult, and she is always ready to run right out of the pose.

I had no idea what to do with a dog, never mind a nervous puppy. But now that I have two dogs of my own (Wrigley and Jeter), I realize that dogs are a big part of the family and make a great addition to a family portrait, so long as you know how to deal with them.

The following are tips for how to successfully add the family dog to the portrait:

- Have an assistant handle the dog or dogs when they are not needed for the portrait. This assistant can be a family friend or a photography assistant.

- Have treats in your pocket.

- Have a squeaky toy in your pocket.

- Try to choose a location where there aren't other dogs. (Dogs are a huge distraction to other dogs.)

- Ask Mom to make sure the dog has gotten exercise before the session. (A tired dog is a better-behaved dog.)

- Bring water for the dog.

Figure 5.27
Pets are like children to a lot of people (some even like their pets more than people),
so I treated the dogs like children and photographed them with their "parents."

The image shown in Figure 5.27 is from my first group shot with multiple dogs and I was really nervous about it. Trying to get five dogs to sit and look at the camera for a portrait is like having two-year-old quadruplets. I instructed the family to continue to look at me with a smile and to not look at the dogs while I was shooting. Adults often look at their pets or children during the portrait to make sure they are looking at the camera. It took a few images and after a lot of squealing and barking, I finally had everyone including the dogs looking at me. Figures 5.28 and 5.29 offer additional examples of portraits of owners and their dogs.

Figure 5.28
How sweet is this? You can see how much this owner loves her dog.

Figure 5.29
Even when pets are part of the image, I still try to find a way to create a strong composition. Notice the triangle between the human and canine subjects.

Working with Elderly Subjects

Being raised with my grandparents, I have a soft spot in my heart for the elderly. I love creating generational portraits; they are truly special. Here is the funny thing: As much as women dread having their portrait taken at any age, it gets worse with age.

One of my favorite memories of photographing families is when I photographed Kathy and her mom, Anna (Figure 5.30). First, Anna stole my heart because my grandmother's name was Anna and my daughter is named after her. Anna was well into her 80s when Kathy decided she wanted a portrait with her mom and Anna was not happy about it. She came into the studio and told me straight out, "I'm not smiling. I'm old and wrinkled, my teeth are yellow, and I can't believe she waited until I was in my 80s to do this. We could have done this 30 years ago." From that moment I was in love with her. In no way was I going to argue with an 80-year-old Italian woman named Anna.

Figure 5.30
Anna and her daughter Kathy. Anna refused to smile but I love this image and so does Kathy.

Figure 5.31

Carolyn told me that this was the last time her mother, Valetta, had her arms around her like this before she passed away.

It can be difficult for the elderly to move and pose. Anna had a walker but wanted to stand without it. It is sometimes easier to stand the elderly subject and have her lean on someone else, like in the image of Kathy and Anna. In most cases, good posture is difficult for an elderly subject when she is sitting, so standing can work best. If standing is not possible, then have the subject sit on the edge of a chair instead of all the way back on the chair; this will help improve posture. Another possible issue with the elderly can be the subjects' hearing or sight. Instead of giving directions from the camera, I will often go over to the subjects and speak to them directly. It is easier for them to see and hear me.

I loved listening to stories my grandparents would tell, so I always take time to ask a lot of questions and engage this special population. They have a lifetime of amazing experiences and almost never get to talk about them.

It is also important to understand that this may be the last professional portrait taken of an elderly person. I take that to heart because this portrait is a truly lasting memory. This is the way this person will be remembered. Occasionally, children have their elderly parents photographed because their parents are sick and the children realize that their parents may not be here much longer. What an incredibly beautiful moment we, as photographers, are entrusted with (Figure 5.31).

Summary

Relating to people of all ages is essential for portrait photographers. Your personality will either help to put your subjects at ease or make them feel uncomfortable. Learning to express yourself in order to bring out the best in people is important. Have fun and relax; you are a mirror to your subjects and I promise, you get back what you give.

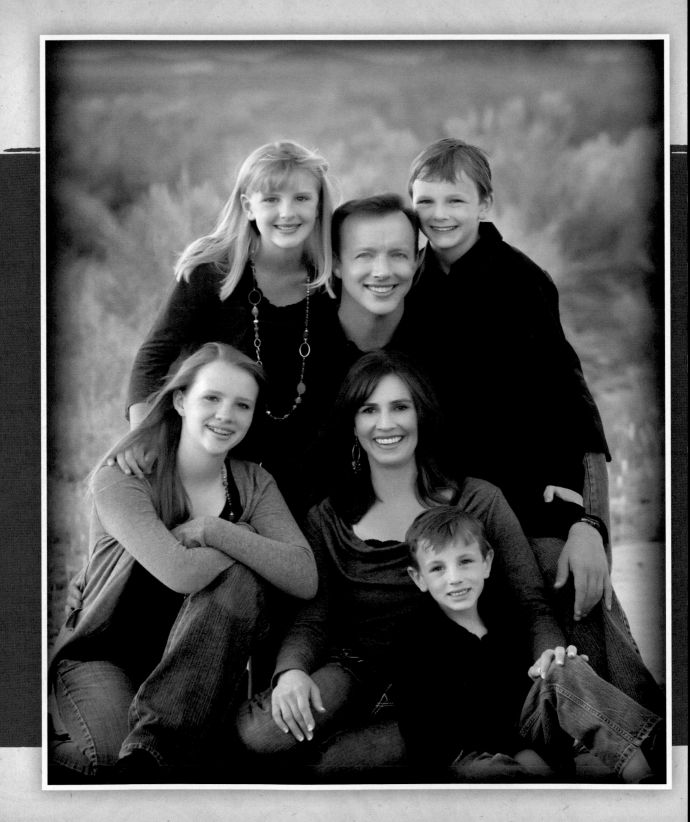

6 | The Art of Posing

The word *posing* has a bad reputation. Throughout the years I have heard more people than I can count say that they hate "posed portraits." I believe what people mean is that they don't like posed portraits that look unnatural and uncomfortable. Badly posed portraits look awkward and uncomfortable; however, if a photographer learns the art of posing people in a natural, relaxed way that makes them look their best, then "posed portraits" is a good thing.

Most people don't like the way they look in "candid" photos or "posed" portraits. Almost every single adult who has sat in front of my camera says the same thing to me: "I never like the way I look in pictures." Some even go so far as to imply that their face might break the camera. My response is always the same, "When was the last time you were photographed by a professional photographer who knows how to pose the body in a way that hides your flaws and makes you look thinner and younger?" Most clients will tell me that it has been many years since a professional photographer has photographed them. Usually, the last time they were photographed professionally was at their wedding. It is up to you, the photographer, to help your clients look and feel beautiful.

I frequently explain to clients that models look they way they do because they know how to pose their bodies correctly. They also have had a hair and make-up team prepare them for the shoot, and in most cases, the images have had a lot of postproduction manipulation. Unfortunately, the media has given us a distorted view of what is beautiful. Nearly every image on a magazine cover has been manipulated by photo-editing software — faces have been retouched, hips and thighs have been slimmed down, and faces have even been elongated sometimes to make the models look thinner. It's no wonder so many people don't like the way they look in pictures — they are trying to look like something that doesn't even exist. Most people, and women in particular, are comparing themselves to unrealistic magazine images. As professionals, we can help our clients look their best and maybe even better.

Walk Like You Are Wearing Versace

Study the fashion runways and the celebrity awards shows. Watch how models walk and stand. These women know how to walk the red carpet and make a $30,000 handmade Versace dress look fabulous. Their shoulders are back, a hip is popped, a hand is on the hip (not the waist), their arms float away from the body, and their bodies are turned to the camera correctly. This is how these women are trained to wear the dresses high-end designers want them to model and ultimately sell.

Explaining to women how much better they look with beautiful, tall posture instead of rounded shoulders helps them understand how proper posing actually enhances her figure. Try it for yourself. Look in the mirror and study your own body and how it changes when you roll your shoulders back and stand tall. Notice what happens to your waist when your arms float slightly away from your body. Take notice of how much wider your body looks when your arms are down by your sides and then rest your hands on the lower part of your hips and notice that you now have a waist.

Stand straight before the mirror and push your hips forward slightly, then press your hips back slightly. Notice how your body appears thinner when you press your hips back (lifting the tailbone slightly). It feels a bit awkward (you feel like you are pushing your butt back) but

Figure 6.1

A low camera angle and lack of proper posing create an unflattering figure.

the mirror or camera doesn't see your backside; it only sees the front of your body, which you just thinned out.

Figures 6.1 and 6.2 illustrate a great example of how to create a smaller waist by bringing the subject's arms away from the body. In Figure 6.1 my subject is standing straight in front of the camera with her arms by her sides, and a lower camera angle gives her an unflattering figure. In Figure 6.2 I am able to flatter her body by getting higher with my camera, turning her body slightly away from the camera, dipping her shoulder, and moving her hand to her thigh crease. Understanding camera height and proper posing completely changed the way her body looks. She did not like the first image at all but loved the second one.

Figure 6.2
Raising the camera height, turning the subject's body away from the camera, and separating her arm from her body completely changes her body and she now has a flattering figure.

The Three Languages of Posing

I have come to realize over the years that there are three main ways we as photographers communicate what we want our subjects to do: through our own body language, by telling them verbally, and through sign language once we are behind the camera.

Body Language

Let's start with body language. What exactly does that mean? Basically you need to learn how to pose yourself so that you can actually show your

Figure 6.3

In this image you can see I am showing my subject exactly how and where I want her to stand.

Figure 6.4

Here I show the men how I want them to separate their feet and push their hips back slightly.

clients what you want them to do. It is a visual cue that helps your subjects see exactly how you want them to pose. I always show clients how and where I want them to stand or sit by doing it myself first (Figures 6.3 and 6.4).

Once you are behind the camera, you will become a little like an aerobics instructor. Clients will mirror your movements; for example, if you face your subjects and point your right toe, they will point their left toes. By becoming the mirror image of the pose you're after, you help your subjects see exactly what they should be doing. I encourage practicing this technique over and over until it feels comfortable for you and becomes second nature. Small adjustments in posing makes a huge difference; therefore, when you show clients with your body language how to drop a shoulder, point a toe, lean over, or roll their shoulders back, the first visual clue they have is your body. Practice this. It takes time but it is worth the effort.

Verbal Language

You not only need to be able to show your subjects how to stand, sit, lean, or turn their faces, but also you need to be able to explain these positions. This is where great verbal communication skills come in handy. Clearly identify which part of the body you want your subject to move or change as you demonstrate it with your own body. It's important to use the words "left" and "right" when explaining which arm or leg to move. For example, instead of saying, "Turn your shoulder to the camera," you should say, "Turn your left shoulder to the camera." Or, instead of, "Tilt your head a little bit," try saying, "Tilt the top of your head toward your right shoulder." People are uncomfortable already, so you need to be as descriptive as possible to ensure that they pose correctly; in turn, their confidence in front of the camera grows. If you pose a client poorly and he doesn't look good, take the shot anyway and move on to another pose. You never want the subject thinking he did something wrong or he doesn't look good. You can edit out a bad image later but it's hard to recover confidence in front of the camera once you have said, "Oh no, that doesn't look good." You just shot down the subject and that will most likely be the end of natural relaxed expressions.

When you want your subjects to turn their bodies a certain way, first show them and then explain, "Turn your left shoulder toward the camera, relax your right shoulder away from your ear, turn your nose a little to your left, drop your chin to your chest a little bit," and so on. If you are not clear, it may confuse the subject and make him feel even more uncomfortable. Unclear instructions such as, "Move this way. No, I mean the other way. Not that shoulder, the other one," will only cause confusion and frustration. Practice this with whoever you can. The more you practice this type of communication, the more proficient you will become.

Sign Language

The last and final step when posing your subjects is honing the fine details. During this last step, I am behind the camera and almost ready to take the portrait, but first need to

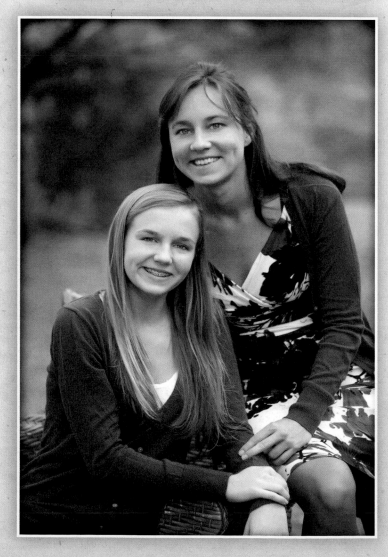

make a few adjustments. This is when "sign" language, or hand signals, comes into play. From behind the camera (which is on the tripod), I can use my hands to direct the last few details. I may say something like, "Follow my finger with your nose." This helps ensure small movements when looking for just the right facial angle. Use your hands to direct head tilts and lifting or lowering the chin. Simply asking your subject to turn or tilt in a certain direction may result in more movement than you want. Using your hand like a conductor gives the subject a visual direction of how much movement you want.

In the final moments right before I am ready to snap the shutter, I instruct my subject to lift up or "pull up from the center of the spine" and lean in. When you are working with groups, by the time you are ready to take the final portrait, group members have often dropped their posture a little bit and a reminder to lift up and lean in gets everyone looking their best.

Figure 6.5

Using my hands I am able to direct the subjects into the exact pose I am looking for.

In these three examples you can see how I use my hands from behind the camera to direct subjects into the pose I want. In Figure 6.5, I ask my subjects to lift up and lean into each other. In Figure 6.6 I ask them to put their heads closer together. And in Figure 6.7 I ask one of my subjects to follow my finger with her nose so I can turn her head exactly how I want it.

Figure 6.6

Sign language and verbal communication are the languages that help the subject understand how they should adjust their pose.

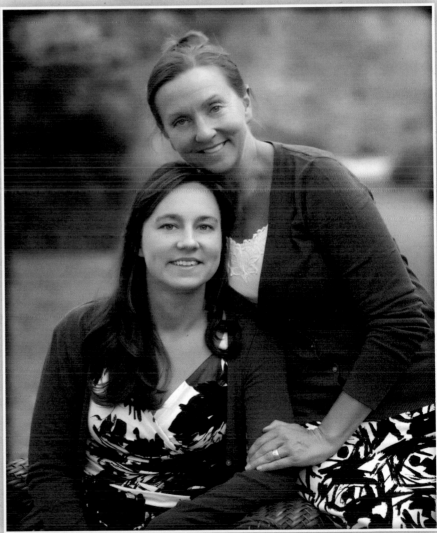

Figure 6.7

Using my hand I am directing the subjects on which way to turn their faces to the camera. It's almost like I have a string attached the nose of my subject and the tip of my fingers. I can move the subject exactly the amount I want with my hands.

Key Phrases to Remember When Posing Your Subjects

The more descriptive you can be with your language the better your subjects will be able to understand your instructions. Here are several key phrases to keep in mind when posing your subjects:

❈ Pull up from the center of your spine.

❈ Lean over your belt from the hips.

❈ Push your hips back slightly.

❈ Pop your left/right hip.

❈ Drop your left/right shoulder.

❈ Bring your jaw to the temple (of the other person).

❈ Let your elbows float away from the body slightly.

❈ Tilt the top of your head to the left/right.

❈ Turn your face to the left/right.

❈ Raise or lower the chin slightly.

❈ Separate your feet.

❈ Lift up and lean into the center of the group.

❈ Place your thumb in the outside corner of your pants pocket.

Are You Hiding Behind Your Camera?

A big black camera with a giant lens in front of it is pretty intimidating for most people and the reality is people cannot connect with a camera. It's not the camera that brings out expressions in people, it's you! If you are hiding behind your camera, your subject can't see you or connect with you (Figure 6.8). It's also hard for them to hear instructions if your face is obscured by a camera (your voice can get muffled). This is why I believe it is critical for portrait photographers to use a tripod (Figure 6.9). Keep in mind that if you are photographing "candid" images of young children, this won't apply. However, the tripod you use when photographing classic portraits will become one of your greatest tools. It allows you more freedom to move around while your camera remains where you are shooting from. It is so much easier to use all the languages of posing when your hands are free from the camera. Your subjects can see you, hear you, and connect with you, and it also takes stress off your body because you are not carrying a heavy camera.

Figure 6.9
Using a tripod allows you to connect with your subjects and smile at them. It is also much easier for your subjects to hear your directions when you are away from the camera.

Figure 6.8
If you are not using a tripod, this is what you look like to your client. Not very friendly, is it?

Understanding Correct Camera Height

Camera height is important when photographing people because you can actually change the size of a person's body depending on the height and angle of the camera. Lower camera angles will make the body appear larger; higher camera angles can make the body appear smaller. Full-length portraits require a different camera height than close-up portraits do. Here are a few simple rules to get you started with camera height:

❋ For full-length portraits, the camera should be at about waist level of your subjects (not at your waist level). If your camera angle is too low or too high, the subjects may be distorted.

❋ For three-quarter length portraits, the camera should be at about the chest level of the subject (Personally, at four foot eleven, I found this out the hard way by shooting from my height level when subjects were taller than me until I realized I was shooting up my subjects' noses or creating double chins where they didn't exist.)

❋ For close-up portraits, the recommended camera height is above the eye level of the subject.

Of course rules are made to be broken, but I cannot stress enough how important it is to learn the rules first and why they work before you break them. Once you understand the principles, you can purposely and artistically break them. For example, a thin woman with a strong jaw line may look incredible when shot from a low camera angle, but I can guarantee a low camera angle won't work for a heavier woman with a full face and neck. Often with heavier clients, the higher the camera angle, the better. I will sometimes get much higher than a heavier subject for a close-up portrait. This technique does several things: it elongates the neck (instantly making the subject appear thinner) and it minimizes the body by directing the focus to the face. In this series of four images (Figures 6.10–6.13) you can see the effects of different camera heights. The subject in these images does not move, only the camera moves.

Figure 6.10
I shot the first image from the highest camera angle. I stood on my posing blocks. Notice the subject's hips and how small they look. Her neck looks long and the background consists almost entirely of the ground.

Figure 6.11
For this image I stepped off my posing blocks. I was still at a slightly higher camera angle. The size of the subject's hips has changed, the shape of her face has changed slightly, and the background is now partly the ground and partly the bushes behind her.

Figure 6.12
For this image I was just about eye level with the subject. Again notice how her hips and face look, and the background is now mostly trees.

Figure 6.13
Here I was below eye level. This works for this subject because she has a great jaw line and is young. Notice the difference in the background; it is all trees and sky.

Figure 6.14
Full view of the face is when you can see the entire face from ear to ear. This is also called the "mask of the face," which is the area of the face from the outside edge of eye to the outside edge of the other eye.

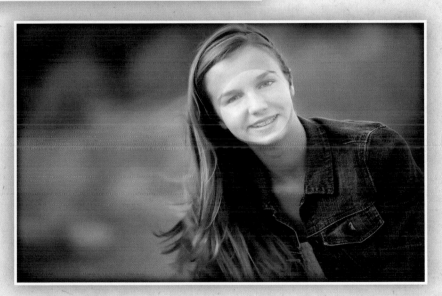

Looking at Facial Angles

It's important to understand the three primary facial angles to look for when creating portraits: full-face view (Figure 6.14), two-thirds view (Figure 6.15), and profile view (Figure 6.16). Every face is different and most people do not have symmetrical faces. Often one eye is bigger than the other, the nose is not perfectly straight, or one eyebrow is higher than the other. It's important to study the faces of your subjects and decide which view will work best and from which side you should photograph them. In my experience most clients tell me which side is their "best side." It's important to pay attention to this because it probably means they don't like the way they look from the other side.

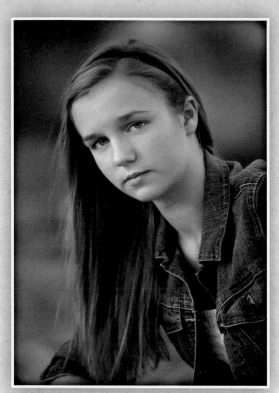

Figure 6.15
Two-thirds view of the face is when you can see the mask of the face but only to the outside edge of one eye.

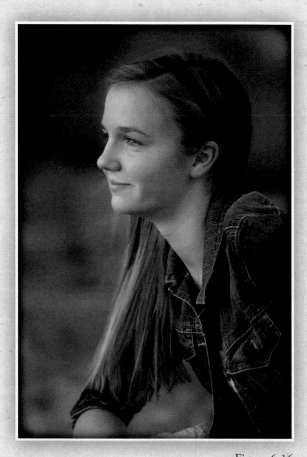

Figure 6.16
A profile view of the face is when you see only one side of the face from a side view. You can still see the eye lashes of the eye facing away from the camera but the nose does not cross the cheek.

Figure 6.17
Norm has deep set eyes. In this example, he is looking directly at the lens, and his eyes appear small.

Open Your Subject's Eyes

Deep-set eyes can be problematic when turning the head in a certain direction (Figure 6.17). Deep-set eyes can appear to be closed when looking directly at the lens. One of the sneakiest tricks I use is having subjects with deep-set eyes look above the lens. I usually direct them to look at me instead of the camera. This trick helps to open the eyes or at least make the eyes appear as though they are not closed or squinting (Figure 6.18). If done correctly, it will look as though the subject is looking at the camera and not above it. A good tip to remember here is that once you can see the white at the bottom of the eye, you have gone too far. As long as the eye socket is filled with the iris, this works almost every time.

Figure 6.18
Just by having Norm look above the lens at my forehead, his eyes appear to be larger.

Figure 6.19
To pose this family of five I had the smallest subject closet to the camera, the oldest child lean over Mom, and Dad (the tallest) lean over his family.

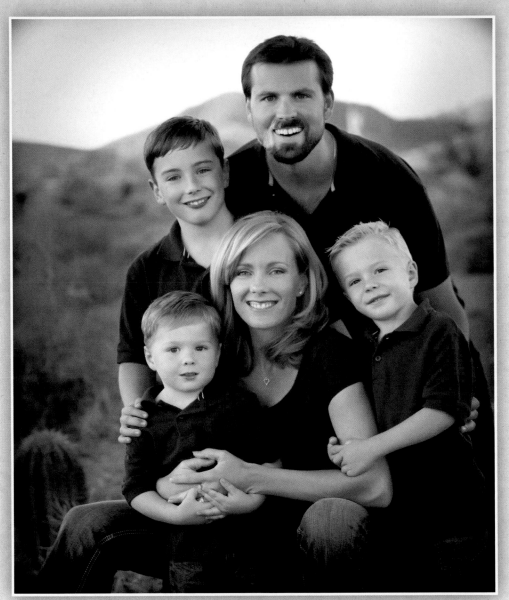

Posing Groups

Posing groups of people together is a lot like putting a puzzle together — you need to figure out how all the pieces fit together. You will have people with bodies of all sizes, from small children to tall dads, so how do you fit them together and make them all look good? Using body sizes, heights, heads, shoulders, elbows, and arms you can begin to assemble the puzzle.

The first thing I do when working with a group of two or more people is analyze the people's bodies. I'm looking to see who is the tallest, who is larger or largest, and who is the smallest; then I start thinking about piecing together a configuration so that everyone looks great. For the family of five shown in Figure 6.19, I started by having Mom sit on my posing blocks. I had the youngest and smallest child stand between her knees, her oldest and tallest son stand over her right shoulder, and her middle child hug her left arm. Dad is taller and therefore I put him behind the family, leaning over them so that everyone's face would be as close to the same plane as possible.

It's important to remember perspective when working with people. The subjects closest to the camera will appear larger and the subjects farthest from the camera will appear smaller. Therefore, you don't want to put small children behind their larger parents. Mom will instantly say that she looks fat because she appears to be so much bigger than her child.

Another important part of posing groups is making sure that each person in the image looks good. Imagine that you were to remove all but one person. Does that one person still look good? That is the question you should be asking yourself each time you put a group together.

Focal Plane

When posing groups it's important to keep the faces on the same focal plane. Imagine that there is a pane of glass in front of your subjects and then imagine moving each subject's head so that each person's nose touches the glass. Depending on how large the group is, it is not always possible to achieve this; however, it is important that the subjects are as close to this imaginary pane of glass as possible. Having subjects toward the back lean forward so that all of the noses touch the "glass" helps to ensure that all head sizes appear to be in proportion to each other.

Another advantage to having the faces on or as close to the same focal plane is you will be able to shoot at larger apertures without some of the faces out of focus. If you are working with a large group and it is not possible to get all of the faces on the same focal plane, it's important that you adjust your aperture to ensure that everyone will be in focus. How deep the group is will determine how much you need to stop down with your aperture.

Creating Triangles

Building triangles with families creates a warm, connected feeling between people. Using your knowledge of body placement, you can begin to pose groups that flow and feel complete. In the series of beach portraits shown in Figures 6.20 and 6.21, you can see triangles in every image, from the standing, full-length poses to the close-up portraits.

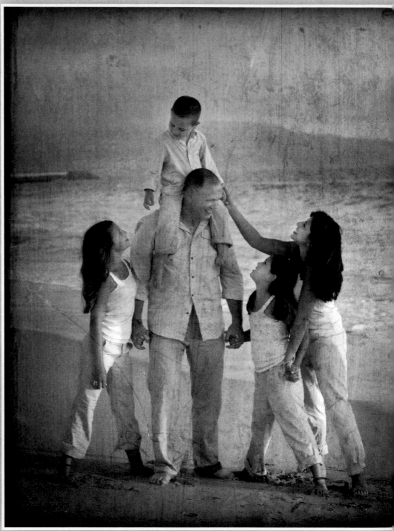

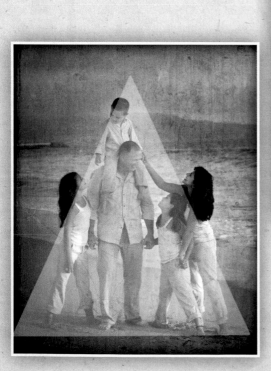

Figure 6.20
You can see the triangle shape of the subjects starting on the bottom left of the image, moving up to the boy on Dad's shoulders, and then moving down to Mom.

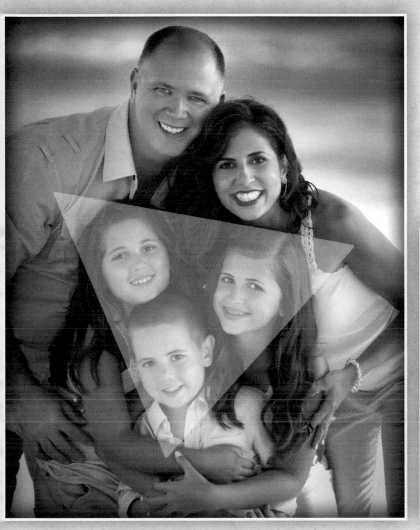

Figure 6.21
This image beautifully demonstrates how posing the bodies based on height and body size keeps everyone in the group at the correct proportional size.

In the close-up image shown in Figure 6.21 I marked out two different triangles. Placing the smallest child in front, bringing his sisters around each of his shoulders, and then placing the parents behind all the children, leaning over them does several things:

❊ All of the faces are as close to the same focal plane as possible.

❊ Mom appears smaller because her body is hidden behind her children.

❊ Dad appears thinner because of the way he is leaning over the children.

The two images of this family, shown in Figures 6.22 and 6.23, illustrate great examples of standing and seated posing. The location is the same in both images. I placed the family in an open shade area that was backlit.

In the standing pose, I use the same concept of puzzling and shape theories. I created a triangular base by having the family members stand with their feet separated. If their legs were not separated, they would look stiff and it would be much harder to place the subjects since the bodies would not have enough room between them. Placing Mom (Mindi) slightly behind Dad (Jeff) makes her appear much smaller. I then posed Madi (far left) in front of Mindi (because Madi is the smallest of the group).

Given Jeff is the tallest, I have him in the center, as the anchor of the group. Having your subjects hold hands in a standing pose is a great way to give them something to do with their hands, opposed to letting them hang at their sides, and it gives a warm family feeling to the image.

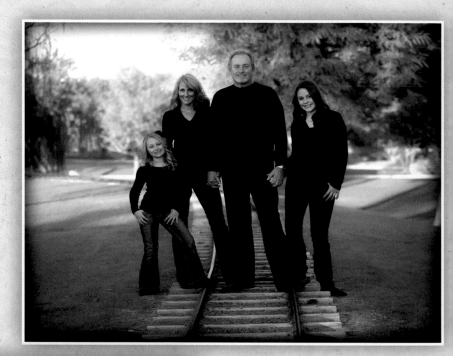

Figure 6.22
Placing the bodies open to the camera provides room for subjects to stand behind each other and space over their shoulders for heads to be placed.

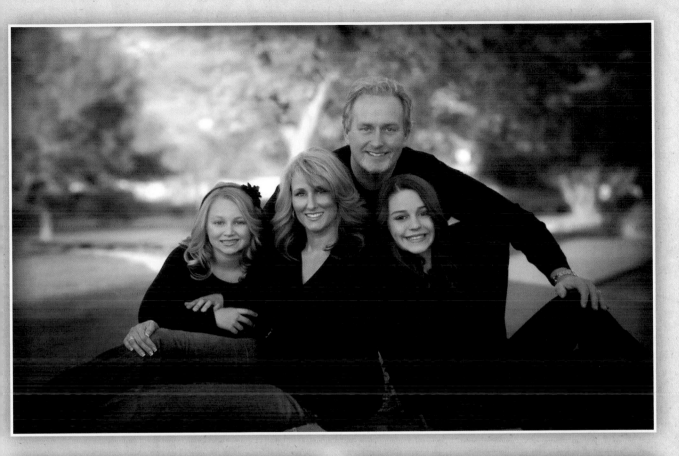

Figure 6.23
Take note of the triangles I created with the entire group as well as the smaller triangles within the group.

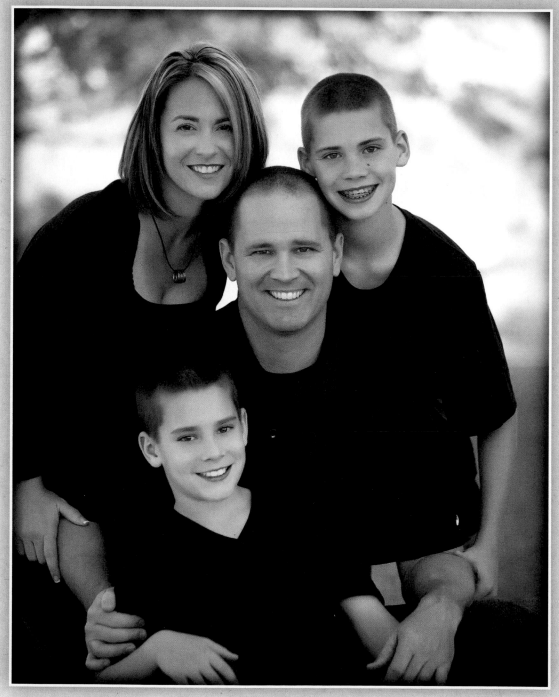

Figure 6.24
Notice the diagonal line running through the heads of Dad and the boys in addition to the triangles I created with their heads.

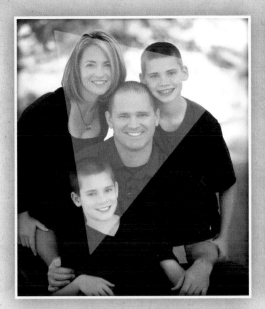

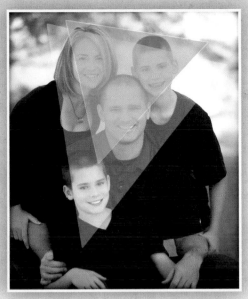

Diagonal Lines

In addition to triangles, I also seek to create diagonal lines in my portraits. Creating diagonal lines with the faces of your subjects is another component of creating interesting portraiture. When posing portraits stacking the heads or faces of subjects in a straight line either vertically or horizontally can appear boring or static. It is more visually appealing to the viewer to have faces on different levels.

Building triangles starts with diagonal lines. If we are working with two subjects I can create a diagonal line through the faces by having one person bring his jaw to the temple of the other person. Using the jaw to temple direction allows the subject to understand where his face needs to be in relation to the other person. Adding another person to the group of two then creates the triangles that I look for in groupings. In Figure 6.24 you can see how diagonal lines are formed from the youngest boy in front to his Dad and then to his brother. A diagonal line is also formed from Mom to Dad. The family in Figure 6.25 has one more person but the principle of diagonal lines and triangle is the same. The first step to creating triangles is to create diagonal lines.

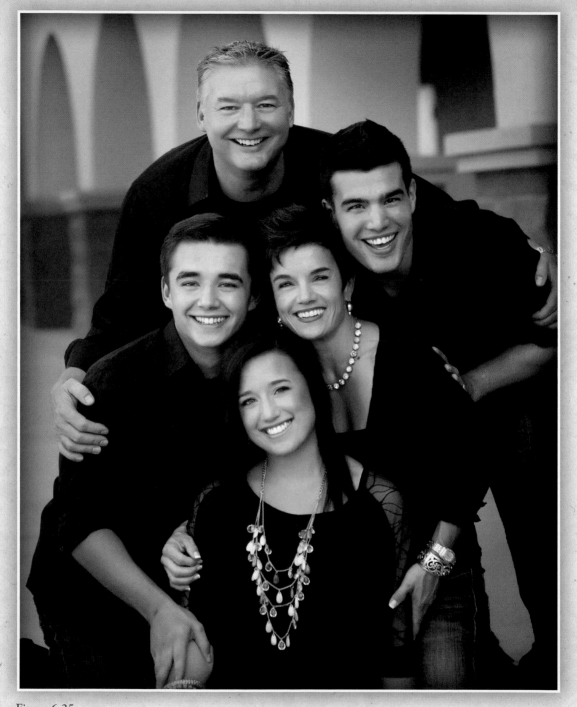

Figure 6.25
Notice the diagonal lines, the triangles, and the placement of the bodies in this image.

Building Groups

As piecing groups together becomes second nature, you will be able to start building groups more easily. An important aspect of photographing families is speed. In most cases 60 to 90 minutes is about the maximum amount of time you have with a group before they become tired and fatigued. This is where building upon groups becomes important.

A portrait session I did with the Neilson family (Steve, Harper, Micaela, Nico, Jackson, and Nina) offers fantastic examples of building groups. This family of six was perfect for showing how many different poses are possible.

I started with Steve (Figure 6.26). He is sitting on the corner edge of a platform under a gazebo. I placed him here for several reasons: (1) the light was beautiful; (2) the platform gives me different heights on which I can build the groups; and (3) the texture and depth from the flowers in the foreground and background help to give the images dimension. I used his right leg as the leading line for the portrait. Then I had him lean his elbow on his knee, drop the height of his right shoulder, and then tilt his head toward his low right shoulder. This pose forms the base for the rest of the group.

Figure 6.26
A simple portrait of Dad will become the base for many different groupings of his family.

Figure 6.27
Adding Harper to the space between Steve's feet allows her to naturally lean into him creating a warm feeling between them.

Figure 6.28
The parents are in the same pose making it easy to add a child to the open space above Mom's shoulder.

It was easy to add Harper into this image (Figure 6.27). I had her sit between Steve's knees. She is sitting on her left hip as opposed to sitting directly on her behind. Leaning on the outer edge of her thigh creates a thinner line in the body. Sitting on the ground below Steve gives them a beautiful diagonal line and enables Steve to lean over her. Although Harper is not on the heavy side, Steve's front leg actually cuts her body in half, making her appear thinner. The camera height is slightly above them, which creates thinner faces.

I always like to photograph each child individually with his or her parents. In Figures 6.28–6.31, it's easy to see how I placed each one in the same spot. I moved each child in behind Mom and Dad by having the child place one knee on the platform next to Dad and lean over toward the camera.

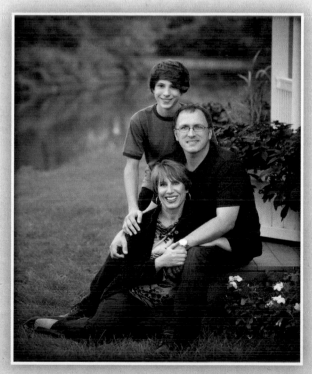

Figure 6.29
Jackson is a little taller than his sister and now creates a diagonal line between his head and his father's head.

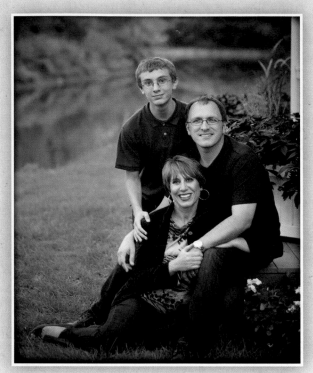

Figure 6.30
This entire series of individual images of each of the
children with his or her parents took no time at all
because I only have to move one person in the group.

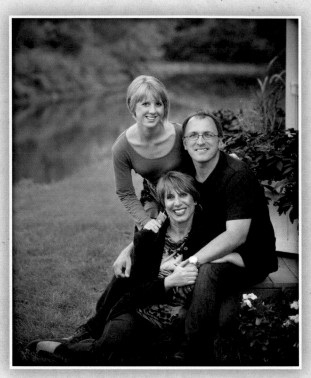

Figure 6.31
Having Micaela lean over her dad ensures that
her face is on the same focal plane.

Now for the entire family. Leaving Steve and Harper in the same place, I placed
their youngest and smallest child Nina in front and the oldest son Nico over Dad's
shoulder. (Nico was also the tallest sibling.) Then I added their eldest daughter
Micaela in the center, above Mom, and added their youngest son Jackson on the end
(Figure 6.32). This entire grouping of images took 10 or 15 minutes at the most. Each
image was carefully created to maintain consistency in the posing and background
and to keep the session moving quickly.

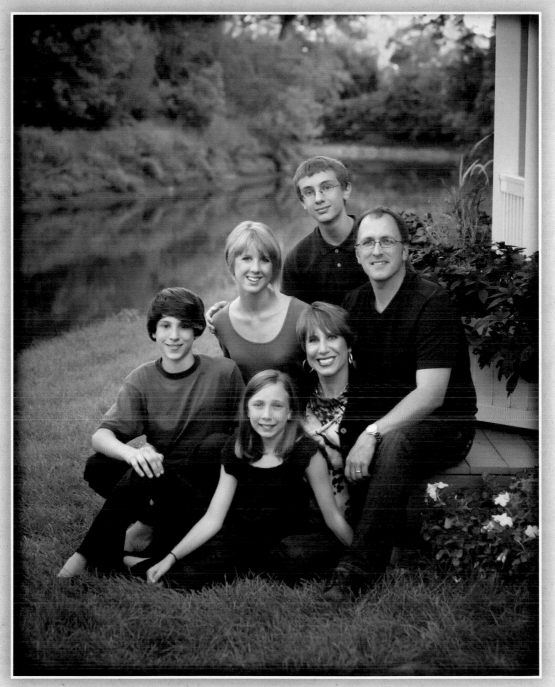

Figure 6.32
Steve and Harper have not moved for this entire series. I have simply moved the children in and out of the pose and now ended with the entire group. Notice the diagonal lines as well as the triangles. Can you find them?

Common Mistakes

The next series of images offer great examples of posing gone wrong and demonstrates how easy it is to correct them. During a workshop I was teaching, I asked a student in my class to pose Steve and his two sons using the same location. As shown in Figure 6.33, the student made every classic mistake: younger brother Jackson is behind older brother Nico, making Jackson look small and dejected. Steve's body is cut in half by Nico, and Nico appears to be the largest subject with no connection between any of them.

In Figure 6.34, you can see how I repositioned the bodies. I used the different heights of the posing props available and was able to stack the bodies. Steve is in the center and is the "rock" of the family, Nico is sitting on the floor between Steve's knees, and Jackson

Figure 6.34

Changing the position of the bodies each person can now be seen and each looks equally important. Having Jackson lean over and place his hand on his brother helps tie the relationships together.

Figure 6.33

In this student attempt, Jackson looks lost and Nico looks larger than his father. It is also difficult to distinguish a relationship between them in this pose.

Figure 6.36
Using the same location but changing the way the bodies are placed created an entirely different pose.

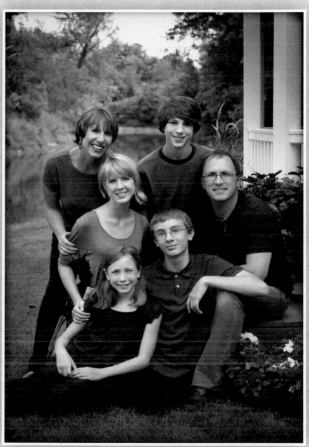

Figure 6.35
When you figure out how to piece bodies together like a puzzle, adding more people to a group becomes very easy.

is leaning on Steve's shoulder. Each of their faces appears to be the same size since they are all on the same focal plane. One face is not further behind or in front of another.

Next I added Micaela to the group (Figure 6.35). You can see how little changed with the other subjects, even though I added another piece to the puzzle. (Also notice the triangles I built into this pose.)

Using the same grouping, I created another variation of the family group combination by continuing to add pieces to the puzzle (Figure 6.36). I added Nina to the front of the image because she is the smallest of the group. I placed Harper behind her daughter, obscuring half of her body and making her appear smaller since she is behind two other subjects.

Figure 6.37
The siblings look stiff in this image and there doesn't seem to be any connection between them.

Next I asked another student in the class to pose the four siblings together. Figure 6.37 is a pretty good attempt; however, there are a few issues. Nico is too far behind the group, which makes him look small and his head is directly over Micaela's head. (Rule of thumb: try to avoid having heads stacked directly over one another. Often when heads are stacked it appears as though one head is growing out of the other. It also creates a straight, static line, which is not pleasing to the eye. Straight lines have no movement, whereas diagonal lines tend to create movement within an image.) Another problem is that Nina looks totally lost behind Micaela. In addition to these issues, the subjects look stiff and there is no connection between them.

Notice how in Figure 6.38 the children display a feeling of being connected and look like they are having fun. By stacking them together I created a warmer pose. I had Nina lean more on Micaela and brought Jackson to the front. Then I had Nico lean around, placing his chin between Micaela and Jackson. Same location, same subjects, but improved posing makes such a big difference between professional portraits and "nice pictures."

Another student posed the family group shown in Figure 6.39. It was a good start but a few things were still wrong. Micaela and Nico both look lost in the background; Steve looks uncomfortable; and I generally don't like the way the parents

Figure 6.38
Stacking the siblings together created a warmer pose.

look seated with their backs toward each other.

In Figure 6.40 I corrected some of the problems with the previous image. I put the children in the front, and Steve is now tall and a strong center of the image as well as the family. Nico no longer looks lost, and Harper's body is partially hidden behind the girls (making her appear smaller and thinner).

Summary

Most of us walk around with poor posture and little awareness of how our bodies look. We tend to sit slumped over instead of sitting up straight with good posture. When we walk, we rarely roll our shoulders back or pull up from the center of the spine to elongate our bodies. Posing is really an art form and takes time to master. Experience and education on the part of the photographer go a long way in helping to teach clients how to pose themselves in ways that look natural and relaxed.

Figure 6.39
This attempt by a student is a good start, but I see a few things wrong here.

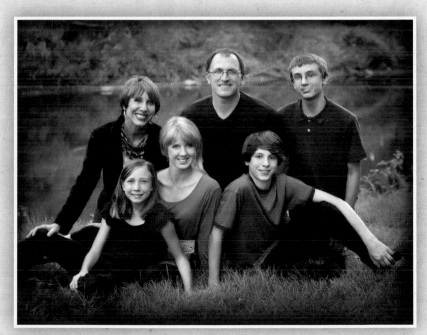

Figure 6.40
In this image everyone appears to be similar in size and equally important.

7 | Building a Profitable Family Portrait Business

Now that you are an expert at creating amazing family portraits, now what? It might be easier to take beautiful portraits than it is to build a truly successful family portrait business, but it can be done. First you need to figure out what makes you special and exactly what you are selling. In today's world, everyone is a photographer. Cameras are easier to use, mobile phones take better pictures than my first professional digital camera did, and everyone can use a computer to manipulate and edit photos. Mobile phone applications such as Instagram make even basic phone camera images look like works of art. So, how exactly are you going to sell your photography? Here is a tip: You are not actually selling photography. You are selling yourself. You are selling your expertise, your experience, and something many moms can't do for themselves — create a family portrait that she is part of.

A common struggle when creating a profitable photography business from a hobby is to actually run it as a business rather than use it as a way to boost your ego. It has to go beyond the fact that people like your "pretty pictures." You have to remove yourself from the emotional attachment you have to your photographs. Let's face it: we are artists and we take it personally when a client doesn't like an image we created. In this chapter, I hope to take some of the initial mystery away from how to turn a hobby you enjoy into a profitable business.

Creating a Business Plan

The first step to launching your family portrait, or any, business is to write a business plan. It doesn't have to be complicated in the beginning stages. Begin by writing down some questions, such as:

❊ What is the name of your business?

❊ Will you run it from a commercial location or from your home?

❊ If it is your home, will you have a separate area in your home just for clients?

❊ Will you travel and meet clients in their home?

❊ Do you plan to have employees?

❊ Are you going to run your business as a DBA ("doing business as") or a limited liability company (LLC)?

❊ How much money would you like to earn?

❊ Will it be a full-time or a part-time business?

❊ How many hours a week do you plan to work?

❊ How many photography sessions do you want to do per week/month/year?

❊ Who is your target client?

❊ What makes you special?

❊ What equipment will you need, and how much will it cost?

❊ Do you have working capital or will you need a loan to get started?

❊ How will you market yourself?

❊ What percentage of sales will be budgeted for marketing and advertising?

❊ Do you need to buy your own health insurance and, if so, how much will it cost?

❊ How much will you invest in education and professional resources each year?

❋How much will you invest in upgrading equipment, computers, and software each year?

❋Who will update your web site and other social media outlets? You? If it is not you, will you pay someone to update them for you?

These are only some of the questions you need to ask yourself, and each business owner will have a different set of answers. The key thing is that you think about these questions and create some type of framework for how you might get started.

Image Branding

Does this sound familiar? You love taking pictures. It becomes a passion and you start photographing friends and family members. Soon people are asking you to take pictures of their children or family because they saw what you did for another friend and really liked your work. Before you know it, you are spending money but not making any money. You "kind of" have a little side business going but you are not exactly sure what you are doing. Do you start charging? If so, how much? Do you provide images on a DVD? Could you sell other products? Next thing you know, you are overwhelmed with a business you didn't realize you started.

Part of the idea of image branding relates back to designing a business plan and model. What is your photography point of view? Do you want to specialize in one area or do you want to offer all types of photography services? The answers to these questions will help you determine what your business "image" will project. With family portraits as a niche market, everything you do will be related to families and showcasing family portraits.

Your image will also depend on what type of client you are targeting. If you want a high volume business with budget friendly prices, your image branding will be very different than if you want to target a high-end clientele and a low-volume business.

Before deciding on an image for your business, study different businesses for ideas. Study businesses that you really like and ones you don't. There is as much to learn from what you don't like as there is from what you do like.

Examine trendy new companies and then study classic older companies. Study budget-friendly companies and high-end companies. Study their logos — what type of font and colors do they use? Study the marketing tactics they use.

Study car companies, department stores, jewelry retailers, and even supermarkets. A clientele exists for every type of business, regardless of the economy. You need to know who your client is, where you will find them, how you should market to them, how they

will respond to certain types of marketing, and the type of customer service they expect. Your high-end clients are going to expect a much higher level of service than your budget-friendly client.

Most new business owners have preconceived notions about how much people will spend on photography based on their own spending habits. This can be a huge mistake if you are targeting extremely high-end clientele — a clientele who will be willing to spend more on professional portraits than you or your friends would. If you are targeting a demographic that has more buying power than you do, don't get caught up in the thought that people won't spend the money. High-end clients want service and brand recognition along with the very best quality. Budget-friendly clients want a great product that falls within their budget. Identifying your target client and a business model is crucial to your success. Without this road map, you won't have any idea of how to market and brand yourself.

When I thought about my logo, the colors I'd use, and the overall image of my business, my goal was to create a classic, cohesive, and sophisticated impression. I worked with a professional graphic artist to create my logo. It was a process that took time and thought. I wanted to use the letter M as a type of signature so that I could

Figure 7.1
This is the final logo design I approved and the logo worked into the color scheme I chose.

use it in many different ways. The logo shown in Figure 7.1 is the final design I approved. I can use the letter M alone or with my name.

The color scheme I chose was black, white, different shades of gray, and light teal blue. I can use the M in any of the colors based on what I am designing. The M becomes the identifiable logo. Figure 7.2 shows a slightly different way to use the same consistent colors. Also I added a tag line to this piece: "The Art of Extraordinary Portraiture." Figure 7.3 is the top header on my blog. When you visit the blog there is no mistaking my identity. My brand stays consistent throughout all of my marketing.

Figure 7.2
I used the same color scheme and added a tag line to this marketing piece.

Figure 7.3
The blog heading stays consistent with the rest of the design and logo.

Marketing: Getting Your Name Out There

As consumers, we are inundated with marketing messages, advertisements, text messages, commercials, radio ads, billboards, e-mail marketing, and junk mail that all try to sell us something. How are you going to get potential clients interested in you? How in the world is your message going to break through the crazy noise that surrounds potential clients?

In years past, marketing experts estimated that potential clients would need to see your message, name, or ad 10 times before they would recognize you and act upon the marketing. I think that number is much higher now. In today's market you need to dominate the competition. To help achieve this, you must have everything about your name and image consistent and recognizable. Your company logo, tag line, and color scheme need to dominate your image. Your website and/or blog have to be consistent and frequently updated.

To gain a foothold in your local photography market, it is important to be creative in your marketing and not rely solely on print ads or direct mail marketing. There are many other marketing avenues and tools a small business owner can use to get her name out there, such as e-mail, e-newsletters, websites, and social media, as well as person-to-person and business-to-business networking. Client referral programs are another great way to reward clients for their loyalty and referrals. In the following sections, I outline a few of the tools that have worked for me.

Websites, Blogs, and Social Media

The Internet is often the first place clients view your work; therefore, your Internet presence should match the rest of your image branding. Figure 7.4 shows the splash page for my website. Figure 7.5 is the portrait site. Again, you can see how I have kept a cohesive look throughout my Internet presence.

Figure 7.4
The home page of my website, www.michelecelentano.com.

If you use social media outlets such as Facebook to help promote your work, your activity on those sites should reflect your style and image. Purposeful posting is important — your clients don't care about what you ate for breakfast or what time you put your kids to bed. They want interesting content related to your business and new images to look at. Talk about what is coming up in your studio

Figure 7.5
The home page of my portrait site.

— are you having a fall special? Did you just get back from a great class and want to share how excited you are about the new ideas you have? Did you have a memorable session? These are some of the things you should talk about. I use Facebook to promote my work by posting new images, seasonal specials, speaking engagements, and even this book (Figure 7.6).

Figure 7.6
I use a Facebook page to help promote my studio.

Silent Auctions

Silent auctions are a great way to promote your studio within the community. Attend the auctions you donate to and make sure you like the cause for the auction. They are often held as fundraisers for charities, schools, churches, and even theater events. Find schools you would like to target and offer to be a part of the fundraising team.

When you offer gift certificates for silent auctions, be sure to include the value of the session and prints you are offering and include an expiration date. Without an expiration date, your gift certificate is likely to get shoved in a junk drawer and you may hear from that potential new client three years from the event. My expiration dates are three months from the date of the event. Putting a date on your certificate helps create an urgency to redeem it. You can also ask the auction organizer for the contact information of the purchaser and you can follow up with the client directly.

Local Business Displays

Displays in local businesses are another great way to promote your work. Find businesses that are family friendly and offer the owner a family session in exchange for allowing you to display their portrait at their business along with your information.

Client Appreciation Parties

Client appreciation parties are another great way to keep your name and business in the minds of your clients and on the tips of their tongues.

Local Business Groups

Get involved with local business networking groups. These types of groups can be an amazing source for referral business. In addition, photographing headshots for local business owners may help introduce your family portraits to them.

Infomercial Tactics

This may sound a little crazy, but I'm addicted to infomercials. You may be laughing right now because you can identify with me, but infomercials are marketing and selling classrooms. Of course, I don't sell my photography like infomercials sell products. ("But wait! If you buy in the next 60 seconds, we will double your order for free!") However, they use valuable strategies that can translate to any business if used correctly. For example, offering a gift with purchase is a great marketing and selling strategy. High-end cosmetic companies use it all the time. The gift is usually something that you can't purchase on its own, making the offer even more attractive.

Marketing Personality

Think outside the box when it comes to marketing. Personality is a huge part of selling. What does your personality say about you and your photography? Think about how many intangible products exist and how companies find a way to put a face to the product and give it a personality.

What company do you think about when you hear the name Flo? Progressive Casualty Insurance Company has found a way to make insurance personable.

A little green gecko gave GEICO a personality. A polar bear and a smile works for the Coca-Cola Company. Round candy-coated chocolates become an entire colorful cast of dancing personalities and suddenly M&Ms are more fun. Think about how Apple used personalities to make the Mac cool and hip and the PC stuffy and old. It's brilliant. This is one of the reasons big companies pay celebrities to endorse and advertise their products — personality! We can identify with a famous face.

If all these companies did was tell you how great they are, they would easily be forgotten. But a marketing smarty-pants gave them a personality and now these companies are remembered.

Figuring Out Your Cost of Goods

This is where many new photographers and business owners really get lost. Figuring out your cost of goods (COG) based on the prices from your lab is not an accurate way to calculate what your prices should be. If you add up the time it takes to produce the final portraits you are selling and then factor in the cost of packaging, advertising, insurance, overhead, your salary, taxes, continuing education, and equipment upgrades, you will quickly realize that you cannot sell an 8x10 for $30 and actually turn a profit.

Don't make the mistake of looking at your lab cost of $2.50 for an 8x10 and thinking, "Wow, I am making a serious profit by selling an 8x10 for $30." I'm telling you straight up: you will lose money and could probably make more working at a fast food restaurant for minimum wage. You need to sit down and do some planning and math. You need to have an idea of how much it will cost you overall to run a photography business. This will take some time, but it is well worth the effort.

For example, an 8x10 print with mounting and texturing costs $5.74 from the lab. The box, tissue paper, ribbon, and gift bag for the print is another $3.00. The total cost of the 8x10 is $8.74. Pricing that 8x10 at $30.00 puts your COG at approximately 30%. Pricing that same 8x10 at $45.00 puts your COG at approximately 20%.

Not all products can be priced this way, however. Items with a higher COG may be priced higher to increase your profit and to account for the extra time it takes to produce the product. For example, a particular album may cost $110.00 for your lab to produce. Pricing it at $550.00 puts the COG at 20%; however, designing an album requires more of your time and also has a higher perceived value than an 8x10 print. Thus, you could potentially price the album at $650.00 to increase your profit margin. Some of the products in my studio run as low as 10% COG and others are at 20%.

If you want your COG at 20%, multiply the total amount it costs to produce a certain product and multiply it by 5 to get the price at which you should sell the product. For a 10% COG, multiply your cost by 10. For a 30% COG, multiply your cost by 3.3. The following example illustrates the sale price and profit margin of a product that costs $8.74 to produce at a 10, 20, and 30% COG:

$8.74 × 3.3 (30% COG) = $28.84 (Profit = $20.10)

$8.74 × 5 (20% COG) = $43.70 (Profit = $34.96)

$8.74 ×10 (10% COG) = $87.40 (Profit = $78.66)

How many sessions and how many 8x10s do you need to sell in a year to cover your fixed expenses? I have seen session fees range from free to $500.00. If the average session fee is $125.00 and you average 50 family portrait sessions per year, you will earn $6,250 in just session fees. Let's add four 8x10s to each session at 20% COG, which according to my numbers is $43.70 per print. Selling 200 8x10s a year will gross $8,740. The COG is $1,748, leaving you with $6,992. Add that to your session fees of $6,200 and your total is $13,192. That $13,000 now has to pay for taxes, your salary, an employee, insurance, equipment, advertising, overhead cost, the list goes on.

The point I am making is that you have to look at the bottom line and not just your lab costs. Consider what you would like your average sale per client to be. Is it $500 per session, $1,000 per session, or is it $2,000 per session? Once you have an idea of what kind of average sale you are looking for, you can price your products accordingly. The following is a sample pricelist of the goods you would need to sell if you would like your average sale to be around $1,000 per session:

1 16x20 wall portrait = $32.00 (cost to produce) × 10 (10% COG) = $320.00

1 8x8 press printed album = $110.00 (cost to produce) × 5 (20% COG) = $550.00

3 8x10 wall portraits = $26.22 (cost to produce) × 5 (20% COG) = $131.10

When you add a $125.00 session fee to this list, the total price of this session and products is $1,126.10. Your COG is $168.22 (15%), which gives you a profit of $957.88. This is a very basic example of how to think about your pricing and to know your numbers. By know your numbers I mean, know what you want your average sale to be, know what percentage of your price is the COG, know per sale how much it costs just produce the entire order.

Let's use the average sale in the previous example to plan out your year in business. At an average net of $957.88 per family session with 50 families per year, you will earn $47, 894 in net sales. That sounds like a decent amount of money but let's break it down further:

Overhead (rent, electric, phone, Internet) = $3,000 per month
(this will vary greatly depending on location)

Advertising/marketing = $1,200 per month

Insurance = $150 per month

Part-time employee = $700 per month

Education/conventions = $2,000 per year

Your salary = $2,000 per month ($24,000 per year)

Software equipment upgrades = $1,500 per year

Accountant = $1,500 per year

Health insurance = $3,600 per year

New samples/displays = $1,500 per year

Potential expenses per year = $78,300 per year

This list will be different for everyone, of course. If you work from a home-based studio your overhead will be lower; if you have health insurance from a spouse, you won't have that expense. There are always hidden costs to running a business as well. And don't forget about state sales taxes and income taxes!

Pricing for Profit

As a business owner, you need to know the cost of *everything* — because everything you spend on your business is a part of your pricing. You cannot simply base your pricing schedule on lab or album company invoices. You must factor in your time, the cost of running your business, and your COG.

Let's first talk about your time. Many newcomers to the industry grossly underestimate how much time they spend on their businesses and how much they are actually getting paid. Most photographers starting out do everything for the business from answering the phone to delivering the portraits.

Here is a list of just some of the jobs you are probably already doing:

❊ Business development

❊ Marketing/advertising

❊ Bookkeeping

❊ Answering the phone and e-mail

❊ Web development/blogging/social media (this alone can take hours)

❊ The actual photography sessions

- ❉ Post-production/editing/retouching/uploading

- ❉ Sales meetings

- ❉ Lab ordering and tracking

- ❉ Packaging

- ❉ Final product delivery

This list includes a lot of jobs you are probably not getting properly compensated for. I have done the math on the number of hours it takes to complete a client portrait session from first point of contact to final pick up and follow up. The average family portrait session takes 7 to 9 hours of work depending on whether I deliver the finished portraits and if I am designing an album.

If you have four portraits a week at 7 hours each, that is 28 hours just in client work. This does not include the time spent on all of the other aspects of your business. If you spend another 12 hours a week on marketing, business development, blogging, social media, bookkeeping, continuing education, and so on, that is easily a 40-hour workweek. So then, how much do you need to make per session to turn a profit?

Industry standards state that your COG should be at about 30% of your price schedule. I actually think it needs to be lower than that. For example, if you sell an 11x14 print for $100, your COG at 30% is $30. That $30 should include the cost of the actual print, mounting (if mounted), and packaging materials (for example, box, tissue, ribbon, shopping bag). Therefore, the $70 you may think is profit still needs to pay for your time/salary, your employee (if you have one), overhead, insurance, marketing/advertising, web hosting, an accountant (if you use one), office supplies, and any other cost associated with running your business.

When you start crunching the numbers, you may find that you need your COG to be at about 20% to 25% of your pricing. That is your decision. Just make sure you are crunching those numbers and you know you are in the black and not the red.

Selling Packages or A la Carte

What is the difference between selling a la carte and selling portrait packages? Packages are products that are grouped together and sold at a single price while products sold a la carte are sold individually.

In my studio I sell a la carte. Over the years it has come to make the most sense. I feel that with a package-based pricing menu, you limit the client to particular products and you inadvertently create a spending ceiling. With an a la carte menu

the clients choose exactly what they need. I have never had two families place exactly the same order.

I compare these pricing options to types of restaurants. The budget-friendly restaurants generally have "packages" or meal deals. Higher-end restaurants generally have a la carte menus. You choose your main entrée and then you choose your sides "a la carte." I take the higher-end approach, not the budget-friendly "meal deal" approach. Again, neither method of pricing is incorrect. The decision is based on how you want to run your business.

If you are targeting a high-end clientele, I recommend an a la carte pricing menu, as shown in Figure 7.7. On the other hand, if you want to focus on higher volume and lower prices, putting packages together is great way to sell your images.

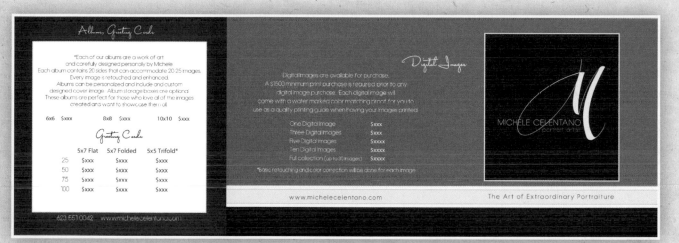

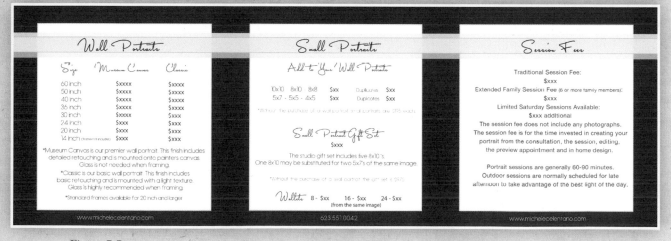

Figure 7.7

This is a sample a la carte product list I use in my studio. It is a trifold brochure that I put into the informational folder when new clients come in for a consultation.

Using a Portrait Agreement

A portrait agreement is similar to wedding photography contract. It protects both you and the client from misunderstandings and addresses your and the clients' expectations. I did not always have a portrait agreement, but after a few years and a couple of issues, I realized that I needed to spell out my policies in an agreement so that the client and I are always on the same page. A portrait agreement also protects you if an issue comes up and a client claims that you never informed him or her of your policies. You can just refer to the agreement.

The portrait agreement, such as the agreement I use shown in Figure 7.8, can spell out whatever you want it to. There are no hard and fast rules but I have a few recommendations for a successful agreement.

You will want to include some important key points in your agreement: the price of the session, your payment policy, your current pricing guarantee, your rescheduling policy, and your refund policy. Your time is valuable. Make sure your clients understand that. I also include an extended family group policy in my agreement. I charge more for groups larger than eight and require a minimum order for extended family sessions since there is a lot more work involved.

My policy regarding proofs and previewing the images is clearly spelled out so that there are no misunderstandings. I also request that all decision makers be present at the consultation meeting. It's very frustrating when after spending an hour and a half with Mom choosing portraits, she then says, "I will have to check with my husband first."

Be sure to also spell out your payment policy. I require a 50% deposit upon placing orders. Some photographers require full payment once the client places the order. There is no right or wrong on this policy as long as you are comfortable with the payment plan you set up. I also include a time frame for portrait orders. This again sets the expectation for the client.

Copyright and usage of the images is another important aspect of your agreement. If you choose to sell digital images, you still want to retain the right to use them for advertising, marketing, or sample images. I always include a copy of my policies regarding the sale of digital images and licensing with the final DVD of the images the client receives.

Once your client decides to schedule a portrait session, go ahead and explain the agreement and have the client sign it. Make a copy for the client to take home along with all of the other information you may provide. Having a portrait agreement gives you a bit more credibility as a professional.

The Art of Extraordinary Portraiture

Commissioned Portrait Agreement

Client Name: _____ Date of Session: _____ Session fee _____

I, _____ agree to commission Michele Celentano,
Portrait Artist, to provide photographic portrait services.

I understand and agree to the following terms.

The session fee is paid at the time your appointment is scheduled and guarantees your time with Michele Celentano.
The fee is payment for the time it takes to create the portrait, edit and prep your images for viewing and includes
one (1) preview appointment. Should a second appointment be needed to view the images a $125 preview
appointment fee will be charged. The session fee does not include any products or prints.
The session fee is non refundable. We require 72 hour notice for cancellations or rescheduling.
Appointments cancelled or rescheduled with less notice will forfeit the session fee.
Exceptions are made for sudden onset illness.

The session fee for extended family group portraits is $450.00, with a minimum portrait order of $1500.
Both the session fee and the minimum order requirement are paid at the time your session appointment is scheduled.
If your extended family reaches 12 or more the minimum order required is $3000.00.

All prints and print products are sold on an 'a la carte' basis and all printed prices are guaranteed for
30 days after the date of your portrait session.

All images from your session will be previewed in the studio by slide show projection.
All decisions regarding your portrait order will be made at the studio during your preview session or during your in
home design appointment. Anyone involved with making purchasing decisions should attend this meeting.

Due to the custom nature of your portrait order, a 50% deposit is due at the time your order is placed.
No part of any order will be delivered until the entire order is complete and paid for in full.

All purchased images will be archived indefinitely by the studio. Unordered images may no
longer be available after 60 days.

Every portrait is individually retouched by Michele Celentano and is custom printed by expert printers in the photographic
industry to ensure the highest quality. Prints, albums, frame orders, and any of our special custom products are finished
with great care and attention to detail. All print orders are estimated to be complete in 6 to 8 weeks.
Albums, handbags and jewelry can take an additional 2 to 4 weeks.

I understand that digital images are available with a minimum portrait purchase of $1500.00
and are subject to the Digital Image Guidelines.

I understand that the copyright of all images remains with Michele Celentano Portrait Artist.

I understand that by commissioning Michele Celentano Portrait Artist I authorize Michele Celentano and her
assignees, licensees, legal representatives, and transferees to use and publish any and all images from the session.
I waive all any and all rights to review or approve any use of the images, any written copy or finished product.
I agree not to make any claim against photographer and those acting under the permission of authority as a
result of the photographs including, without limitation, libel, and any other person and or property right.

Client Signature Date

Studio Representative Signature Date

4631 West Heyerdahl Court Phoenix AZ 85087 623.551.0042 www.michelecelentano.com

Figure 7.8
A sample portrait agreement.

Stay in Control of Your Business

My studio has always been proofless and clients are required to return to the studio to preview and choose their portraits. Prior to this policy being spelled out in a portrait agreement, I would occasionally receive a call from clients who demanded proofs because they did not have time to come into the studio.

One case in particular convinced me that I needed to put this policy into an agreement. I had photographed a large three-generational family portrait session with older parents and their grown children and grandchildren. In total I photographed five different family groups: the entire family and then each of the four grown children with their children. I also photographed the grandparents with the children and the grandparents with the grandchildren and basically every other family portrait combination you can think of.

Before the session I met with the mother and one of her daughters for the consultation and explained what they could expect and how they would view their images. We were all on the same page … or so I thought. After several attempts to make a preview appointment, the patriarch of the family called the studio and flat out demanded 5x7 proofs of every image, stating that because he ran a multimillion dollar business, he had no time to sit through my sales presentation. I'm pretty sure my head turned 360 degrees and I had fire coming out of my ears. I had offered the family evening appointments, weekend appointments, and even an in-home preview session, but the only thing this guy wanted was me to send him the proofs, and I refused. (It's important to stick to your policies because if one client finds out you bent the rules or policies for another client, you will be forced to do the same for each client who asks.)

I did inform the gentleman who requested the proofs that I had explained my policy to his wife when she met me for the consultation. He responded, "Well, I wasn't there and I would not have agreed to that." He then threatened that he would not buy any portraits. I said, "I'm very sorry you feel that way; you have beautiful portraits and it would be a shame to not have them. If I change my business policies for one client, I have to do it for all my clients and that is not how I run my business." We then hung up. Oh, and you can only imagine how angry I was. My staff heard a few choice words and I then asked my assistant to type a letter letting the clients know that if they were not interested in seeing or ordering any portraits, I would be deleting all of their digital images. About an hour later his wife called, apologized for her husband's behavior, and made an appointment to preview the images. The order she placed came to more than $4,000.

I know without a doubt that if I had allowed one client to bully me into changing my policies, I would regret it for a long time and who knows what else he would try to bully me about? I went to the client's home when the portraits were ready and gladly hung them on the wall for them. It was tough to ride that one out — my staff wanted me to bend and end the whole situation — but I knew better.

I was willing to lose the sale for the sake of holding true to the way I choose to run my business. I firmly believe that giving client proofs is the fastest way to kill any kind of large sale, which in turn would hurt my business over time. Sending clients home with proofs is also not the best way to truly serve your clients' needs. The moral of the story is to run your business; don't let clients run it for you. Not everyone will be the right client for you and that is okay.

Studio Management Software

Once you have your business in the beginning stages you may find that you need help keeping track of your client orders, your pricing schedule, your product lines, even your COG. Many great software products on the market today can help you manage these details, such as ShootQ (http://web.shootq.com), Simply Studio (www.simplystudio.com), and Pixifi (www.pixifi.com). For many years I have used SuccessWare studio management software (www.successware.net). It is software designed by photographers for photographers, and includes tools for everything from managing your schedule to managing your business's profit and loss. You can forecast profits, track sales and client orders, and create reports that show you which are your most profitable product lines. Figures 7.9 and 7.10 show examples of SuccessWare's schedule tool.

Figure 7.9

With SuccessWare's Scheduler, you can view a day, week, or month at a time.

Figure 7.10

Manage employee schedules and link all appointments to each client so you track each client and session.time.

Finding the Right Software for Your Studio

It is important that you find the right software to manage your business. Following are a few questions to ask when you are making that decision:

- Is the software user-friendly?

- Can you schedule different types of appointments?

- Can you create product lines, pricing, and invoices?

- Is it web-friendly or cloud-based so that you can use it anywhere?

- Does it have mobile device capabilities?

- Can you track profit and loss or get reports?

- How comprehensive is the client tracking system?

- How many users can you have on the system?

- How much are the monthly fees?

- Does it have e-mail marketing capabilities?

Summary

I hope this chapter has shed some light on how little running a photography business has to do with actually taking pictures. The portraits won't market or sell themselves. You may spend 75% of your time running your business and in postproduction and only 25% of your time doing what you love most: taking pictures. I don't want to discourage you from creating an amazing career in photography; I just want you to be successful at earning a living doing what you love and have all of the information you need to get started. Happy image branding, marketing, and number crunching!

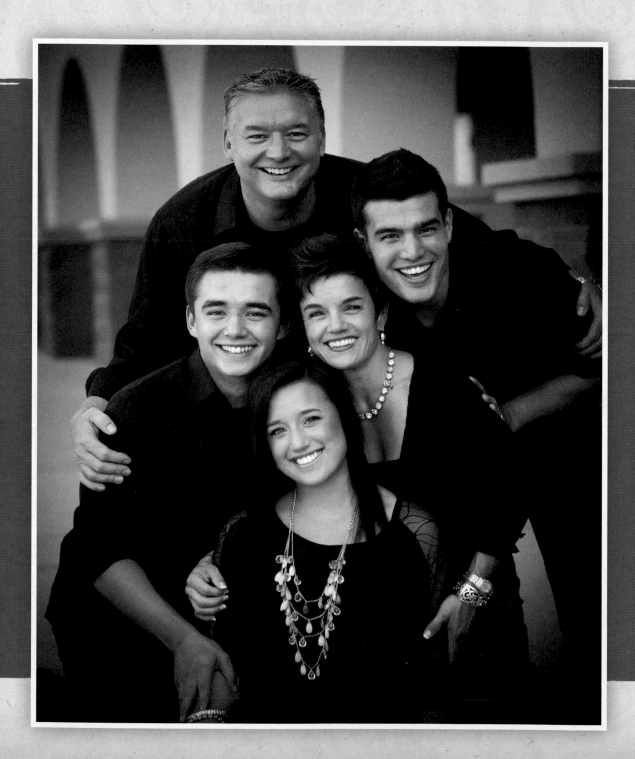

8 | Selling Your Portraits

Photographing families is the fun part of the portrait photography business, but for many people sales can be frightening. However, with the right instruction and the right tools, it can be extremely rewarding to make a good living doing what you love. In this chapter I will help you understand how anticipating and overcoming client objections early in the portrait sales process can make the final sale smooth. I also cover how to help indecisive clients though the decision-making process. If selling your portraits scares you to death, hang out in this chapter for a while — it's packed with easy techniques to make sales easier for both you and your clients.

Figure 8.1
Example of images before and after retouching can assist you in selling your services. Moms and even grandmas want to know that you are going to "fix" all of their flaws.

Conducting the Pre-Portrait Consultation

Without a doubt, a pre-portrait consultation may be the most important meeting you have with your client. This is the time when you showcase your work, plant the seed for large wall portrait and album sales, find out about your client's needs, manage expectations, and make clothing and location decisions. It could be your client's first impression of you if you have never met before.

Take plenty of notes about your meeting. Write down which sample images and locations your client prefers. This is the time to ask about the children if they are not there. If the children are at the meeting, depending on their ages I ask them questions as well. The more questions you ask, the better you will understand your client. I think it's more important for you to ask questions about your client than to just sell your services or talk about yourself. The images and your personality will sell themselves. Your job is to be interested in your clients, who in turn will become interested in you.

Know How to Handle Objections

Clients often have a lot of objections when it comes to having portraits taken. One of the biggest and most common objections I hear is from Mom, who often says, "I never like the way I look in pictures." The first question

Figure 8.2
This example illustrates how you can soften wrinkles, even out skin tones, brighten eyes, and remove dark circles.

I ask Mom is, "When was the last time you were photographed by a professional photographer?" Surprisingly, she often says it was her wedding. It's important to ask what exactly what she doesn't like about pictures of herself. It may be that she feels she is over-weight, or she doesn't like her wrinkles, or she never has a natural smile. These are three concerns I can immediately address by showing her examples of how images look before and after I've retouched them, such as the examples shown in Figures 8.1 and 8.2. I explain that I even out the skin tone, remove blemishes and dark circles, and soften lines on the face and neck. I then explain how proper lenses and camera height can take 10 pounds off right in the camera. Helping Mom to understand that proper posing, camera height, and the right lenses can work miracles on what she considers problem areas will make her feel more comfortable.

I also explain to my clients that digital images are incredibly sharp. Film grain is beautiful and when photographers used film, it hid many wrinkles and blemishes. However, digital and the 200-gazillion megapixels our cameras have today are very unforgiving to skin. I even have to soften the skin in baby portraits with a skin-softening filter. My standard joke is that with digital imaging, I can see wrinkles on my own face that I don't even have yet. Of course, I retouch and enhance my images to make the skin look more refined for all of my clients.

Another objection I often hear is, "You are too expensive." Yes, I may be priced higher than other photographers, but there is a reason. I guarantee all of my work; if the client isn't happy with the images I create from the session, I will refund 100% of the session fee. I believe you get what you pay for, and quality is not cheap. I also believe that the portraits clients purchase today are not for themselves but for their children and grandchildren. Portraits are an investment and gift you leave behind for your children, and they will have them long after you are gone.

Yes, I'm Italian: I play the death card. It may sound harsh, but it is the truth. I have spelled out these thoughts in my marketing materials. Let me refer back to the 99-year-old portrait I have of my great-grandparents. There is no price tag on that 8x10 image. Long after my great-grandparents and grandparents are gone, I am here showing my children a portrait of their history. That portrait from 1911 has outlasted the photographer and every person in the portrait. It's a fact that our portraits will outlast us, so let's make them worth passing down to the next generation.

Another thing I hear from moms constantly is, "I'm going to call you for our family portrait. I'm just waiting until I lose some weight." This is truly one of the silliest excuses I have ever heard. My response is, "I have never heard anyone say, 'I wish my mother would have lost some weight before having that portrait taken.'" Yes, moms often are stunned by my reply, but again, it's true. The flaws we see in ourselves, our children are blind to. They love you just the way you are, and if you keep waiting to lose weight, you may never have a family portrait taken. You will never regret having a family portrait taken, but someday you will regret not having one. Then I add that I can take 10 pounds and 10 years off, so there's nothing to worry about!

Show What You Want to Sell

Most clients think an 11x14 portrait is gigantic, when in reality it's pretty small for a wall portrait. Clients generally have no idea how large of a portrait they will need to fill wall space. A key sales tool is to show large wall portraits in your studio or home so the client can visualize what those sizes may look like on their walls. Usually, a client will buy one size down from your largest display. So go ahead and display a 30x40 portrait. The next size down is a 30x30 or 24x30 and again, that sounds like a huge portrait to a client, but it is a great size for a medium-sized wall in a home. If your clients can't imagine it in their own homes, they won't buy it.

Figure 8.3
In this portrait display, the entire family is centered in the middle as a slightly larger print surrounded by different combinations of the family.

If you want to sell albums, show examples of different types of albums in your studio. Also, take a quick picture of a wall display you have created in a client's home; this is a great way to show different options that clients may relate to. It gives clients an idea of how their homes might look with a similar size print or multiple prints.

Wall collages are yet another great way to display different combinations of family portraits. The image shown in Figure 8.3 is a quick shot I took with my phone after hanging a nine-piece gallery block display for the client. This family had a huge niche in the main hallway of their home. They knew they wanted to use the space for portraits, but had no idea how to design something that would work. Spending a little time doing an in-home design session helped me to see the niche was the perfect space for a gallery block collection.

Selling Large Wall Portraits

There's a secret to selling large wall portraits!

❊ Show examples of large portraits in your studio or home.

❊ Project your client's session on a large screen or large television. Clients will have a hard time imagining how a large portrait will look if you are showing them small proofs or selling your images online.

❊ Do in-home design sessions. I promise it is worth the effort, not only as a benefit to your clients but also to your bottom line.

Create Effective Slide Shows

Slide shows are a wonderful way to showcase your work and to get your client emotionally involved. During the initial pre-portrait consultation, my clients view a slide show of my work that is set to music. You can tailor your slide show to the type of session your client is coming in for. Obliviously you wouldn't show a potential wedding client a slide show of infants or show a young family a series of generational portraits, so create several slide shows based on the session type. You can create slide shows for families with young children, grown children, extended families, and generational portraits. You want your clients to identify with the images and see themselves having something similar.

Ask the Right Questions

The more you know about your clients, the better your chances of creating a portrait they will really love. I always start my pre-portrait consultations with this question: "What do you have in mind for your family portrait?" Jot down the things Mom says. Many times she will let you know her concerns about her children or her husband. The comments are usually along the lines of "My three-year-old is impossible." Or better yet, "My six-year-old is a natural model and loves the camera." That right there is my clue to the problem child. It's always the one Mom says will be a delight to work with — I'm not kidding, it never fails. Mom's supermodel child is usually my nightmare.

Okay, back to the questions you should be asking and taking notes on. Following are a few of the questions I ask during a pre-portrait consultation so that I know my client better and my client's expectations:

❊ Where in your home or office do you plan on displaying your portrait? Is it a formal room or a casual room?

❊ What type of setting/background do you like? A studio, an outdoor setting, or your home?

❊ How many children do you have? What are their names and ages?

❊ What type of sports or activities are the children involved in? (This gives me something to talk to the children about. For younger children, I will ask about favorite movies and games.)

❊ Will some of these portraits be used for gifts?

Presenting the Images

My favorite appointment with a client is the one where I present the images from the portrait session. I love seeing the client's reaction. So many times the portrait session can feel like complete chaos to the client, especially a client with very young children who don't always cooperate. So when Mom and Dad get to see that there are actually a lot of beautiful images, they are thrilled.

Projection Slide Shows

I have always used a projection method of presenting images and I have found that using projection increases my sales. You can use a projector and slide screen if you have the room. Alternatively, a large screen television will work. I have used both with equal sales results.

In the same way I presented the clients with a slide show of my work during our first meeting, I present them now with a slide show of their own images set to music. There is no decision-making during the slide show, but I do take note of which images the clients comment on, whether the comments are positive or negative. This way, when we are editing down the images to their favorites, I already have an idea of which images we won't be using. After the initial slide show, I then go back and show each image individually to the client and ask for a rating of "love," "not sure," or "don't like" and place the images accordingly into the categories. Once we are done, I have the favorites narrowed down.

Music for Slide Shows

Music is an important part of the initial slide show. It helps set the mood and bring another emotional level to the pre-portrait consultation as well as when I present my final images to the client after our portrait session. Be aware that using popular copyrighted music is illegal. However, you can buy amazing options for great music to use in your slide shows. Quite a few companies sell fantastic music. My personal favorite is Triple Scoop Music (http://triplescoopmusic.com). I have been buying and using their music for years.

Less Is More

When presenting images to clients, less is more. Too many images can kill your sale because the client becomes overwhelmed with choices and then ultimately can't make any decisions. I suggest you edit the session down to only the very best images. When I first started photographing families, I was showing 70 or more images, and clients left without placing an order because there were just too many to choose from.

Now I show between 35 and 45 images based on the size of the group I am photographing. Keeping the number of images down helps the client decide faster and keeps them from getting overwhelmed — even with 30 or so images, clients still often say, "How am I ever going to choose? There are so many good ones." In the case of large family portraits with multiple families the number of images will be higher.

My goal is to have clients choose 20 to 25 favorite images. With about 25 images, I can make an album with all of the favorites as well as help them choose one or more portraits to display on a wall in their homes. Because of the different family combinations I photograph, an album is the perfect complement to a framed wall portrait.

Presentation Software

The options for creating a slide show presentation for your clients are plentiful. Adobe Bridge (www.adobe.com) has slide show abilities and a way to mark or star your favorites. Adobe Lightroom also has many features that enable you to present your images to clients. iPhoto (www.apple.com) and ProShow (www.photodex.com) are additional options.

There are many advantages of conducting a face-to-face sales presentation with your clients using a good presentation sales tool. In my experience online sales are never as good as in-person sales. In most cases it is difficult for clients to envision how their portraits will look as large wall portraits. By using a projection system the client is able to see what the portraits look like in a large size. Projection is also a great way to see fine details that may be missed in small printed proofs or on a home computer monitor if you are doing online sales.

Helping to guide your clients when making decisions about their portraits is also a way of providing good customer service. Honestly, most people don't know all the design options for displaying portraits in their home. This is where a great sales presentation tool can help.

I use ProSelect presentation and sales software by Time Exposure (www.timeexposure. com) to create the slide shows I present to clients as well as a sales tool. The capabilities of this software are enough to fill a book on its own. Figures 8.4–8.8 illustrate examples of how I use ProSelect to sell to my clients without proofs.

Figure 8.4
This view of ProSelect shows the images the clients narrowed down as their favorites. They have 25 favorite images indicated by the happy face in the upper-left corner of the screen.

Figure 8.5
This view shows each individual image by itself. You can zoom into the image to view facial details as well. This is a great tool for helping Mom see small details in the image or for being able to see small faces within larger groups.

Figure 8.6
Clients often ask about black-and-white images. In ProSelect I can easily show the original color, black-and-white, or sepia-toned options. Sepia is shown here.

Figure 8.7
Comparing images side by side is easy to do with ProSelect and is often important when clients are choosing between two favorite images for a single wall portrait.

Figure 8.8
How many times have I heard, "Can you zoom in on the face a little more?" I can show the client exactly what the crop will look like with ProSelect.

Managing Indecisive Clients

Let's face it, some people are great decision makers and others are not. The easy clients are the ones who measured their wall, know exactly what they want, and make decisions easily. The tougher clients are the ones who have no idea what they want, where they are going to put a portrait, love every image, can't chose a favorite, and basically needs hand-holding every step of the way. Sometimes I have clients who need help figuring out which images of themselves they look best in. I find that some clients feel better when I tell them how great they look in their portraits or why I would chose one over the other. These types of clients are willing to spend the money for portraits; they just need help making decisions and usually want the expert to decide for them. (That's you!)

You can identify these personality traits during the initial pre-portrait consultation when discussing a location and clothing. If your client continually asks what you think, there is a good chance the sales meeting will go the same way; and it's your job to help guide these indecisive clients and provide them with an exceptional experience.

In-Home Consultation

This is where you take on the multiple roles of photographer/sales person/interior designer. I can detect instantly when I am sitting with a client who needs me to hold her hand through the process of choosing a portrait and the correct size for her home. The comments I usually hear from this type of client are, "Oh, I don't know, I love them all. What do you think?"

When I hear "What do you think?" it's time for an in-home consultation. It is so much easier for the client and for me when I visit the client's home, measure her walls, and suggest where I think the portraits should go. In general, it solves an argument between Mom and Dad, who have different ideas of where the portraits should be displayed.

You will need to bring a few things with you when you do an in-home portrait design consultation:

- ❊ *A laptop or a tablet with the client's favorite images.* I prefer using my iPad for this because it is easy to hold up on a wall and show the image that may be displayed there. It is a helpful visual for the client even though the image is small on the tablet.

- ❊ *Frame samples that work with different decors.* Again, holding up a frame sample on the wall starts to give the client an idea of how the final product can look.

- ❊ *Tape measure.* A tape measure is necessary for measuring the wall and to show the approximate size of the portrait or portraits that will go there.

✳**Calculator.** You should be able to price out what the clients are ordering and let them know the total before leaving their home. You may consider mobile credit card processing such as Square for the iPhone or iPad or check with your current credit card merchant to see if they have a mobile option. By using your already existing merchant account there is no need to open a second account. If you plan on doing in-home design consultations on a regular basis it is much easier to take a deposit on the spot as opposed to waiting until you return to the studio and taking it over the phone. Checks and cash always work, too!

✳**Sample prints.** If your vehicle is large enough, you may want to bring sample prints of various sizes to hold up against the wall; this gives a client an even better idea of the sizes that are appropriate for a particular wall space. The idea is not to sell the largest most expensive print you have on your pricing menu, but to demonstrate the appropriate size for a given wall. As I said earlier, most clients have no idea what size they want or need and believe an 11x14 is a huge portrait when the reality is an 11x14 alone on most walls would become lost.

Selling Online

Online sales can be a great tool in many ways, but I do not recommend it for family portrait sales. First, you do not know the quality of the monitor your client is viewing the images on or if the monitor is color or density correct. Do you really want your client to see a poor representation of your images on an old, off-color computer screen?

Second, you have no control over what your client sees and who is seeing it with them. If the client is not a good decision-maker, every neighbor, friend, and family member can influence her thoughts on the images. Talk about confusion. She may love one image but her best friend or mother may like a different one and now she doesn't know what to do. Good luck getting a decent order from that session.

Another problem I find with online sales it that it removes the personal touch from your business. It is important to maintain that personal relationship with your clients and selling online does not allow you to do that. Remember the 80/20 rule discussed in the introduction to this book? Maintain a relationship with your clients; be the expert who helps guide them in choosing the right portraits for their homes.

I view selling online the same way I view giving out proofs: it's a big fat no-no! If you have any chance of controlling your sales and your business, do not sell your family portraits online.

Figure 8.9
Remember to include your logo on the images you post to social media sites. I add my logo to all images I post to my company blog.

Using Social Media

Using social media to help you sell your portraits has its positives and negatives. It can be a great way to keep your name in front of your clients and their friends and family if you do it properly. However, the overuse of images on social media can diminish the value of your work. Images are everywhere — people post pictures of everything from breakfast

to bugs on their car windows. How special is the portrait if it is now being used as an online cover image? In part, technology has made imaging disposable to a degree, which is why I advocate making prints and albums. Prints and albums are tangible, they are special, and you can't just scroll through them quickly on a screen.

That said, social media, when used sparingly, is still a great way to keep your name out there and for happy clients to spread the word about you and your business. You can use social media to communicate your point of view and personality, and get your images in front of potential clients. Make sure you add your logo to every image you post on the Internet, though. The last thing you want is a client copying your photos from an online source and printing them on their home printers. Figure 8.9 is a screenshot of my blog with my logo clearly placed on the image.

If you choose to post images through social media, do it after your client has met with you and has placed an order. Some photographers I know charge for social media postings and some post the entire session for free. Personally, I like to post one or two of my personal favorites as a way for clients to share their excitement about the portraits and help spread my name to family and friends. In my mind it's a happy medium.

Summary

Selling is a huge part of running a portrait photography business. It is not as simple as taking good photographs and your client buying every image just because they love them all. You need to offer buying options and different product lines, design ideas, and incentives to purchase. Honestly, taking the pictures is the easiest part of the process. If you are not good at sales and helping people make decisions, you may want to consider hiring a sales person to handle these aspects of the business for you. Selling your images can be scary, but if you are prepared from the beginning by having a pre-portrait consultation, getting to know your clients needs, and understanding that the sales meeting is an extension of customer service you will be on the right track.

Show what you want to sell — if you show only 8x10s you will sell a lot of them. If you show large wall portraits, gallery displays, albums, and framing options you will sell those. Using presentation/sales software is helpful when working with your clients, and don't be afraid to offer in-home design consultations. In-home consultations are the best way to help indecisive clients, and it is the ultimate in customer service. Have fun creating beautiful portraits and don't be afraid to sell them.

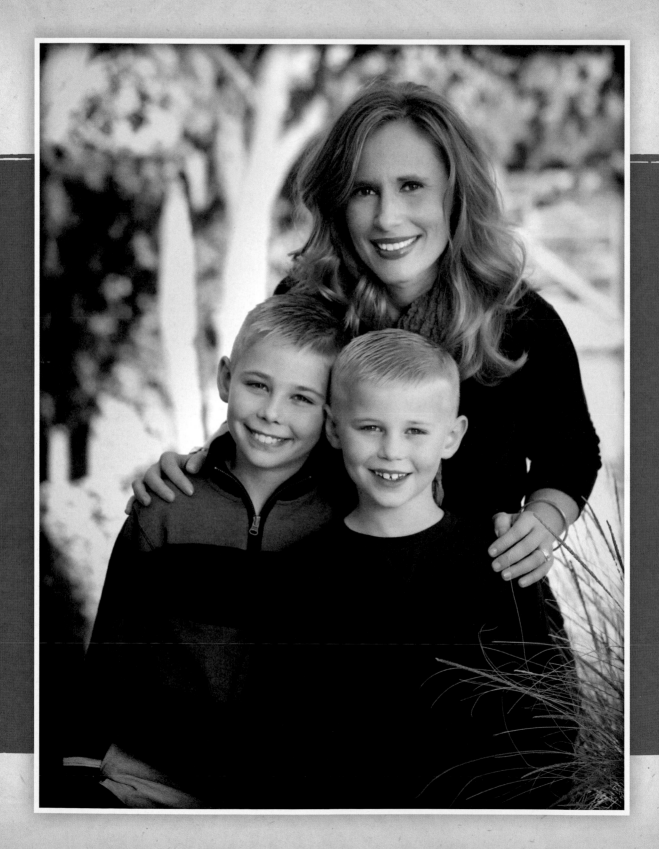

9 | Postproduction

Postproduction. It can inspire a love-hate relationship with your computer. If you are a computer geek who loves to create digital art, and do not mind spending loads of time behind the computer, postproduction might be for you. If, on the other hand, you are a single photographer running a portrait business and think of time as money, the last thing you want to do is spend unnecessary time in front of the computer.

Most new photographers greatly underestimate the time they spend in front of the computer editing, adjusting, and retouching images. I have witnessed several new photographers give up their businesses because they did not like postproduction work or they had no idea how much time it entailed. Many photographers today either run a home-based business, or have a part-time studio assistant. Photographers with small boutique studios need ways to make their workflows fast and efficient. The best way to speed up postproduction work is to set your shot up correctly in the camera, as I discuss in Chapter 3. It is common for inexperienced photographers to use postproduction as a way to "fix" problems with exposure, white balance, and cropping instead of using it as a tool to enhance well-exposed photographs. (Part of my passion for "getting it right in the camera" comes from the fact that I am not a huge fan of postproduction work.)

In this chapter I discuss postproduction as a basic workflow and not as a creative art. My discussion is directed toward the small-studio photographer who does it all — marketing, shooting, selling, accounting, and everything else involved with running a photography business — and who wants to know the basics of a postproduction workflow. This chapter is also for the hobbyist photographer who may not be running a business, but loves taking pictures of family and friends and does not like sitting behind a computer adjusting or enhancing those images for hours at a time.

Essential Postproduction Software

The list of postproduction software, plug-ins, actions, presets, and enhancement tools available is endless and can be overwhelming. There are hundreds of photographers who sell actions and presets as well as companies that offer retouching tools, templates, overlays, textures, and backgrounds. It is easy to make yourself crazy navigating the options and to fill up hard drive space with all that is available for postproduction.

Following is a list of what I consider to be essential software for postproduction work on family portraits:

- ❊ Adobe Photoshop (www.adobe.com/products/photoshop.html)

- ❊ Adobe Lightroom (www.adobe.com/products/photoshop-lightroom.html)

- ❊ Imagenomic Portraiture (http://imagenomic.com)

- ❊ Ron Nichols Retouching Palette (www.ronnichols.com)

The options for these products are virtually endless. You could spend days and weeks looking at cornucopia of actions and presets and spend a small fortune buying them. The tools I use most in my everyday postproduction workflow include Bridge, Lightroom, and Photoshop from Adobe; Ron Nichols Studio Retouching Palette; Imagenomic Portraiture; and Kubota Image

What Are Actions and Presets?

Actions are Photoshop's way of applying many changes to a photograph in one easy click. It is like creating a recipe for a certain "look" you want to create with your images. You create the recipe and save it as an action so that you can use it again and again. *Presets* are Lightroom's way of saving recipes and using one click to create the same look over and over again in different images. You can create your own actions and presets or you can purchase them from many different sources.

Tools and SpeedKeys (http://kubotaimagetools.com). I also use Fundy Album Builder (www.fundysoftware.com) and Photoshop templates from Graphic Authority (www.graphicauthority.com) on a regular basis for designing albums, creating greeting cards, and adding textures and backgrounds.

Calibrating Your Monitor

One of the easiest ways to ruin a photograph in postproduction is to work on them when your computer monitor is not properly calibrated. Monitor colors and brightness vary greatly between monitors. Without proper calibration, the color you see on your monitor may not match the actual print, and if you make color corrections based on the color and brightness of an uncalibrated monitor, you may wind up with photographs that look entirely different from what you saw on your computer screen.

You can use several different calibration tools to calibrate your monitor. The two industry leading calibrations tools are i1Display Pro by X-Rite (www.xrite.com/home.aspx) and Spyder4 by Datacolor (http://spyder.datacolor.com). Regardless of the calibration system you chose, setting it up and calibrating your monitor is fairly easy. Both makers have an auto calibration setting as well as advanced calibrations.

Postproduction Workflow

There is no wrong or right way to approach your postproduction workflow. Nearly every photographer has a different way to organize, edit, and retouch her photos. The key is to find the best, and fastest, workflow for your particular approach. Following is a walkthrough of the postproduction workflow I follow.

Organize Your Images

You have photographed a great session and you have a ton of images — now what? Organizing your images can be a nightmare, but staying organized is important and can be quite easy. I use Adobe Bridge to download my images and organize client folders. You can also use Lightroom or Apple Aperture (www.apple.com/aperture) to catalog and organize images.

Here's how to create a folder structure to keep your images organized:

1. Create a folder on the hard drive on which you will be storing your images. (You may have mirrored hard drives so that you are automatically backing up to a second hard drive.)

2. Name the folder (for example, Portrait Clients 2013, Wedding Clients 2013).

3. Within the main folder, create alphabetical folders, as shown in Figure 9.1.

4. Label each client subfolder Last name, First name and place the folders into the appropriate alphabetical folder, as shown in Figure 9.2.

5. Within each client subfolder, create a folder for the original images and a folder for the edited images, as shown in Figure 9.3. Make sure the folder name includes the client's last name.

6. Using Adobe Bridge Downloader, download the session to the original images folder.

If you want to rename all of the files from a particular photo session, it is easy to batch rename the images in Bridge. Simply select Batch

Figure 9.1
Within the main folder "Portrait Clients" I created alphabetical folders.

Figure 9.2
Within each alphabetical folder create a client folder.

Figure 9.3

Within the client folder create a folder for the original images and a folder for the edited images. Be sure to include the client's name in the folder title.

Rename from the Tools menu. The Batch Rename dialog box appears, as shown in Figure 9.4, with options you can use to adjust the filenames. I like to keep the original file number the camera created as part of my image filenames. The part of the filename I adjust is adding the client name and year. I use the client's last name and current year. I like to do this because if I need to search the computer for an image, I can simply type in the client's last name and the year the portrait was created and I will find the entire session.

Select Your Favorite Images

After I download and organize the images from a client session, I edit my favorite images by giving each one I know I want to keep five stars. In Bridge I simply type the number 5 and that image gets a 5-star rating. Once I have done this, I select all the 5-star images and move them to the Last Name-Edited folder. At this point I have a folder with my favorite images and a folder with everything else from the session. This process should not take more than 30 to 45 minutes. It may take longer when you first get started, but with practice the workflow will get faster.

Figure 9.4

The batch rename dialog box in Adobe Bridge.

Figure 9.5

This is the library window in Lightroom after I imported the edited folder of images from a session.

Prep Your Images

Now it's time for pre-retouching, converting the files from RAW to JPEG, and exporting. For this step, I use Adobe Lightroom. Other programs available are Apple Aperture and Capture One Pro from Phase One (www.phaseone.com). Each of these programs will manage photo catalogs and allow you to make adjustments to your images and enhance them. Each program has its own unique capabilities for importing, organizing, selecting, sharing, printing, and exporting images.

From the Library window in Lightroom, you can import the edited folder of the session you are working on, as shown in Figure 9.5. Importing only the best images makes my work in Lightroom go a bit faster.

You can make any necessary adjustments to exposure or color in the Lightroom Develop window, shown in Figure 9.6. I may bump the contrast of an image or change it to black and white. I almost always add a vignette to my images because I like the way a slightly darker edge looks on my images. In Lightroom, you can sync, or "batch process," all of your images using just a few keystrokes; this way you do not have to spend time enhancing each image individually. You can also use the crop tool in the Develop window. If you like to print or sell 8x10 format images, you may want to crop your images from a 4x6 to an 8x10 format at this time. I think it makes it easier for clients to see this crop when you are selling 16x20, 20x24, or 24x30 prints.

Figure 9.6
The Develop window in Adobe Lightroom.

Add Presets and Actions

Lightroom has presets built in that you can use to enhance your images, and there are literally millions of presets available for purchase that you can load into Lightroom. It's easy to get addicted to buying presets (and actions for Photoshop) and it can also get very expensive. Another issue with having too many presets or actions is that you may easily forget what you have or you spend a lot of wasted time previewing different actions with your images. This is a real time killer. I suggest finding a few actions that you really like and that enhance your images without distorting them.

I know it's fun to sit at the computer and "play" with images; however, time is money when you are running a business and playing with actions will not increase your bottom line. Another trap I see photographers fall into with actions or presets is using them to fix or cover up badly exposed images. Again, if you get it right in the camera, there is no need to spend time or money fixing mistakes.

My favorite workflow presets and actions are on my Kubota SpeedKeys, which can be used in both Adobe Lightroom and Photoshop. SpeedKeys is a small keypad that allows you to use presets with just a keystroke, which is a great way to speed up your workflow.

In Lightroom, the action presets appear on the left side of the Develop window. A preview of the preset appears at the top of the panel above the presets, and gives you a quick view of the action or preset; or you can split your screen with a before and after image for better viewing. Figures 9.7, 9.8, and 9.9 illustrate three examples of an image treated with three different presets. Figures 9.10 and 9.11 demonstrate side-by-side comparisons of different image treatments.

Figure 9.7
This image is enhanced with Kubota's Lightroom preset Default Auto Tone, which gives the image a bit more "punch," or contrast.

Figure 9.8
This image is enhanced with Kubota's 60s Film Lightroom preset from the Workflow Collection.

Figure 9.9

This image is enhanced with Kubota's BW Old Grainy Film Lightroom preset from the KIT Vintage Delish collection.

Figure 9.10

The original image is on the left. The image enhanced with Kubota's BW Ethereal Lightroom preset from the KIT Vintage Delish collection is on the right.

Figure 9.11
The original image is on the left. The image treated with Kubota's Vitamin K Lightroom preset is on the right. This preset added contrast, warmth, and a little softness to the image.

Export Your Images

Once you have completed any enhancements or adjustments by using actions or presets, the next step in your postproduction workflow is to export the images from Lightroom. Imagenomic Portraiture, a plug-in specifically for Lightroom, makes it easy to batch process all of your images, export them to a new folder, and convert them to high-resolution JPEG images you can present to the client and send to your lab for printing.

To export your images, click the Export button in the Library window in Lightroom. A window with export options will appear and you can choose among them based on your preferences. In the example shown in Figure 9.12, I selected the option to export to Imagenomic Portraiture. For the Export Location, I chose a subfolder named Portraiture Export-Kuchta. It is within this window that you will choose the type of file to output. If you shot your session in the RAW file format you will want to convert your images to JPEG for showing to your clients.

Add Skin Softness

Once you make your export choices, Lightroom processes the images and then because I chose to export my images to Imagenomic Portraiture, a new window appears for the

Figure 9.12
The Export window in Adobe Lightroom. This window allows you to decide how you want your images exported (file type) and where you want them to go.

Portraiture plug-in. There are a lot of options available in the Portraiture plug-in skin softening filter, as shown in Figure 9.13. The software contains a few presets for smoothing skin, such as Default, Smoothing Normal, Smoothing Medium, Smoothing High, and Enhance Glamour. It's up to you how much softening you want to add to the skin. The nice thing about this particular skin-softening filter is that it only affects skin tone and does not make the eyes look out of focus. In addition, you can use the Portraiture plug-in to make your own presets with the amount of softening you want for your portraits. It is completely customizable. Once you click okay, Portraiture will apply the softening filter to all of the images and then export to the client folder you designated.

At this point in my workflow, I choose one or two of my personal favorite family images and fully retouch them. I like to be able to show the client my favorite portrait "all dressed up" (retouched). It gives Mom the opportunity to see what she will look like retouched. In most cases, the image I choose to retouch is the one the family will purchase. I am now ready to show my client the images. (Refer to Chapter 8 for tips on how to present your images to your clients.)

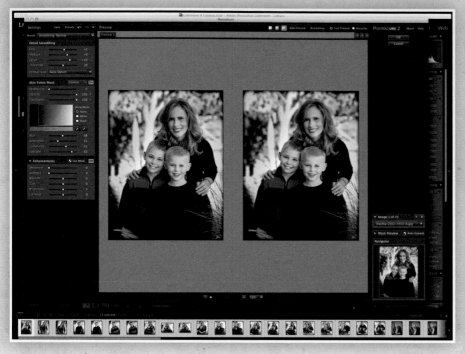

Figure 9.13
The Options window for the Imagenomic Portraiture plug-in for Lightroom. Here you can chose from the presets within the software or customize the amount of skin softening.

Figure 9.14
The Ron Nichols Studio Retouching Palette is set up to create a retouching layer, crop the image, remove blemishes, brighten eyes, whiten teeth, and perform other creative retouching.

Retouching

Once the client has placed an order, I can work on the finishing touches for the ordered images. This is when I do the actual retouching of the portraits. When I refer to retouching, I'm taking about removing blemishes, softening dark circles, whitening teeth, enhancing eyes, and making any other changes I find necessary.

The most valuable tool I use to do retouching is the Ron Nichols Studio Retouching Palette. This palette, which works in Adobe Photoshop or Photoshop Elements, is designed for portrait retouching and workflow (Figure 9.14). It is a click-and-paint tool that allows me to retouch images quickly. The magic of this palette is that is has taken all the

guesswork out of Photoshop. There is no need to figure out which brush size, color, opacity, or tool you need to do the job you want. (You can adjust all of those things as desired but in most cases it is not necessary.)

Figures 9.15 and 9.16 show the before and after images of a sample portrait I retouched in Photoshop. Figures 9.17, 9.18, and 9.19 illustrate the process.

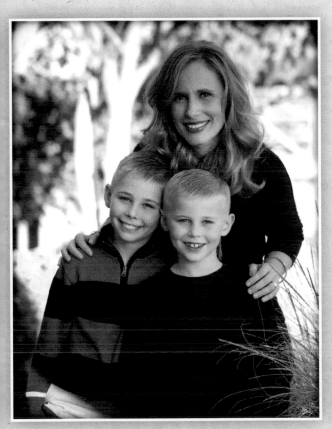

Figure 9.15
The image before retouching.

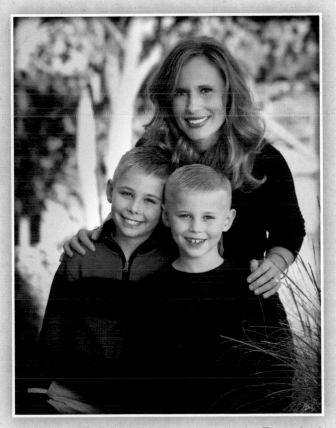

Figure 9.16
The image after retouching.

Figure 9.17

Here the image is in Photoshop. You can see the Layers palette and the Retouching palette on the right.

The differences between the before and after images are subtle. It's important to keep in mind that it is easy to go crazy retouching and go overboard. In most cases for portrait photography I believe in taking the "less is more" approach. Remove blemishes and simply soften lines, wrinkles, and dark circles — if you remove them completely, you change the way a person actually looks. Brightening eyes and whitening teeth are also subtle ways to improve a subject's appearance without changing their appearance completely. You can make someone look completely flawless; however, the portrait then won't look like the subject. Portraits are about bringing out the soul and spirit of your subject. It is also about portraying family relationships. I don't think it is about creating flawless, over-retouched images that at some point no longer truly look like the person in real life.

It is a personal preference on how much retouching you or your clients prefer and you can

Figure 9.18

In Photoshop I created a retouching layer and am using the Remove Blemishes and Eye Bags tool from the Ron Nichols Studio Retouching Palette.

Figure 9.19
I lightened up Mom's face a little bit, added a low-key vignette, and flattened the image.

discuss it with them. In some cases women will want to look like a magazine cover and be completely flawless and in other cases they want to look natural with a little "softening." Remember: there is a big difference between enhancing portraits and making your subject look like plastic.

Figures 9.20, 9.21, and 9.22 offer three examples of images with different levels of retouching. Figure 9.20 is the original image without any retouching. In Figure 9.21 I removed blemishes and lightened dark circles. I decided to leave Nick's hand where it was, on the right side of the image, because it didn't bother me and I liked that he has his arm around his sister. I did extensive retouching in the final image (Figure 9.22). I removed Nick's hand extending around his sister's back. I removed nearly every line, blemish, and dark circle I could find.

I also over-enhanced the eyes. The white area of the eye is different in every person. It is never completely bright white. Some people have a slightly yellow-white hue, or even veins, in the white of the eye. Over-whitening the eye is a common mistake I see in retouched images. I like to lighten the whites of the eye a little bit, but making them too white makes them look unnatural.

For women, a little extra retouching may not be a problem; however, over-retouching men is never a good thing. I have never had a mom tell me I over-retouched her but I have had dads say they didn't like the way they looked after being retouched. They often say that they look as though they are wearing make-up.

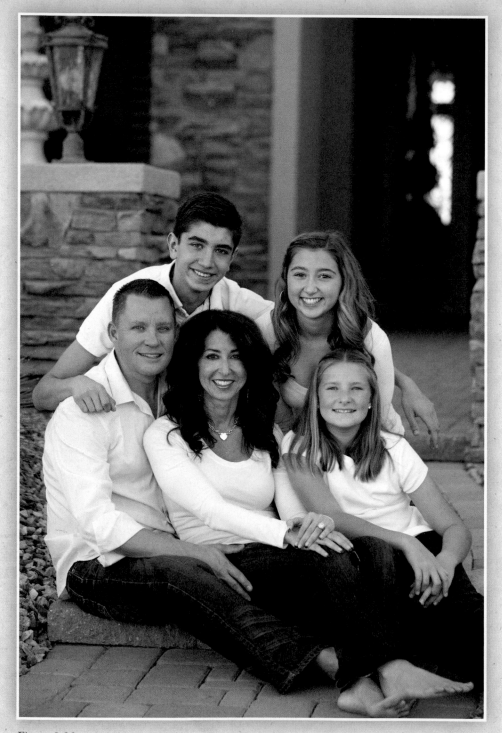

Figure 9.20
This image is straight out of the camera. No retouching or cropping has been done.

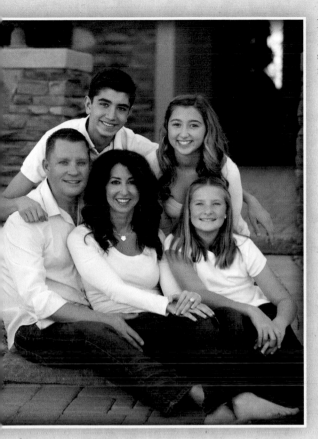

Figure 9.21
In this image I did some subtle, "natural" retouching.

Figure 9.22
This image is heavily retouched.

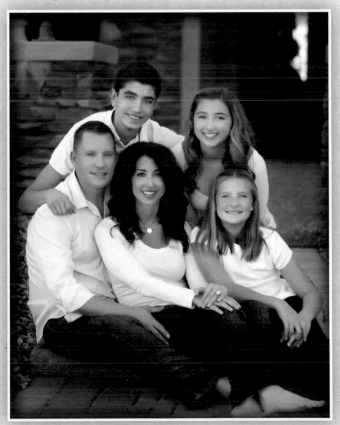

Figure 9.23
This image is right out of the camera. Nothing has been done to it.

Figure 9.24
Softening the skin and lighting some of the lines and dark circles softens the subject's face but does not take away from her character.

Over-retouching the elderly is tricky, too, as shown in Figures 9.23, 9.24, and 9.25. The changes in this portrait offer a great example of how over-retouching can take the character out of an already beautiful face.

Figure 9.25
I purposely over-
retouched this example
to show how over-
retouching makes a
subject look unrealistic
and artificial.

Designing Albums

Based on my style of photography and the different combinations of portraits I create, album sales are a no-brainer. It makes perfect sense to offer albums along with wall portraits because most clients do not want to put twenty family images on the wall. Often clients will order anywhere from one to five portraits for the wall, and then ask me, "What about the rest of our favorites?" Albums are perfect for this reason.

In the past, designing and creating albums was about as much fun for me as getting a root canal. However, a few years ago I came across software that changed my album workflow life: Album Builder by Fundy Software. Album Builder works within Adobe Bridge and Photoshop and automates much of the work that comes with designing an album (Figure 9.26). It also works with many popular album companies and labs for album sizing.

You can work from Bridge, using your client folder of images for the album. Click one or multiple images to be placed into the album design. You can either choose your own layout or have the software automatically design a page based on the images you highlight in Bridge. Once an image has been used in the album, it is flagged in Bridge so you don't make the mistake of using the same image twice (Figure 9.27). Figures 9.28 and 9.29 show the images dropped into Album Builder design templates. The template starts with eight square images. You can add different backgrounds, papers, or textures. I use many of the Graphic Authority templates,

Figure 9.26
Looking at the Album Builder window, you can get an idea of the functionality of the software.

which I can easily drop in or manipulate in Album Builder.

The possibilities for album design are truly endless. Prior to finding an effective workflow, it would literally take me hours to complete an album, and therefore, I did not like designing them. Since I didn't like designing them, well, I didn't sell that many. My album design process now takes anywhere from 20 to 60 minutes, depending on how large the album is and how creative with the design I am.

Whether you are creating albums to sell to clients or your own family albums, Fundy Album Builder makes it easy. The program allows you to maintain creative control while taking advantage of automation. With today's technology, not many people sit down and put photo albums together anymore. I remember, as a kid, my mom sitting down with those old-fashioned peel-and-stick albums, adding holiday and vacation pictures. I have all the albums, and I still love going through then and reminiscing about the past. I bet most of your own family pictures are loaded onto a hard drive, or maybe a digital frame, or might be used as your screen saver. Don't forget to make albums — you never know when a hard drive will fail, or if in ten years, you will even remember where your memories are stored.

I learned this lesson the hard way last year when I found out that two different back-up hard drives had failed. I was trying to pull images to make albums of my kids for their grandparents and sure enough, everything I was looking for was on two non-working hard drives. To say I was a wreck and broken-hearted is an understatement. Luckily, the images were recovered from the hard drives and I was able to make the albums. It was a few days before I knew I would get all the images back. I realized how many images I had stored on hard drives, but had never used in albums when the technician who recovered the images called to tell me that he recovered 214,000 files — all photographs. As I started to look through the folders, I realized that there were images there I had forgotten about.

Don't let your memories or your client's portraits sit in "virtual storage," where they may never be seen again. Make prints and albums that friends and family can appreciate, and your children will love flipping though someday. Just remember all those times you sat around with your family looking at old photos, making fun of bad outfits and old hairstyles.

Summary

This chapter is designed to give you the basics of getting your workflow started in an easy and manageable way. As you get started with workflow and postproduction you will figure out which software products work best for you. There is an endless learning curve with technology that is always changing and evolving. Newer versions of software are constantly emerging with added features and just about all of the product suggestions

Figure 9.27
Here Bridge is open in the background. The purple highlight under an image indicates that it has been used.

Figure 9.28
The software automatically resizes and places the images into the template.

Figure 9.29
The layers panel is open and each image, including the background, is a layer that can be altered from the Layers palette in Photoshop.

for software, actions, presets, and templates have tutorials and live training classes on their websites for easy learning. Many of them also offer 30-day trials so you can figure out what you are most comfortable using.

Many photographers today work on their own in a home-based business. A photographer with a small boutique studio needs ways to make his postproduction workflow faster and more efficient because more often than not, it is the photographer who does all of the postproduction work. While workflow for production should be streamlined in any business, sometimes you may want to have fun creating art with your images. Many of the tools listed in this chapter will give you the freedom to have fun and play with your images, too. That is a wonderful part about photography: creating beautiful memorable art with photographic images.

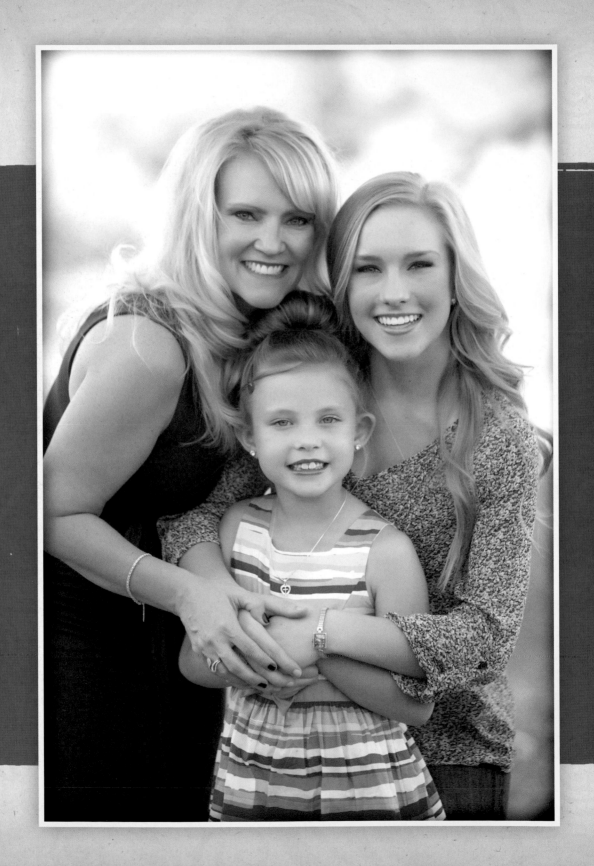

10 | All Wrapped Up

It's all about the details. You can deliver a diamond ring in a Cracker Jack box or a beautiful teal blue box tied in white ribbon. Same ring, but the perception is different based on the packaging. What do you want your presentation to say about you and the value of your work? It's the final detail —yet one of the most important to consider.

The way you present your work will leave a lasting impression. Does it look expensive or does it look cheap? Packaging is all about perceived value and the final impression. Have you ever purchased a pair of shoes that had an individual bag for each shoe, or a purse that came in a beautiful bag of its own? Those details raised the value of the purchase and so does the way you package and present your portraits.

Each print should stand alone as a valuable work of art from the finish of the print to the way it is presented on an archival mount board to the tissue paper, box, and ribbon tied around it. The portraits are a gift that should be wrapped perfectly to make the people receiving them feel like they are getting something truly wonderful. This chapter is about creating that feeling for your client.

Packaging Considerations

How you package and present your final images is an important consideration when you deliver finished orders to clients. Beautiful packaging adds value to what you do and to your business. Mounted and textured prints, certificates of authenticity, bow-tied boxes, and gift bags filled with colored tissue and a note tag are all ways you can present your work to clients. Everyone likes getting gifts and I always want my clients to feel as if they are opening a special gift when they receive their final images.

Marathon Press (www.marathonpress.com), a company I patronize often, provides beautiful packaging options for professional photographers. You can have custom packaging created for you or choose from their product line. Bags and Bows (www. bagsandbowsonline.com), HB Photo (www.h-bphoto.com), Paper Mart (www. papermart.com), and Rice Studio Supply (www.ricestudiosupply.com) are more great companies that offer customized packaging materials. Local craft stores are also a great place to find ribbons, bows, and gift tags to tie around boxes. Many of these companies can customize your gift bags and boxes with your logo.

The goal is to make your photography look and feel special to the client. We have come a long way from putting loose prints in cheap-looking folders and paper bags. Your portrait boxes, ribbon, shopping bags, and packaging accessories are part of your brand identity. Imagine going to Tiffany & Co. for a gift and leaving there with your diamond ring in a plain white box and a brown paper bag. The perceived value of the product increases dramatically when it is beautifully packaged in the signature Tiffany Blue box with a white ribbon.

If you are selling DVDs with digital images, you can still increase the value of the product with the packaging you choose. As shown in Figures 10.1, 10.2, and 10.3, a custom-printed DVD and case with information on how to handle reproducing images conveys to the client that the images contained on the DVD are valuable.

Digital Portrait Images

623-551-0042
michelecelentano.com

MICHELE CELENTANO
portrait artist

Figure 10.1
Custom printed DVDs look more professional than ones with a label. They are now affordable in small quantities or you can purchase a DVD printer.

Figure 10.2
The right side is the front of the case and the left is the back of the DVD case I give to my clients.

Digital Image Information and Recommendations

Your disk includes high resolution digital images, as well as a usage license to show to your lab when you print the images. The usage license gives you permission to:

*print the images as many times as you like
*share the images with friends and family
*upload the images to the web and/or your personal computer

Copyright of the images remains with Michele Celentano Portrait Artist. You are prohibited from any of the following:

*selling the images
*altering the images
*using the images for any advertising or competition
*redistributing the images, in any way, for profit

Please backup your digital files as soon as possible by copying them to a hard drive on your computer. For increased security in archiving, consider adding a second backup via a backup service like mozy.com, to ensure that you never lose any of your precious family photos.

When you print your images, remember that not all photo labs are alike. We recommend www.mpix.com as an excellent place for near professional print quality available to consumers.

Regardless of where you choose to print your images, remember that these files have already been color corrected, enhanced and/or retouched. To ensure the best possible print quality, be sure to clarify with your lab that these files do not require color correction.

Figure 10.3
I include information about the digital images inside the DVD case.

Most art pieces come with a certificate of authenticity — why not your photographs? I include the certificate of authenticity shown in Figure 10.4 with all of my photographs. Using this sticker on the back of every mounted print adds to its value. It has the image number printed on it in case the client would like to order another print and does not remember the number of this particular image. Or, if the print is damaged, it is easy for the client to find the image number so that I can replace it without any trouble. It also has my signature and copyright information.

Figure 10.4
I include a certificate of authenticity with all of my photographs.

Your packaging should match the rest of your image branding (Figures 10.5 and 10.6). Using the same colors, have bags, tags, and note cards printed with your logo. A cohesive look throughout your business is important to keeping your brand consistent in your clients' minds. Consistent branding is one of the reasons I prefer clean, classic logos and designs. Trendy colors and logos look great while they are in style but when they become outdated, and you suddenly update your branding, you will confuse your clients. Using Tiffany & Co. as an example again, imagine if Tiffany's changed its branding every couple of years to be trendy. Tiffany's signature blue box and logo are iconic and classic and recognized by almost everyone.

These custom designed portraits
have been created for

The Art of Extraordinary Portraiture

Figure 10.5
I tie this tag with a
ribbon to the bag's
handle. It identifies
the client order
also includes a
thank-you note.

The Art of Extraordinary Portraiture

www.michelecelentano.com 623.551.0042
4631 West Heyerdahl Crt. Phoenix AZ 85087

MICHELE CELENTANO
portrait artist

Figure 10.6
This is the front and back of the note card I use to send notes to clients.

In-Home Delivery

Delivering large portraits to a client's home is one of my favorite things to do. This service is complementary to clients who order more than one wall portrait. It's like seeing my babies in their adoptive homes. I also love to see how thrilled clients are when they see the finished work displayed on their walls. Delivering portraits is also a wonderful way to extend extraordinary customer service. It really is the final touch of the process.

It's rare to meet a dad who likes hanging portraits on the walls and so when I do it, Dad is usually very happy that he didn't have to deal with the measuring, hammering, and nailing. It is especially important to offer to hang the finished prints on the wall when customers order multiple prints to create a collage. Most clients don't know how to create a collage on the wall, or they worry they won't know how to hang all the prints so they are level.

Framing

Custom framing is a wonderful way to add to your sales and deliver completely finished portraits that are ready to be displayed in your client's home. I have always offered framing and at one point actually did my own framing in my studio. However, for my business it became a waste of time and resources to do framing in-house. Several years ago I partnered with a local framer who does all of my framing work for me. I carry samples of the frames that work with my style of photography and that tend to be classic and traditional. When I have prints that need to be framed, I either bring them to my framer or they will pick them up for me. Framing is one of those tasks that I am not properly set up for and takes time away from the work that actually adds to my bottom line. Check out local framers in your area and see if they are willing to work with you on a wholesale basis. It is a great way to add to sales without the added work.

Customer Service

Portrait photography is a people business. It is about creating relationships with your clients, your community, and the industry. Think back to the 80/20 rule discussed in the Introduction of this book. People want to work with people they like. When your clients love you, they love your work. That is how you can build a successful business — by positive word of mouth. It really is the least expensive marketing you can do.

This means more than just being a nice person and taking nice pictures. It means truly taking care of your clients. Returning calls and e-mail promptly, getting orders done on time or even early, and adding extra value to what you do is all part of being in business. Fixing any client issues right away instead of shying away from them is extremely important for excellent customer service. People understand

mistakes but they also expect them to be handled with urgency. Spending time to send hand-written notes and making follow-up phone calls goes a long way in establishing that you offer impeccable customer service.

As part of the customer service I offer (and it is something I enjoy doing), I give a holiday gift to my clients when they place an order around the holidays. When I first started to do this I simply gave my clients boxes of chocolate when they picked up their order. That was nice, but it wasn't very special. Now, I send gifts to my client's homes for the holidays. Gift baskets, cookies, wine, or chocolates are great ways to say "thank you" to your clients at the holidays. Having something delivered is far more special than just handing clients a box of candy with their order.

Treat your clients the way you like to be treated and remember that negative comments spread faster than positive comments — so work hard to make sure your clients have only the best compliments for your work and you.

Summary

Leave a positive lasting impression on your clients. The final step in creating timeless portraits is beautiful wrapping that makes your work look and feel like a special gift to your client. Packaging is also an extension of your branding and should reflect the overall look of your image. Gift giving is a way of showing how much you appreciate your clients, their business, and their referrals. Gifts can be seasonal or they can be given when your client orders are finished and you just want to say, "thank you." Taking the extra step to deliver your portraits and hang them on the wall for your client is the ultimate in customer service. Take pride and have fun presenting your clients with their finished orders. It is a wonderful feeling to know you did your best and that your clients love their portraits.

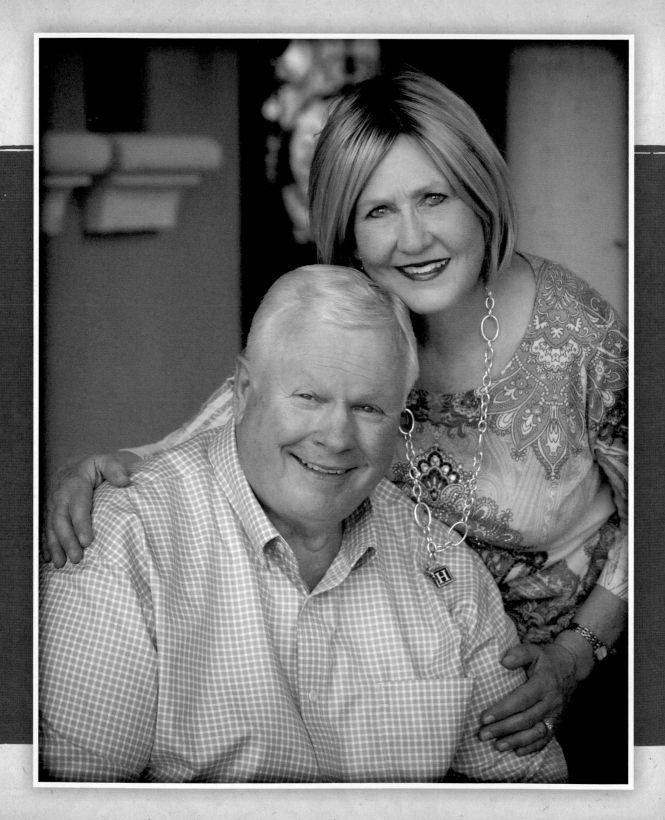

A | Four Generations of a Family

One of the most challenging portrait sessions I photograph is an extended family group. Extended families can include people who range in age from newborns to 95 years old (or older!). This is a challenge in every single way you can imagine. It is often hard for elderly subjects to move or pose, and young children often don't cooperate. Large families require a lot of extra time and both the young and old can lose patience quickly. These sessions require a game plan (that is of course, flexible). Speed, efficiency, and precision are critical. You can never afford to lose the confidence of your subjects.

I adored photographing Ann and Harvey's extended family. You could feel a closeness between all of the family members. It is such a joy for grandparents to have their children and grandchildren around, and it was obvious on the faces of Ann and Harvey. Anytime you have 17 children in one place there are bound to be a few problems, but I have to say the children in this family were some of the most well-behaved children I have ever met.

I will walk you through this family portrait session. It was unique in many ways. Harvey and Ann have a beautiful home set in the Superstition Mountains in Arizona. I wanted to use their home as the background, knowing it would be most comfortable for everyone and the easiest for the families to get to. It's helpful to have an area for those not being photographed to go and relax until it is their turn to be photographed.

I visited the home several weeks prior to the session to scout the location, looking for an area that would accommodate a group this large. Often the clients have a vision of where they would like the portrait taken, which is not always the best place. When I am looking at areas to use as backgrounds, I am looking for directional soft light, texture, and depth.

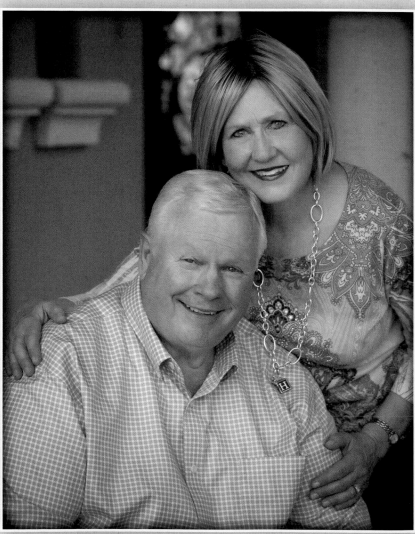

The views from the back patio of the home were beautiful; however, I did not think these views offered the most pleasing background for family portraits. The lighting in that area would be perfect at sunrise but not late in the day. Go ahead and try to get a family up before the crack of dawn for family portraits because the light is perfect at that time. Believe me, that won't happen (in most cases)!

The front of the home had a stunning portico area with beautiful covered shade, columns, an old cart filled with colorful flowers, great texture, and the perfect light in the late afternoon.

Ann and Harvey.

When photographing families I also like to keep the images consistent so that when I display multiple images or make an album, all the images work together.

I used an ottoman from the outdoor furniture as a posing stool. Again, when you are working with a group this large you need to be quick, so changing locations and props is not recommended because it will eat up a ton of time.

Ann and Harvey's family had 29 people in total. Whew! That's a big group. There were 17 grandchildren and one great-grandmother. It's important to me to photograph every combination of family members I can think of. I often start by photographing each child alone. This gives the child an opportunity to be in the spotlight for a moment and it gives me a chance to personally connect with him or her. Some children were excited to have their pictures taken and some were not.

In addition to the number of people in this portrait and their varying ages, I also had the added challenge of photographing a special needs child. It takes extra sensitivity to photograph special needs children one on one; it is even more challenging when incorporating them into a large group. In the end it's best to not upset them by asking them to do something that is outside their capabilities. In this case, I did not try to push Caleb at all; I just let him be himself and he did a great job.

For this one family, I shot more than 30 different group and individual portraits, wrapped up in one session of about 90 minutes. Think about it: that is one portrait every three minutes!

I included images from the entire session so that you can see the progression and all of the combinations I created. In the end, the entire group shot was the toughest. Trying to get 17 children to all smile at the camera at the same time is nearly impossible.

The Equipment

Camera: Canon EOS 5D Mark II

Lens: 70-200mm f/2.8 IS

ISO: 800

Reflector: 6-foot silver reflector

Metering Mode: Evaluative metering mode; center-weighted focus point

White Balancing: Custom white balance using ExpoDisc

The back patio had beautiful views, but the railing was distracting to me in addition to the fact that the light would not be in the right place at the right time.

I liked this view of the home, but I knew I would be limited to the images I could create here given the size of the group and the lighting pattern.

The side of the house had great columns, but the area was too closed in to provide any directional light.

The Background

These are the images I took of the property prior to the actual session. There were some interesting locations but not all of them had good lighting.

I knew this location would provide the covered shade with directional lighting I would need. I could use the columns, and the house in the background would add another layer of texture. I added a 6-foot silver freestanding reflector to kick in a fill light and to add a catch light to the eyes. When I came for the session Ann had planted beautiful flowers in the wooden cart, so I brought a piece of it in to each frame for color, texture, and depth.

The Children

I worked with the children first, asking them who would like to have his or her picture taken first. This gives me an idea of who the outgoing children are and who the shy children are.

The outgoing kids are usually comfortable in front of the camera, and the children who are on the shy side can stand back and watch. Within a few minutes, all the kids are jockeying to be next. Kids also like to be helpful, so I ask them to hold the reflector. This makes them feel like a part of the process and important.

One of the problems you might run into when photographing a group this large is the adults often stand behind you trying to help get the child's attention. Before you know it, that poor kid is looking all over the place and not at you.

Sometimes I turn around and make silly faces at the group and let them know I only need one person standing right next to me. Too many cooks in the kitchen can kill the meal — it's same with too many people trying to get the attention of one. It's very confusing. Most times just talking to my subject and having everyone else keep quite is the best thing to do. Very young children with separation anxiety need to see Mom or Dad to feel comfortable so I have one of them standing next me.

In this series of images I kept it consistent for these younger children. I loved the texture of the flowers and the perfect light this area offered. My 6-foot reflector was placed to the right of the camera to kick back a little fill light.

For the older children I wanted a similar but more grown-up look, so I changed my camera orientation and moved some of the subjects to left side of the frame to make their portraits a bit different than the younger children's portraits.

For these three children I changed it up again and had them stand. The first little boy wanted to play with the cart, so I just let him stand there and hang onto the handle. The second boy had such a cute personality that I want to show off his attitude by having him lean against the column. Again, these slight changes give each portrait its own personality while still keeping the theme and look cohesive.

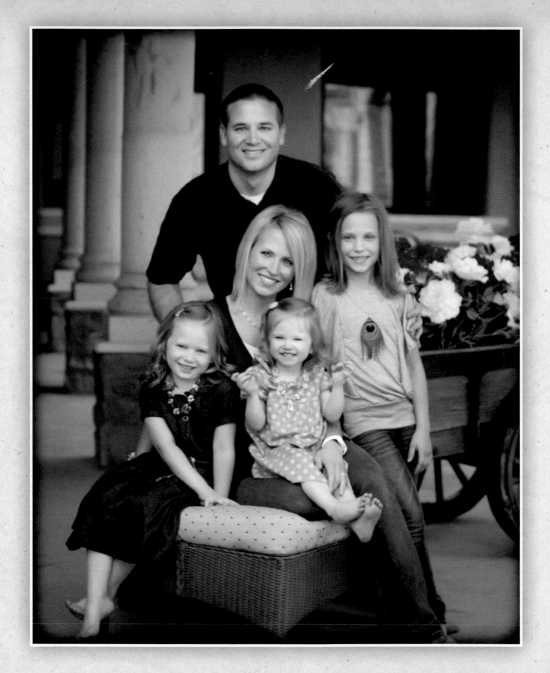

Family Groups

Once the children were comfortable with me and having fun, I moved onto the individual family groups. I still used the same location, mostly because of how beautiful the light was and to keep all of the images consistent.

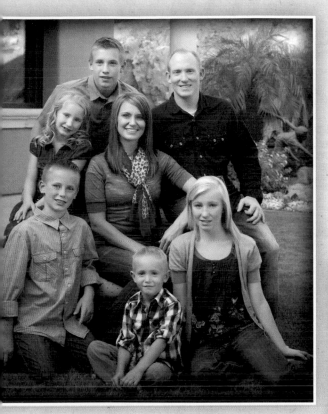

Using the ottoman for my posing seat again, I carefully stacked and placed the subjects where I thought they would work best. I usually have Mom sit in the center, and place her children around her, with the youngest or smallest child on her lap to hide her body. As you look at the groups in this series, you can see that the subject's heads appear at different heights for visual interest.

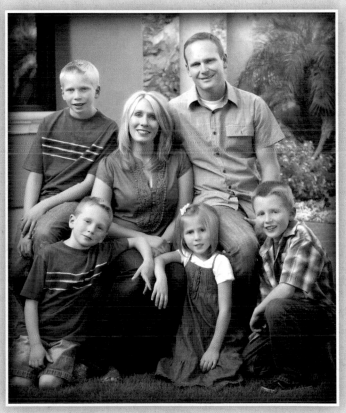

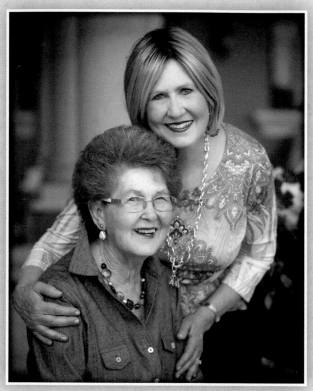

I made sure to photograph Ann with her mother as well as her mother alone.

Four Generations

Ann and Harvey's family consisted of four generations. The idea of having a great-grandmother in this portrait was incredible to me. I remember Ann asking if I would like her mother to be in the portraits, and my response was, "Oh my gosh, of course!" What a rare opportunity and something I know the family would be thrilled about.

That's a wrap! I was totally worn out after this session, but it was worth it. It was a blast to spend time with the family and to photograph them as well.

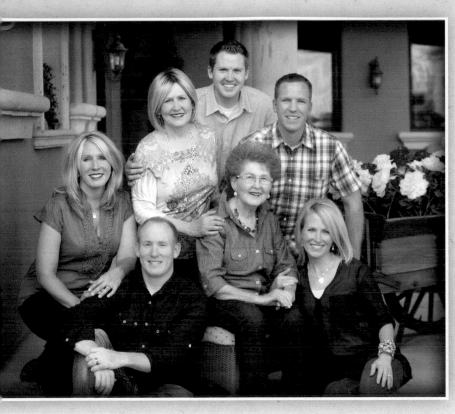

This is a portrait of Anne with all of her children and her mother. This is a portrait I know Anne will treasure.

This is the entire family. It is never easy to get 12 adults to look at the camera at the same time when you also have 17 children ranging in age from 6 months to 15 years old. If you look you can see the personality of each of these children in the way they are posing and looking at the camera. This is one of those images that is not meant to be perfect in every way; rather it is a portrait a loved one looks at and can say, "Oh, that face is so him or her."

Index